RICHMOND

THROUGH THE 20TH CENTURY

AMY WATERS YARSINSKE

AMERICA
THROUGH TIME®
ADDING COLOR TO AMERICAN HISTORY

AMERICA THROUGH TIME is an imprint of Fonthill Media LLC

First published 2016

Copyright © Amy Waters Yarsinske

Unless otherwise indicated in the caption, the pictures in this book are
courtesy of the author.

ISBN 978-1-63499-000-4

Typeset in Rotis Serif Std

Published by Arcadia Publishing by arrangement with Fonthill Media LLC
For all general information, please contact Arcadia Publishing:
Telephone: 843-853-2070
Fax: 843-853-0044
E-mail: sales@arcadiapublishing.com
For customer service and orders:
Toll-Free 1-888-313-2665

Visit us on the internet at www.arcadiapublishing.com

INTRODUCTION

Richmond is a city with a pedigree, a past that can be traced back to the first English settlers who landed at Jamestown in 1607. Yet the focus of this volume is the twentieth century, which was, by all rights, America's century and Richmond's rebirth as a modern, changed city. "The closer Richmond moved toward the twentieth century, the more it seemed to be a city of archives and icons, the 'holy city' of the Confederacy, and an American industrial city, reflecting the prosperity and problems of mass production," wrote historian Marie Tyler-McGraw[1], of the city that had held on so tightly to its status as capital of the Confederacy and bastion of the South's cause in the war. "The Lost Cause as a form of civil religion for the South was especially evocative in Richmond," McGraw continued, "Yet the political influence of the Lost Cause zealots was probably not as great as its acolytes imagined. Both politicians and businessmen found the Lost Cause to be a malleable concept, adaptable to new circumstances." Richmond was ready for a makeover – and it got it.

In those salad days of the twentieth century, when life was good and businesses were thriving, it was readily apparent to many, especially those disenfranchised by the city's leading political and business class who continued to preserve and promote the legacy of the Lost Cause in Richmond and used it liberally to develop the New South, that change was, just then, on a slow roll. The city focused on its role as the premier city of the South, a place that had evolved since the Civil War but still built monuments and statues to Confederate leaders in the same manner Washington, D.C. put up those who had led the Union.[2] Richmond had become a symbol of the industrial "New South," moving quickly from its agrarian past. City leaders worked particularly hard to shape the city as progressive and modern. Franklin Street was repeatedly compared to New York's Fifth Avenue and Broad Street to Broadway. As McGraw aptly put it: "The white cultural solidarity of the Lost Cause did not hamper the business coalition in Richmond. Instead, the institution of civil religion created a surface harmony among whites that muted class issues and helped to maintain racial separation at a time when these class divisions were deep and sharp in other American cities. The Lost Cause was," she continued, "too flexible politically and economically and too valuable as a commodity not to be reinvented and revived as occasion demanded."[3]

Richmond emerged from the nineteenth-century looking over its shoulder. Smaller in size than Baltimore, Richmond's mid-nineteenth century potential as a metropolis comparable to other east coast cities, had been thwarted, observed historians and planners, by dependence on canal transportation rather than the new, faster railroad, and by heavy reliance on slave labor. Certainly, these were issues that limited the city's growth in the antebellum period and,

most assuredly, continued during the Civil War. Richmond would emerge from the smoldering rubble of the war as an economic powerhouse; the city rebuilt with impressive iron front buildings and massive brick factories that could also lay claim as an influential railroad center that surpassed Philadelphia, Baltimore and Norfolk combined in goods shipped by rail.

Though there would be a dip in economic productivity during the depression of 1873, Richmond ended the nineteenth century with a booming economy. Iron, tobacco, flour, paper, textiles, locomotives, ships, fertilizer, carriages, soap and spices were produced in large quantities. Tobacco was king, just had it had been before the war. Tobacco warehousing and processing continued to play a role, boosted by the world's first cigarette-rolling machine, invented by James Albert Bonsack of Roanoke in 1880/81.[4] Contributing, too, to the city's postwar comeback was the first successful electrically powered trolley system in the United States; this was the Richmond Union Passenger Railway. The first line opened in 1888. In 1890, according to city data, the population of Richmond was 81,000, which more than doubled the number of residents from 1860. The streetcar arguably contributed to this spike in the city's resident population. By the start of the twentieth century, Richmond's population had climbed to 85,050 in five square miles, making it the most densely populated city in the South.[5] The 1900 census density data translates to 16,000 persons per square mile. Further, the Census Bureau reported that Richmond's population was 62.1 percent white and 37.9 percent black. By the end of the century this statistic would change dramatically.

The January 1, 1901 *Richmond Times Dispatch* pronounced that the first year of a new century had not been surpassed during the previous hundred years, "probably, as a year of natural advancement along every line that makes a city great." Richmond was pushing boundaries, culturally, socially, economically and physically, the latter being of particular importance as the city pushed for greater population numbers resulting in a larger tax base, diversification and, thus, economic advantage. The city has been extended eleven times since the original incorporation in 1742, the latest occurring in 1970 when roughly 23 square miles and 47,000 new residents were annexed from Chesterfield County. But the city had already launched a particularly aggressive annexation campaign between the years 1906 and 1914, resulting in an increase to the city's physical boundaries of more than 400 percent; this included merging with the town of Manchester in 1910. From a little over 85,000 people in 1900, Richmond grew to a population of nearly 155,000 by 1914, largely as a result of annexation.

City documentation tells the story. Early annexation efforts were undertaken to enlarge the tax base by including the growing middle-class population flourishing outside the city's formal boundary, to open up new areas for needed development, and to counter overcrowding in the city center. Annexation was not the best means of directing the city's growth. With each successive annexation, critics observed the enormous cost of adding land and population to the city. Additionally, many business leaders and residents were leery of expanding the powers of local government and suggested that the solution to the city's existing challenges such as poor infrastructure, substandard housing, and overdue public improvements should not be predicated on annexation. Despite this admonishment, the annexation process steamed ahead.

A major annexation occurred in 1942 that added land to Richmond's tax base from all sides and increased the population of the city to just over 208,000; this would be the last successful annexation of surrounding suburban land until the Chesterfield annexation in 1970, due largely to the contentious nature of the process that embroiled Richmond and other municipalities such as Norfolk and Virginia Beach in land battles that involuntarily annexed

large swaths of real estate to the city that possessed the greater political and economic clout. Richmond annexed the northern part of Chesterfield county, to include Midlothian, Huguenot, and much of the Broad Rock planning districts. Shortly thereafter, the Virginia General Assembly passed a moratorium on involuntary annexations, which remains in effect. Richmond today serves as the cultural, financial, and business center of a rapidly growing metropolitan area, and is the capital of the Commonwealth. City, state and federal government offices, universities and a medical center, a symphony, museums, and theater all add to the vibrancy of the city, one that is still often referred to as "the Capital of the South." By the early twenty-first century, the population of the greater Richmond metropolitan area, now 62.5 square miles, had reached approximately 1.1 million although the population of the city itself had declined to less than 200,000.

Data, though helpful to telling the story, does not explain Richmond's unique mystique, which historian Virginius Dabney observed "is one of only about a half-dozen American cities of which this can be said. If there is a single explanation for this above all others, it is that Richmond was the capital of the Confederacy, the citadel for four years against invading armies. Once this mystique is gone," he cautioned, "Richmond will be just another city."[6] Perhaps this has already happened but let's hope not. As Richmonders ended the twentieth century and entered the new millennia, it is incumbent on them to heed Dabney's words and zealously guard and preserve the qualities that have set the city apart, "qualities that, once lost, can never be recovered."[7]

Endnotes

1 McGraw, Marie Tyler. *At the Falls: Richmond, Virginia, and Its People.* Chapel Hill: University of North Carolina Press, 1994.
2 Winthrop, Robert P. *Architecture in Downtown Richmond. Richmond*: Historic Richmond Foundation, 1982.
3 McGraw, Ibid.
4 Smil, Vaclav. *Creating the Twentieth Century: Technical Innovations of 1867-1914 and Their Lasting Impact.* New York and London: Oxford, 2005.
5 Gibson, Campbell, "Population of the 100 largest cities and other urban places in the United States: 1790 to 1990. United States Census Bureau, June 1998. www.census. gov/population/www/documentation/twps0027/twps0027.html
6 Dabney, Virginius. *Richmond: The Story of a City.* New York: Doubleday, 1976.
7 Ibid.

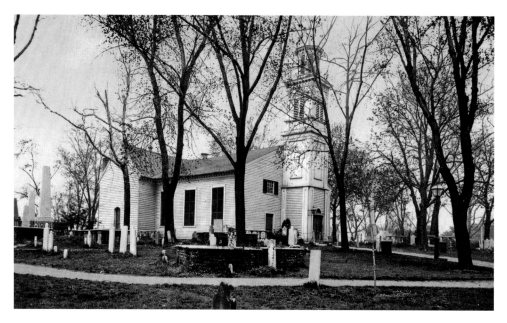

Located in Richmond's oldest standing neighborhood, Church Hill, the 1741 period Saint John's Church (shown here in this 1901 photochrom) was the first church ever built in the city as part of Henrico Parish. The graveyard (foreground) is the site of the first public cemetery in Richmond. Many persons who made contributions to the history of Richmond and Virginia are buried here: George Wythe, signer of the Declaration of Independence and teacher of law to Thomas Jefferson, first chief justice of the Supreme Court John Marshall, and Henry Clay; the National Park Service designated Saint John's Church a National Historic Landmark in 1961. *Detroit Publishing Collection, Library of Congress.*

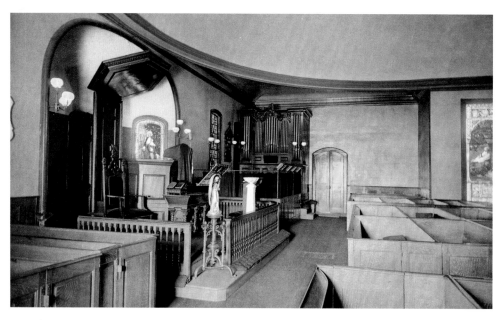

According to the church's history, before Thomas Jefferson drafted the Declaration of Independence in 1776, he attended the Second Virginia Convention at Saint John's Church in Richmond a year earlier (interior shown here, 1901 photochrom). Alongside George Washington, Richard Henry Lee and other important figures in the American Revolution, Jefferson listened as Patrick Henry gave his now-famous "Give me liberty or give me death" speech; it is this oratory that ignited the war for independence that followed. This view of the interior of Saint John's is from Patrick Henry's pew. *Detroit Publishing Collection, Library of Congress.*

Virginia's Washington Monument in Capitol Square (shown in this 1900 view) originated with the Virginia General Assembly's establishment of a fund for a monument to Washington in 1817. At its unveiling on February 22, 1858, the statue became only the second equestrian statue of George Washington ever dedicated; it was inspirational toward generating a national wave of representational memorial sculptures. The design consists of three tiers of pedestals, each featuring a series of representational sculptures: Washington on top; Virginia patriots in the middle tier; and a series of allegorical figures and shields with inscriptions memorializing Revolutionary War principles or events on the lower tier. The six Virginia patriots are Thomas Jefferson, Patrick Henry, John Marshall, Thomas Nelson, George Mason, and Andrew Lewis. The six shields memorialize Revolution, Bill of Rights, Independence, Finance, Justice, and Colonial Times. Thomas Crawford executed the figures of Washington, Jefferson, and Henry and began Mason and Marshall. Randolph Rodgers completed Mason and Marshall and executed the figures of Nelson and Lewis. *Detroit Publishing Collection, Library of Congress.*

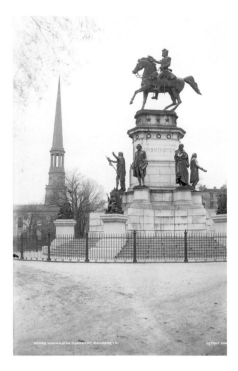

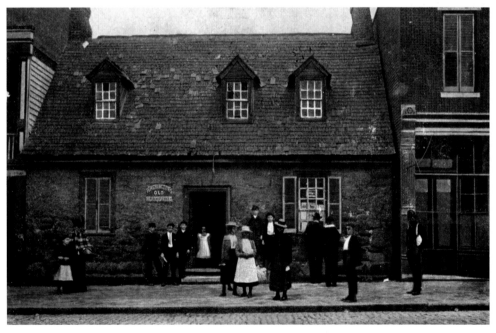

This private mailing card of "Old Stone House" – Richmond's oldest standing residence – dates to 1902. The house was long promoted as General George Washington's Richmond headquarters yet this Founding Father never visited the home nor did he ever use it in any capacity. Located today at 1914 East Main Street, the house was originally built by Jacob Ege about 1740 and is often cited as the oldest original building in Richmond. Ege emigrated from Germany to Philadelphia in 1738 and came to the James River settlements and Colonel William Byrd's land grant – subsequently known as Richmond – in the company of his fiancée Maria Dorothea Scheerer's family; he later married her and the house was made fit for her as his bride. Jacob died in 1762. The house remained in the Ege family until 1911. The "Old Stone House" became a shrine to poet Edgar Allan Poe – who spent part of his youth in Richmond – on October 7, 1921. But Poe never lived or worked in the house either.

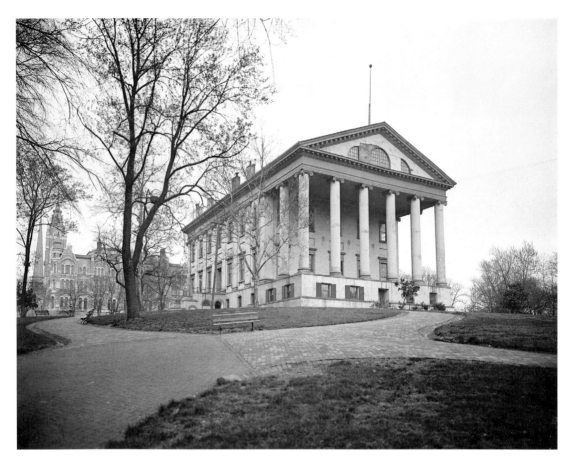

The Virginia State Capitol, conceived in 1785, is the second oldest working capitol in the United States. Designed by Thomas Jefferson while he was in France, the building was modeled after a Roman temple, the Maison Carrée. While Jefferson did not directly copy the Maison Carrée, but modified it to accommodate modern necessities, he did respect the general temple form and introduced the Classical Revival style into America. A half a century after the erection of the building, the General Assembly commissioned Maximilian Godefroy to develop a landscaping plan that would supply an appropriate setting for the public building. The formal French layout that resulted was drastically transformed in 1850 by John Notman who turned Capitol Square into the first picturesque park in America. The Capitol building remained intact until the Capitol disaster of 1870 in which a structural failure caused the destruction of the north end of the building. Following the catastrophe, the building was restored only to be completely gutted, renovated and enlarged with the addition of 1904 to 1906. This addition, designed collaboratively by the architecture firms of Noland and Baskervill, Frye and Chesterman, and Peebles, consisted of the addition of front stairs and two wings with connecting hyphens, to house the Senate chamber and the hall of the House of Delegates. In 1964, there was a total restoration of the Capitol and a widening of the hyphens to accommodate stairs on the interior of the building and to supply more office space on both the basement and fourth floor levels. In 2007 a Capitol restoration and extension project was initiated and completed, the first major restoration project in almost 100 years. William Henry Jackson took this 1900 period photograph of the Virginia State Capitol, prior to the 1904 to 1906 restoration. *Detroit Publishing Collection, Library of Congress.*

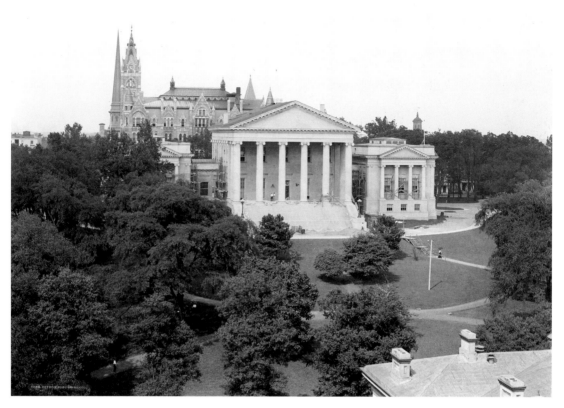

The Virginia State Capitol, shown here during the 1904-1906 renovation and enlargement, emerged from this construction with east and west wings to house the House of Delegates Chamber and the Senate Chamber respectively, and monumental granite steps to the columned south portico. Though Thomas Jefferson designed the original building, shown here, his footprint was enlarged due to a premature foundation laid before Jefferson completed his plans, and additional changes made during construction. The original building was completed between 1786 and 1798. *Detroit Publishing Collection, Library of Congress.*

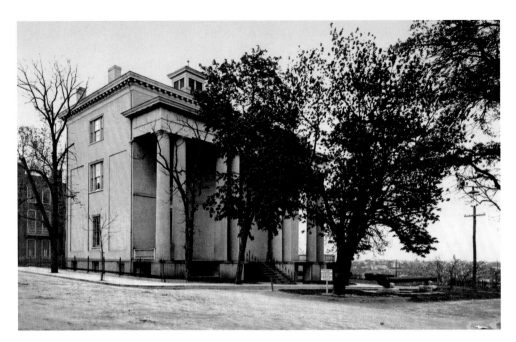

Known since the Civil War as the White House of Confederacy, this neoclassical mansion (shown in this 1901 photochrom) was built in 1818 by John Brockenbrough, president of the Bank of Virginia. Designed by Robert Mills, Brockenbrough's private residence was constructed on East Clay Street in Richmond's affluent Shockoe Hill neighborhood (later known as the Court End District), and was two blocks north of the Virginia State Capitol. Among Brockenbrough's neighbors were first chief justice of the Supreme Court John Marshall, Aaron Burr, defense attorney John Wickham, and future United States senator Benjamin Watkins Leigh. The house passed through the ownership of several wealthy Richmond families before it became the executive mansion of Jefferson Davis, president of the Confederate States of America, and his family from August 1861 to April 1865. *Library of Congress.*

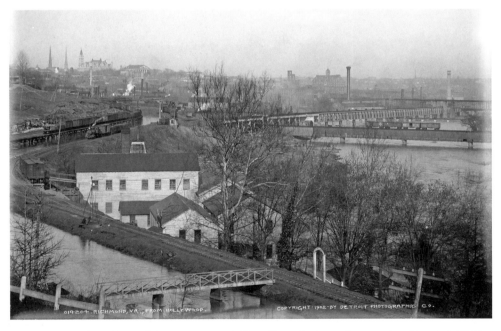

Richmond from the Hollywood Cemetery, 1902. William Henry Jackson, photographer. *Detroit Publishing Collection, Library of Congress.*

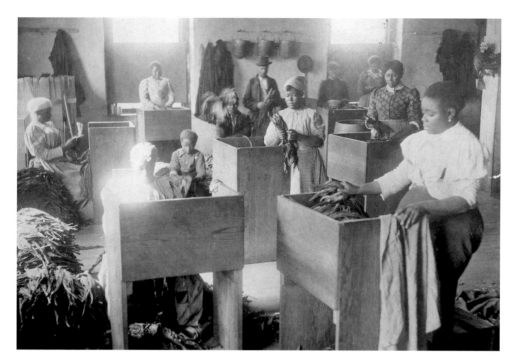

African Americans, mostly women, were photographed sorting tobacco at the T. C. Williams Tobacco Company at the turn of the century. This photograph, among others, was collected by William Edward Burghardt "W. E. B." Du Bois, an American sociologist, historian, civil rights activist, Pan-Africanist, author and editor, and Thomas Junius Calloway, a prominent lawyer, educator, civil servant, and African American activist, for the "American Negro Exhibit" at the Paris Exposition of 1900. T. C. Williams, which began operation in 1853, was one of the largest companies in the United States manufacturing tobacco for export. In 1903, when Williams became a subsidiary of the British-American Tobacco Company, the company exported nearly five million pounds of chewing tobacco. *Library of Congress.*

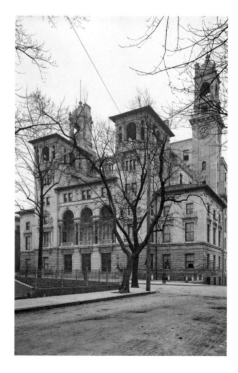

Tobacco baron Lewis Ginter planned the development of the Jefferson Hotel as a premier property in the city of Richmond, capital of the state. It was designed in the Beaux-Arts style by Carrère and Hastings, noted national architects based in New York, who later designed the New York Public Library. Construction began in 1892 and the hotel opened for business in 1895. After a fire gutted the interior of the hotel in 1901, it was restored and reopened in 1907. William Henry Jackson took this picture of the Jefferson Hotel in 1900. *Detroit Publishing Collection, Library of Congress.*

THE FIRST QUARTER CENTURY

At the beginning of the twentieth century, Richmond was moving strongly past a business depression and expanding as a railroad center, a continuation of the city's postbellum revival and growth. After the Civil War, the city's railroad footprint had surpassed Philadelphia, Baltimore, and Norfolk combined in the amount of goods shipped by rail. Notwithstanding the economic depression of 1873, Richmond flourished in the late nineteenth century and Richmond by the turn of the twentieth century was booming, from tobacco, flour, paper, textiles, locomotives, carriages, ships, fertilizer, soap and spices, all produced in large quantities. The city was not growing as fast as rivals Atlanta and Nashville, and certainly nothing approaching cities in the industrial North, but it did have regional retail and particularly proud history, observed historian Marie Tyler- McGraw, and it had a commercial center with a diversifying industrial base that was certainly driven by rail. Certainly, too, "it was [the advent of] Richmond's modern electric streetcar, more than [the city's] Confederate monuments, that sped up the process of creating new suburbs that sorted the city out by race and economic class, demonstrating once again, [in large measure] that the modernizing technology in the New South was in harmony with the Lost Cause."[1] As a new century dawned, the city's segregated population was collectively just over 85,000.

Newcomers to Richmond could get to the city by one of six major rail lines, a narrow gauge track from Farmville, or six steamship companies, that ran to the capital of the Commonwealth. The Chesapeake and Ohio-Seaboard Air Line depot on Main Street between Fifteenth and Sixteenth Streets, and the Southern Railway station at Fourteenth and Mill Streets were soon built to facilitate passenger travel. Ambitious rail expansion included new bridging over the James River. In addition to what was manufactured and milled in Richmond, rail and river lines carried coal from western Virginia to Norfolk, and fertilizer materials, ice, lumber, railroad ties, and grain came through Richmond for processing or use.[2] Tobacco was still king, as it would remain for the duration of the century. More than 10,000 men and women engaged in the manufacture of cigarettes, cigars, and cheroots,[3] a number that would grow exponentially as the city's tobacco magnates diversified and expanded their holdings.

According to Virginius Dabney, a significant Richmond industry scarcely mentioned was the quarrying of granite on the south side of the James. The stone used in the State, War and Navy Building (now the Eisenhower Executive Office Building) in Washington, D. C., came from Westham Quarry upriver from Forest Hill Park; this building, located west of the White House, was the most elaborate and largest granite structure in the United States when it was completed in 1888. Stone from these quarries was also used in the construction

of Richmond's city hall, finished in 1894, and for the soldiers' and sailors' monument on Libby Hill, also completed that year.[4]

Freed slaves and their descendants created a thriving black business community in the salad days of the new century, and they were so successful that the city's historic Jackson Ward quickly became known as the "Wall Street of Black America." Despite the growing influence of the city's black population, the city council election of 1900 demonstrated, as documented by McGraw, how far white Richmond Democrats would go to suppress the black vote. In that election, though blacks managed to overcome internal divisions to offer a slate of candidates, white Democrats added bogus and similar-sounding names to the registration list and stuffed the ballot boxes during the election.[5] The same year the Virginia General Assembly passed a law that segregated passenger trains. But that was not all. At the state level, the 1902 Virginia Constitution, which imposed a poll tax and other restrictions on voting, severely reduced the number of voters, and although some blacks in Richmond continued to pay the poll tax and vote, observed McGraw, their political bargaining power was all but gone. A generation of negotiated politics was at an end, and the early twentieth century saw the completion of the segregated city.[6] The following year, in 1903, the city council abolished Jackson Ward as a political entity and thereby eliminated the possibility of a black councilman, a setback that would take decades for the black community to overcome.

Postbellum segregation rippled across the South, and while it might have dampened progress in Richmond's black community, it did not stop it. In 1903, just as the Jackson Ward was denigrated, black businesswoman and financier Maggie L. Walker chartered Saint Luke Penny Savings Bank, and served as its first president, as well as the first female (of any race) bank president in the United States. Today, the bank is called the Consolidated Bank and Trust Company, and it is the oldest surviving black bank in the United States. Walker would also cofound the Richmond Council of Colored Women in 1912.

Beginning in the first decade of the twentieth century theater mogul Jake Wells built a number of vaudeville theaters and opera houses in Richmond. Other theaters and opera houses would open on Broad Street - the city's "Theater Row" - to include the Bijou (1905); the Lyric Opera House (1913), and the Colonial Theater (1921), among them. But it was Wells who trailblazed the city's vibrant theater district. Importantly, in 1926, The Mosque (now called the Altria Theatre) was constructed by the Shriners as their ACCA Temple, Ancient Arabic Order of the Nobles of the Mystic Shrine (AAONMS), a headquarters and convention center, and since then, many of America's greatest entertainers have appeared on its stage beneath its towering minarets and desert murals. Loew's Theater was built in 1927, and was described as, "the ultimate in 1920s movie palace fantasy design." It later suffered a decline in popularity as the movie-going population moved to the suburbs, but was restored during the 1980s and renamed as the Carpenter Center for the Performing Arts. In 1928, the Byrd Theater was built by local architect Fred Bishop on Westhampton Avenue (now called Cary Street) in a residential area of the city. To this day, the Byrd remains in operation as one of the last of the great movie palaces of the 1920s and 1930s.

The boundaries of the city of Richmond have been extended a total of eleven times since the original incorporation in 1742. The city launched an especially aggressive annexation campaign between 1906 and 1914, resulting in an increase to the city's physical boundaries of more than four hundred percent. This included, in 1910, the former town of Manchester, and four years later, in 1914, the city annexed the Barton Heights, Ginter Park, and Highland Park areas of adjacent Henrico County. The city's population jumped from 85,000 in 1900 to 155,000 by 1914, largely due to this period of annexation. Early annexation efforts,

according to the city's master plan, were undertaken to enlarge the tax base by including the growing middle-class population that had blossomed outside the city's existing boundaries; to open up new areas for needed development, and to counter overcrowding in the city's center. The 1900 census cited a density in Richmond of almost 16,000 persons per square mile, making it the most crowded city in the South at that time.

Annexation was not universally accepted as the best way to direct the city's growth and critics of the tactic cited the enormous cost of adding land and population to the city. Further, many business leaders and residents remained skeptical of expanding local government powers and recommended that the solution to Richmond's plaguing problems, which included poor infrastructure, substandard housing and overdue public improvements would not be found in annexation. Despite their growing issues with the city's annexation plans, business flourished. The financial district, centered on Main Street, was booming along with the white shopping mecca on the south side of Broad Street while the black community patronized small shops on the north side of the street. Importantly, in May of 1914, the Federal Reserve Commission chose Richmond over Atlanta for its Fifth District headquarters and thus made the former Confederate capital the focal point of finance for much of the southeast. The commission chose Richmond for its geographic location, importance as a commercial and financial hub, and Virginia's leading role in the banking industry. Though the Federal Reserve building was originally located near the federal courts downtown, it was moved to a building near the Capitol complex in 1922 (today the Supreme Court of Virginia building), and finally to its present location overlooking the James River in 1978.

The First World War brought heightened prosperity to the city but also significant changes in the way government would envelope the daily routine of Richmonders, from planning to city services. Though planning was originally the function of the city's public works department, which designed new streets and subdivisions, in 1918, a City Planning Commission composed of city officials was formed and charged with development of a comprehensive plan; however, according to city documentation, the commission never met and was eventually replaced. Three years later, in 1922, the city successfully petitioned the General Assembly for an amendment to Virginia's 1918 Plat Act, which enabled Richmond to regulate subdivisions within a five-mile radius of the city limits. This action was followed by a period, largely during the 1920s and 1930s, of public spending on infrastructure improvements in fringe areas that dictated the form and direction of future urban expansion. The city's first comprehensive zoning ordinance was passed in 1927. Investment of public money in street development and sewer line extension would influence the direction of suburban development in the years to come. As private development came at the cost of the city. As private development sprung outside the city center, the white population followed, thus abandoning old city neighborhoods. By the end of the 1920s, the white population comprised seventy percent of the population. City center infrastructure was neglected in favor of urban expansion. Richmond's black population, in the statistical minority, moved into the residential and commercial sections abandoned by white residents who left for the city's newly annexed suburbs and outlying open land that offered new opportunities.

Richmond's economic prosperity in advance of the Great Depression was most visible on Broad Street, the city's main shopping corridor. "Its center was a retail section that reached to Boulevard at the west end of the Fan District to the city hall and a cluster of public buildings on the east. Richmond's downtown drew shoppers from a wide section of the Upper South," wrote McGraw. "To the west, Broad Street continued through successive layers of suburbs toward the foothills of the Piedmont; to the east, it dropped into Seventeenth Street Bottom,

near Shockoe Creek, then ascended into the old neighborhood of Church Hill and ended at Chimborazo Park."

Before the end of the nineteen teens, several important markers of the city's booming success had come to fruition. Between the annexations of 1914 and the end of the decade, the city's population climbed to 171,000, much of it in the city's expanded borders and further driven by wartime production moving through Richmond's plants and mills. Richmonders saw the opening of the Broad Street Railroad Station in 1919 on the site of the old state fairgrounds, and as one historian would observe, it came on scene "just a few days before the automobile, the airplane, and suburban industrialization began to remove the business traveler from the central city."[7] Also in 1919, at the end of the war, Philip Morris was incorporated in Richmond and built its first plant in the city in 1926.

After Prohibition took full effect in 1920, the saloons, gentlemen's clubs and taverns that dotted the north side of Broad Street were closed and padlocked. Despite the loss of these establishments, the economic boon continued, some of it was the kind that Richmonders had not yet seen in great number. McGraw documented small stores that offered patrons "a dollar down, dollar a week" to pay for household and disposable items, most of them dotting Broad where bar businesses formerly flourished. These "easy pay" storefronts that gave shoppers the chance to furnish their homes and apartments on credit contrasted dramatically with Thalhimer's and Miller and Rhoads, the city's two major retailers, who had built new department stores across the street.

From the time the horseless carriage first appeared on a Richmond street, it changed the way Richmonders saw the city and most importantly how they used it. "The automobile," observed McGraw, "changed the spatial pattern of downtown and suburbs and freed for development many areas that weren't near streetcar tracks." One revolution – the streetcar – soon succumbed to another. The greater the number of vehicles on the streets of Virginia's capital city, the less need for trolleys and passenger trains, the latter eclipsed in the decades to follow. Motorized cars, trucks and motorcycles moved people further from the city center and away from the streetcar lines that had proven such an effective mode of transportation at the turn of the twentieth century. The advent of car congestion also necessitated the installation of traffic signals in 1926, and by the following year, nearly a third of the city's streets were paved. The fact that only one-third of the streets were paved was not unusual among southern cities at that time, and "outside the city limits, the state imposed gasoline taxes to build and maintain state highways, while federal highways were built between major cities."[8]

The automobile also did something else: paved roads and something called paid vacation brought tourism to the city of Richmond. Tourism was decidedly a manifestation of the 1920s, one that combined the convenience of travel embodied in the automobile and the history by which Richmond metaphorically lived and breathed. Those many Americans who had before hesitated to travel saw Richmond in a different light after the advent of the so-called touring car that now enabled them to delve into the rich history located in the heart of the state's capital. Attractions closely associated with the city's past, from Founding Fathers to the Civil War, including records and memorials, statues and other tributes became accessible. As McGraw observed, these were both genuine, like the John Marshall house, and bogus, like the small stone house once in the Ege family, which was designated as "Washington's headquarters," though it was certainly not the case.

Importantly, "the twenties also saw the construction of affluent estates in the city's west end, developed around important manor houses and reflecting a nationwide interest in the

architecture of the English manor house," wrote McGraw. "These houses reflected the desire of wealthy Richmonders, including some whose new wealth had been acquired through legal, financial and brokerage firms" in the boon that followed the First World War. The areas in which wealthy Richmonders built their homes were private retreats, a place where the most renowned architects of the period could create and recreate architectural masterpieces, some, as McGraw and others would later observe, were their own version of the English past with them as the new lord of the manor. In 1925, Thomas C. "T. C." Williams Jr., the son of a successful Richmond tobacco manufacturer, chose a sixteenth-century manor house called Agecroft in Lancashire, England, for his future Richmond residence. For centuries, it was the home of the distinguished English Langley and Dauntesey families, during the tempestuous yet brilliant Tudor and Stuart ages, when England was taking its place among the major powers of Europe and the New World. Agecroft stood proudly during the reigns of Henry VIII, Elizabeth I, and James I, the namesake of the river that would eventually flow past Agecroft's banks. By the mid 1920s, the building in Lancashire had deteriorated largely due to coal mining in its vicinity, and the structure was bought by Williams, dismantled, and shipped across the Atlantic to Richmond, where it has stood since it was reconstructed between 1926 and 1927, and occupied in the spring of 1928. Taking the most dramatic features from the quadrangle of buildings, he reinstalled them as one structure in the city's West End and situated on the banks of the James. After decades of service as a private residence, it then became a house museum with glorious gardens, all of which pay tribute to the Elizabethan Age. Nearby, Alexander Weddell reinstalled features of Warwick Priory, a sixteenth-century English structure, aiming at a reproduction of the ancestral home of George Washington. The structure was called Virginia House. Finally, Wilton, a pre-Revolutionary James River manor house, was moved to the West End and restored as a house museum. "With these three historic edifices as anchors for the area, Williams developed the suburb Windsor Farms," noted McGraw. "Modeled after an English village, Windsor Farms was laid out on a common green, and owners of houses there favored Georgian styles and the architecture of William Lawrence Bottomley, who designed houses on Monument Avenue in addition to the Williams project."

At the time Windsor Farms was nearing completion, "Richmond's West End had gone far toward creating a cluster of elite private educational and social institutions. The exclusive Country Club of Virginia was established there in 1910, and Richmond College moved to Westhampton in the same year, becoming the University of Richmond in 1920. Saint Christopher's School for Boys was founded nearby in 1920, and Saint Catherine's School for Girls, founded in 1890, moved to the area in 1917."[9] But there were other landmarks that entered the Richmond scene as well, including, in 1926, the beginning of construction of the Carillon in Byrd Park, constructed as a memorial to First World War dead by John Taylor & Company, The Loughborough Bell Foundry of England. The Carillon still towers above Byrd Park in the city. The following year, in 1927, the dedication of Byrd Airfield (now Richmond International Airport) included a visit by Charles Lindbergh. The airport was named after Richard Evelyn Byrd, the famous American polar explorer. Thousands of visitors came to attend the ceremonies surrounding the dedication of Monument Avenue statues to Stonewall Jackson in 1919 and Matthew Fontaine Maury in 1929, both well documented in the Richmond newspapers, and the dedication of the Confederate Memorial Institute, popularly known as Battle Abbey, in 1921. The John Marshall Hotel opened its doors in October 1929, capping a decade that was good to the city.

Endnotes

1 McGraw, Marie Tyler. *At the Falls: Richmond, Virginia, and Its People.* Chapel Hill: University of North Carolina Press, 1994.

2 McGraw, Ibid.

3 Ibid.

4 Dabney, Virginius. *Richmond: The Story of a City.* New York: Doubleday, 1976.

5 McGraw, Ibid.

6 Ibid.

7 Ibid.

8 Ibid.

9 Ibid.

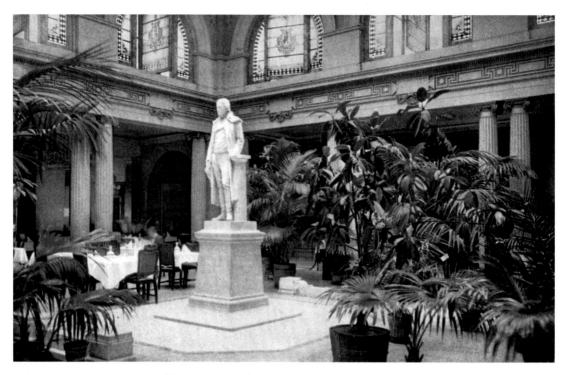

Above: The Japanese palm garden (shown here, 1908) surrounds the statue of Thomas Jefferson inside the Jefferson Hotel. *Detroit Publishing Collection, Library of Congress.*

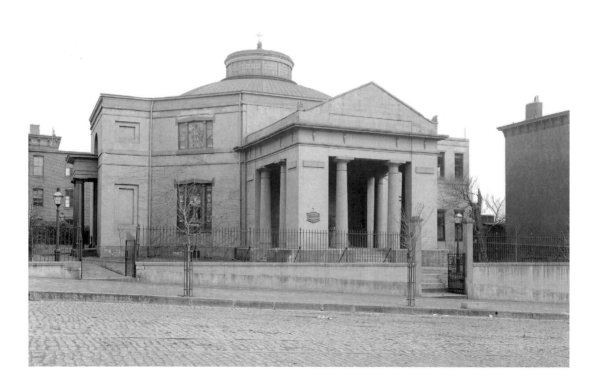

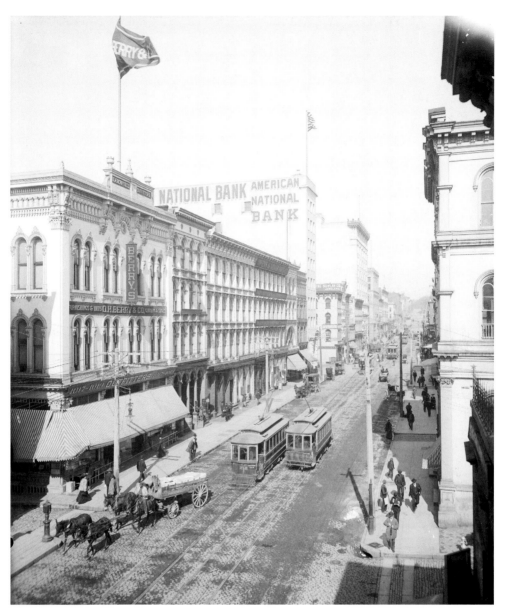

Above: This image of the city's vibrant East Main Street was taken on July 8, 1905. *Detroit Publishing Collection, Library of Congress.*

Opposite below: Monumental Church, built between 1812 and 1814, was designed by architect Robert Mills to commemorate the deaths of seventy-two persons, including Virginia governor George William Smith and Abraham B. Venable, president of the Virginia Bank, who perished in a December 26, 1811 fire that destroyed the Richmond Theater on Academy Square at East Broad Street (on the site of the church). Conceived as both an active church and commemorative monument, its dual role is expressed by a stone memorial portico and adjoining octagonal church. As an early example of Greek Revival styling, Monumental Church is derived from the work and ideas of numerous renowned designers, especially Benjamin H. Latrobe. Mills, however, an American-trained architect who explored progressive concepts such as fireproof-construction techniques, is credited with synthesizing contemporary architectural trends into buildings that have become identified with the Federal era. Although Monumental Church was altered and enlarged during the late nineteenth century, subsequent rehabilitations have restored its original appearance. William Henry Jackson took this photograph of the church in 1903. *Detroit Publishing Collection, Library of Congress.*

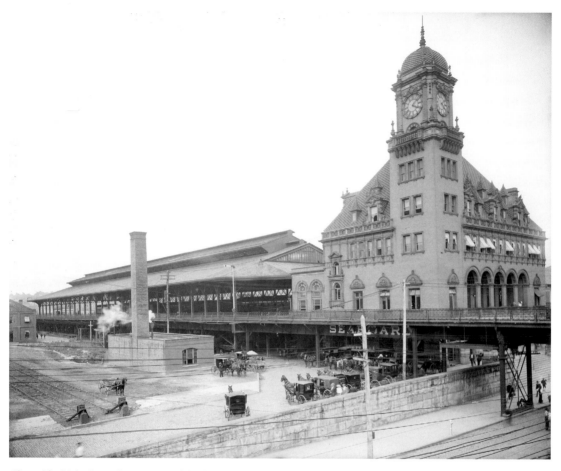

Above: The Main Street Station, one of the few French Renaissance buildings in Richmond, exemplifies a standard train station plan of the late nineteenth century. Designed by Wilson, Harris and Richards of Philadelphia, Pennsylvania, who also designed the Pennsylvania-Reading Station, the station was a very busy travel center of the city during the heyday of passenger service. Initial construction took place in 1901 with train service established by that November. The station is shown here as it appeared shortly after opening, in 1902. *Detroit Publishing Collection, Library of Congress.*

Opposite below: Broad Street was lined with children praising President Theodore Roosevelt on his October 18, 1905 visit to the city (shown here on this Underwood & Underwood stereoview); the president was accompanied by the Richmond Horse Guards. At a welcome banquet held of his arrival, Roosevelt observed: "One among the many great Virginians of the time when this Nation was born – Patrick Henry – said: 'We are no longer New Yorkers, New Englanders, Pennsylvanians or Virginians, we are Americans.' And surely, Mr. Mayor [Democrat Carlton McCarthy], the man would be but a poor American who was not touched and stirred to the depths by the reception that I have met with to-day by the this great historic city of America." Roosevelt continued. "Coming today by the statue of Stonewall Jackson, in the city of Lee, I felt what a privilege it is that I, as an American, have in claiming that you yourselves have no more right of kinship in Lee and Jackson than I have." Giving his remarks a personal touch: "There was an uncle of mine, now dead, my mother's brother, who has always been, among all the men I have ever met, the man who it seemed to me came nearest to typifying in the flesh that most beautiful of all characters in fiction, Thackeray's Colonel Newcome – my uncle, James Dunwoody Bulloch, an admiral in the Confederate Navy..." *Library of Congress.*

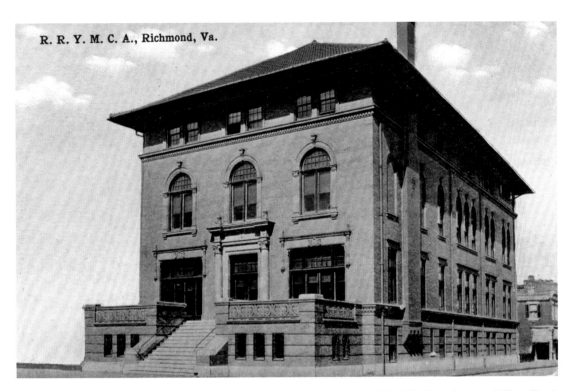

R. R. Y. M. C. A., Richmond, Va.

Above: In 1907, the same Philadelphia architectural firm that had designed the Main Street Station – Wilson, Harris and Richards – also designed the adjacent Railroad YMCA at 1552 East Main Street in the French Renaissance style with equal attention to the Beaux Arts Classical flare that made the train depot an iconic Richmond landmark. The Railroad YMCA is shown on this period postcard. Today, the Railroad YMCA has been converted to loft apartments.

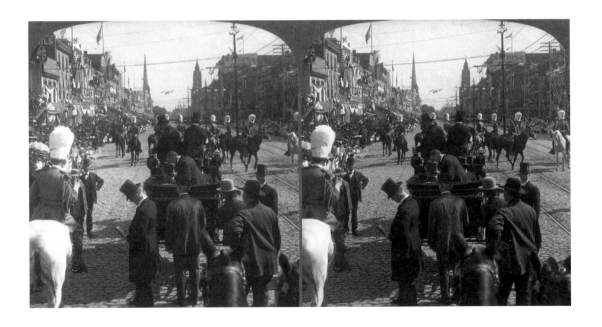

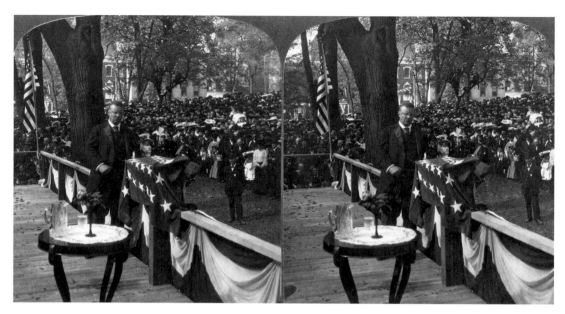

President Theodore Roosevelt delivered a speech at Capitol Square (shown above on this Underwood & Underwood stereoview) on October 18, 1905, praising the courage of the South in war and peace. Roosevelt and his wife made a tour of the Southern states, reported in an article entitled "Visit of the President to the South," which appeared in *The Confederate Veteran*, Volume XIII, No. 9, November, 1905, and other publications of the day. "The proud self-sacrifice, the resolute and daring courage, the high and steadfast devotion to the right as each man saw it, whether Northerner or Southerner – these qualities render all Americans forever the debtors of those who in the dark days from '61 to '65 proved their truth by their endeavor. Here around Richmond, here in your own State, there lies battlefield after battlefield, rendered forever memorable by the men who counted death as but a little thing when weighted in the balance against doing their duty as it was given them to see it..." He also remarked: "These men [North and South] have left us of the younger generation not merely the memory of what they did in war but what they did in peace." *Library of Congress.*

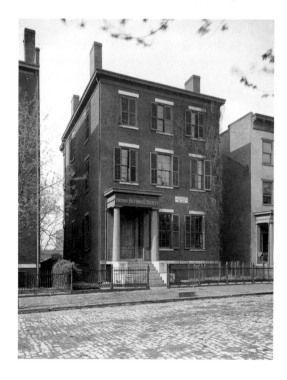

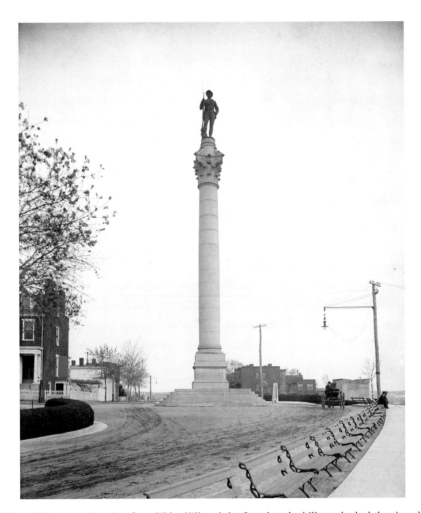

Above: Given the impressive view from Libby Hill and the fact that the hill overlooked the site where the Confederate Navy Yard had operated, it was once planned to erect a memorial there to General Robert E. Lee. When it was decided that the Lee Memorial would be built on the other side of Richmond, on Monument Avenue, plans for a monument to all Confederate soldiers and sailors on Libby Hill was planned. The Confederate Soldiers' and Sailors' Monument Association was formed in 1889. The association decided the monument should be modeled after "Pompeii's Pillar" in Alexandria, Egypt. The monument, designed by William Ludwell Sheppard and shown here as it looked in 1905, depicts a bronze Confederate private standing on top of the pillar, which is composed of thirteen granite blocks to symbolize each of the Confederate states. The monument was completed at the south end of Twenty-Ninth Street in 1894. *Detroit Publishing Collection, Library of Congress.*

Opposite below: Originally part of a group of five houses built by tobacco merchant Norman Stewart between 1844 and 1849, the Stewart-Lee House is the solitary domestic survivor of what once was one of Richmond's finest residential blocks. The house ranks among the best-preserved remaining examples of the three-story Greek Revival town houses popular in Richmond from 1840 to 1850. The building (shown here, 1905) still survives largely because of its brief historical connection to General Robert E. Lee. When Norman Stewart died in 1856, he left the building to his nephew John Stewart, who rented it to General George Washington Custis Lee, Robert E. Lee's son, and a group of young Confederate officers. The officers used the house as the "bachelor's mess" until 1864, when Robert E. Lee's wife and daughters arrived to live there after the confiscation of their home, Arlington House. General Lee retired to the house joining his family on April 15, 1865, following the surrender of the Confederate army at Appomattox. The family left Richmond together for the country in June of that same year. *Detroit Publishing Collection, Library of Congress.*

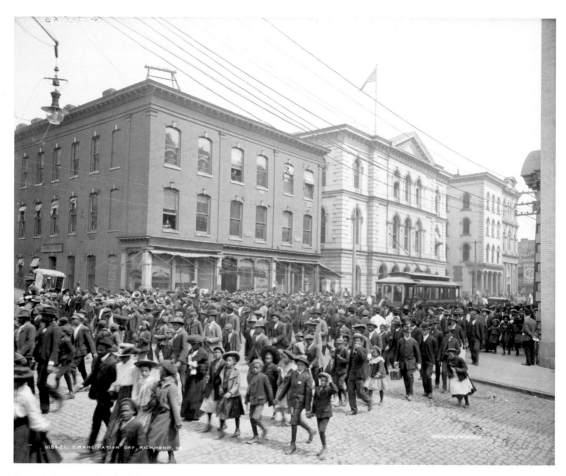

Though this event is called the Emancipation Day parade, held April 3, 1905, the march marked the fall of Richmond and not President Abraham Lincoln's Emancipation Proclamation. The image shown here was taken as the parade entered the intersection at Tenth and Main Streets with the Shafer Building at the corner and the old Custom House and Richmond post office building to the right; the latter was one of the few buildings to survive the Confederate evacuation fire in 1865. To the right of that building is the Mutual Assurance Society Building. *Detroit Publishing Collection, Library of Congress.*

Opposite above: This is the 800-block of West Franklin Street; 806, a Second Empire residence, is in the foreground. The West Franklin Street area, extending three blocks from Monroe Park to Ryland Street, forms a section of the northern boundary of the Fan District, the region that fans out from Monroe Park to the Boulevard. Going west on West Franklin Street from Capitol Square, the irregular skyline created by high modern buildings juxtaposed to older residences can be seen. Today, faculty, staff and graduate student offices for the Virginia Commonwealth University Department of Psychology are housed in five historic buildings along West Franklin Street: Bird House (820), Hunton House (810), Thurston House (808), White House (806, shown here foreground) and Williams House (800). The Second Empire residence at 806 was the home of Norfolk born William Henry White, a prominent lawyer who became president of the Richmond, Fredericksburg and Potomac Railroad, and the Washington and Southern Railway Company on January 1, 1907, and soon after moved from Norfolk to Richmond. White died in Richmond on August 5, 1920, at the age of seventy-three.

The 1000-block (from 1012) of West Franklin Street, shown here in 1905, included a number of turn-of-the-century apartments and townhomes, many of them today used by Virginia Commonwealth University. *Detroit Publishing Collection, Library of Congress.*

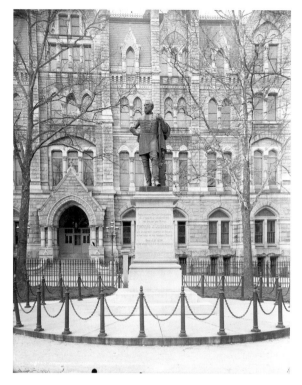

The statue of Confederate general Thomas Jonathan "Stonewall" Jackson (January 21, 1824-May 10, 1863), located on the north side of the Capitol between the George Washington Equestrian Monument and the Executive Mansion, was unveiled on October 26, 1875, before a crowd of some forty to fifty thousand, including many who served under Jackson during the Civil War. Designed by Irish sculptor John Henry Foley, the bronze sculpture was the gift of English gentlemen, in honor of the great Virginia soldier. Richmond's old City Hall is in the background of this photograph, taken in 1905. *Detroit Publishing Collection, Library of Congress.*

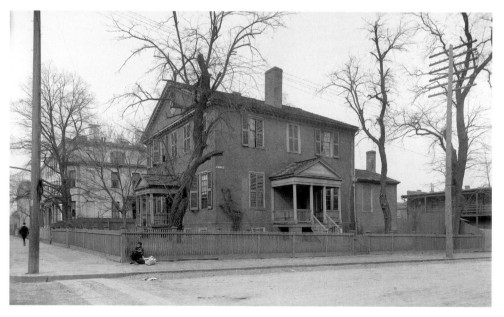

For forty-five years, until his death in 1835, the residence at the corner of Ninth and Marshall Streets was the home of the great Chief Justice John Marshall. Built in 1790, just as Marshall was emerging as leader of the Federalist party in Virginia, the house served as his home until the end of his distinguished judicial career. Marshall remained in Washington much of the time during his brief career in Congress and in President John Adams' cabinet, but after he became Chief Justice in 1801 he was able to spend much time in the house, located in the Court End section of the city. The property remained in the Marshall family until 1911, when it was bought by the city and saved by local preservationists. The house has been a museum since 1913 and is today administered by Preservation Virginia. William Henry Jackson took this picture of Chief Justice John Marshall's residence in 1905. *Detroit Publishing Collection, Library of Congress.*

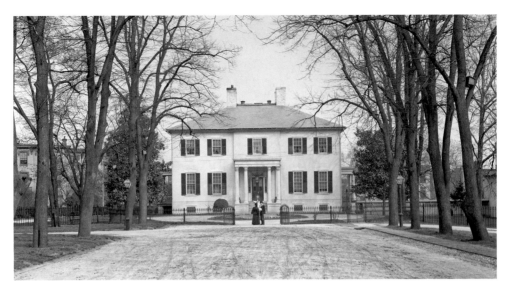

Completed in 1813, the Virginia Executive Mansion (shown here, 1905) bears the distinction of being the oldest, continuously occupied governor's residence in the United States. Boston architect Alexander Parris designed the Federal style residence and construction was undertaken by Christopher Tompkins. Parris' square plan included a wide center hall with beautifully detailed arches, plaster frieze and two stairways, a wide principal stair and a narrower service stair. The Executive Mansion is an elegant Federal structure. Embellished with three porches, the front or west entry is the most ornate. Corinthian columns, paneled double doors, side lights and transom adorned with mullioned tracery are typical of the Federal style. The hip roof culminates in a balustraded "captain's walk" framed by a double pair of chimneys. Parris' plan was enlarged in 1906 with an elliptical dining room addition designed by Duncan Lee, a Richmond architect. Also, at the same time, a large ballroom was created by removing the rear center hall partitions and replacing them with stately columns. Another major change came in 1958 with the addition of a library and a breakfast room at the rear, east end. Originally occupying a prominent knoll intended to give the occupants a view of the James River, the mansion now sits on "Capitol Square," surrounded by tall buildings. Its serene beauty, however, has been retained by stately gardens, bordered by English boxwood, dogwood, holly and magnolia. *Detroit Publishing Collection, Library of Congress.*

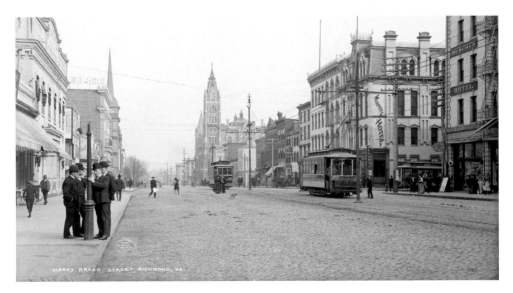

This photograph of Broad Street at Eighth Street was taken in 1905; Murphy's Hotel is on the right. *Detroit Publishing Collection, Library of Congress.*

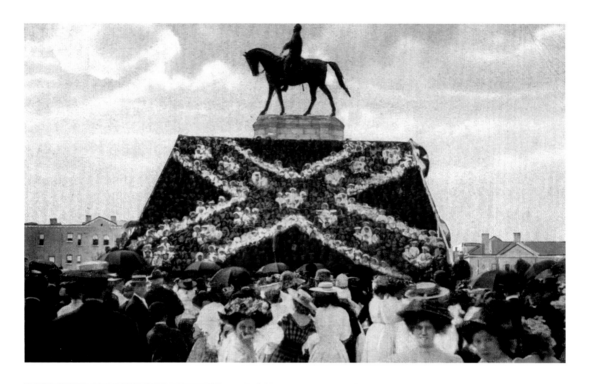

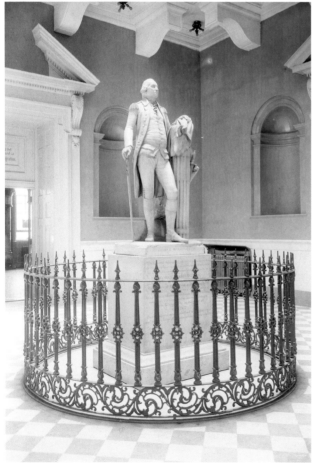

Above: A great reunion of Confederate veterans that was held in Richmond in May and June of 1907 in conjunction with the unveiling of Monument Avenue statues in honor of Major General James Ewell Brown "J.E.B." Stuart and Confederate States of America president Jefferson Davis. To that end (shown here), there was an arrangement and costuming of 600 school children in the form and colors of the Confederate battle flag. The children occupied a stand within the General Robert E. Lee monument enclosure and sang "Dixie" and other period Southern songs.

Left: The Jean Antoine Houdon statue of George Washington, completed in 1791/2 in France, was delivered to Richmond in 1796 and placed in the rotunda of the Virginia State Capitol on May 14, 1796, where it was photographed in 1908. Made of carved Carrara marble, the statue is based on a life mask and other measurements of George Washington taken by Houdon and three assistants at Mount Vernon, and is considered one of the most accurate depictions of the nation's first president. *Detroit Publishing Collection, Library of Congress.*

The bell tower in the southwest section of Capitol Square was originally a guardhouse for the Virginia Public Guard, the predecessors of the modern-day Virginia Capitol Police, and a signal tower for emergencies and public meetings. While the tower is architecturally significant, the building is also noteworthy because of its history and its location in Capitol Square. Designed by builder Levi Swain and erected between 1824 and 1825, the square, Neoclassical building has one bay surrounded by blind arches on each side and is topped by an arcaded, octagonal cupola. The brick tower is laid in Flemish bond and accented with Aquia sandstone. The original bell was removed prior to 1900 and given to a local fire company. The tower fell into disuse in the late nineteenth century but the early twentieth century historic preservation movement led to restoration and new purpose. Today, as it did beginning in the 1930s, the bell in the tower calls the Virginia General Assembly into session. The Virginia Tourism Corporation maintains a tourist information center on the tower's first floor. The bell tower is shown in this 1908 view. *Detroit Publishing Collection, Library of Congress.*

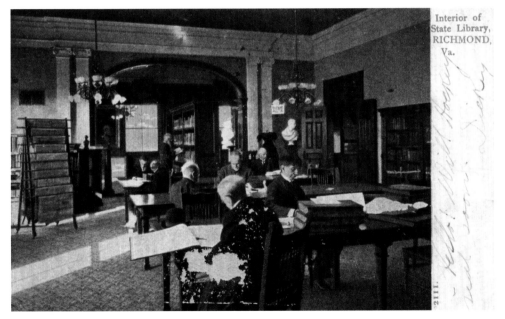

The Library of Virginia was created by the General Assembly in 1823 to organize, care for, and manage the commonwealth's growing collection of books and official records – many of which date back to the early Colonial period. The library occupied rooms on the third floor of the Capitol in Richmond until 1895, when Virginia erected a new library and office building on the eastern side of Capitol Square. Outgrowing this location, the library in 1940 moved to a handsome, new Art Deco building on Capitol Street, adjacent to Richmond City Hall and the Executive Mansion. In 1997, the library opened to the public at 800 East Broad Street, its fourth home since its founding. This undivided back postcard, mailed in 1908, features the second facility, on Capitol Square and named the Oliver Hill Building, used for the library; this view of the interior is vivid and also rare of this period. The original library stacks were located in the east wing of the building's third floor. The main reading room was situated on the first floor of the south wing.

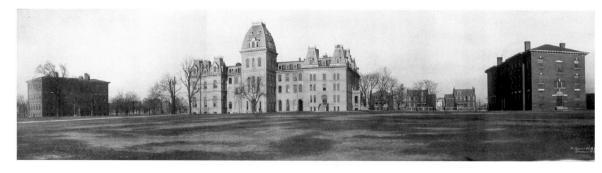

This 1909 panoramic photograph of Richmond College shows the first Ryland Hall (center) that would be destroyed by fire the following year. Richmond College was begun in 1830 as an academy to educate Baptist ministers. The campus, located in Richmond's downtown just then, was bounded by Broad, Franklin, Ryland and Lombardy Streets, and initially consisted only of Columbia Hall, the Philip Haxall mansion and numerous outbuildings; the Virginia Baptist Seminary incorporated in 1840 as Richmond College. In the 1870s, the first Ryland Hall (shown here) was built and named in honor of the school's first president, Dr. Robert J. Ryland. The 1910 fire hastened the college's move to the 350-acre Westhampton campus in one of the city's western suburbs. In 1920, after an amendment to the charter, the name University of Richmond was extended to cover Richmond College, Westhampton College (the women's college), and the T. C. Williams School of Law. *Library of Congress.*

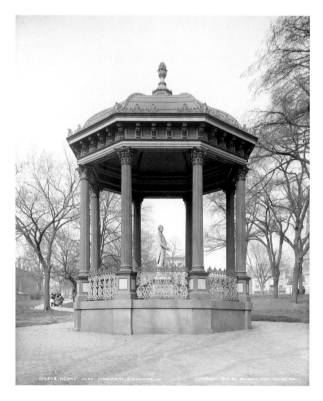

The John T. Hart marble statue of Henry Clay, shown in this 1905 period photograph, was dedicated on April 12, 1860, on the west side on the Capitol Square near Ninth Street, where it was enclosed in a cast-iron gazebo. The gazebo was in such bad shape by 1930 that Governor John Garland Pollard ordered it taken down; the statue was relocated inside the Old Hall of the House of Delegates. *Detroit Publishing Collection, Library of Congress.*

Opposite above: Beth Ahabah is a Reform synagogue founded in 1789 by Spanish and Portuguese Jews as Kahal Kadosh Beth Shalome; it is one of the oldest synagogues in the United States. On March 4, 1904, the congregation laid the cornerstone for its present building, known as the Franklin Street Synagogue. The building was dedicated on December 9, 1904, at 1111 West Franklin Street. The domed, neoclassical synagogue was designed by the Richmond-based firm of Noland and Baskervill, who also designed nearby Saint James Episcopal Church and the wings of the Virginia State Capitol. The synagogue has twenty-nine stained glass windows. Most notable is a window on the building's eastern wall created and signed by the Louis Comfort Tiffany Studios in 1923; it depicts Mount Sinai. The synagogue is shown on this rare early postcard, mailed in 1907.

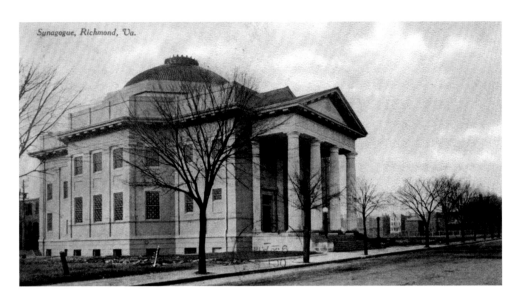

Synagogue, Richmond, Va.

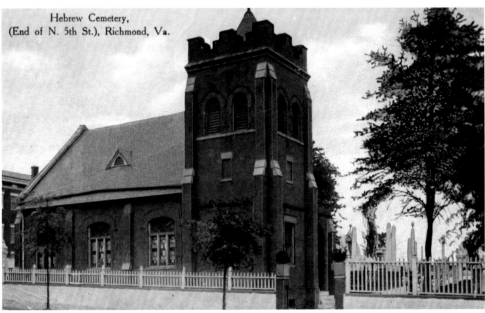

Hebrew Cemetery,
(End of N. 5th St.), Richmond, Va.

Richmond's Hebrew Cemetery, also known as the Hebrew Burying Ground, is located on Shockoe Hill at the north end of Fourth Street in an area by Hospital Street; however, the original parcel of the cemetery (shown here on this period 1907 postcard) consisted of approximately one acre located on the north side of Hospital Street on the western side of North Fifth Street; it was acquired in 1816. The Hebrew Cemetery on Shockoe Hill was the successor to the 1789 Franklin Street Burial Grounds; it is thus one of the oldest Jewish cemeteries in the United States. In 1871, 1880, and 1896 this parcel was expanded by three separate additions to its western boundary. In 1886, a parcel located at a slightly lower elevation and below the crest of the hill to the north of the original cemetery was added at the northern boundary, extending it to Bacon Quarter Branch along the present CSX railroad right-of-way. The cemetery is bounded on the west by the 1861 city almshouse, on the south by Hospital Street, on the east by Fifth Street, and on the north by the CSX right-of-way. Among those interred here are Josephine Cohen Joel, who was well known in the early twentieth century as the founder of Richmond Art Company. Within Hebrew Cemetery is a plot known as the Soldier's Section; it contains the graves of thirty Jewish Confederate soldiers who died in or near Richmond and is the only Jewish military cemetery outside of the State of Israel. The cemetery is maintained by Congregation Beth Ahabah, a Reform congregation founded in Richmond in 1789.

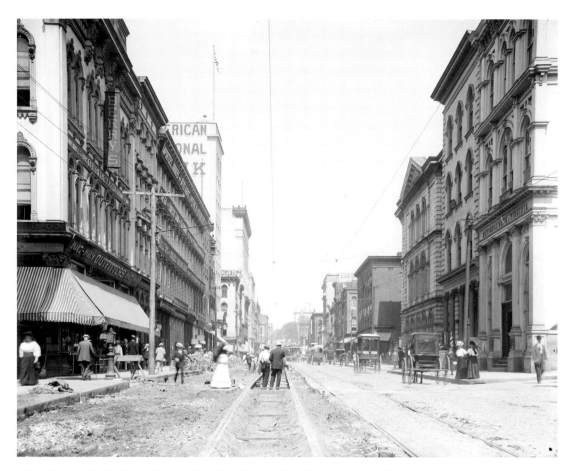

Above: Richmond's East Main Street, looking from Eleventh Street (shown here, 1905), was under construction when this picture was taken. The American National Bank on the corner of Tenth and East Main Streets, visible on the left, was built in 1904 as a three-bay, nine-story building designed by the architectural firm of Wyatt and Nolting of Baltimore. Originally, the building was an early Commercial-style skyscraper with Renaissance Revival details, but in 1909, Virginia architect Charles K. Bryant drew plans for a three-bay addition to the east side of the building. This addition also raised the building to eleven stories with a parapet and a highly decorative cornice. In the 1960s, the architectural firm of Armstrong and Solomansky modernized the building by removing elaborate architectural decoration and covering the building in a metal skin with metal windows. In 2003, the former bank building was restored with decorative elements using modern materials. *Detroit Publishing Collection, Library of Congress.*

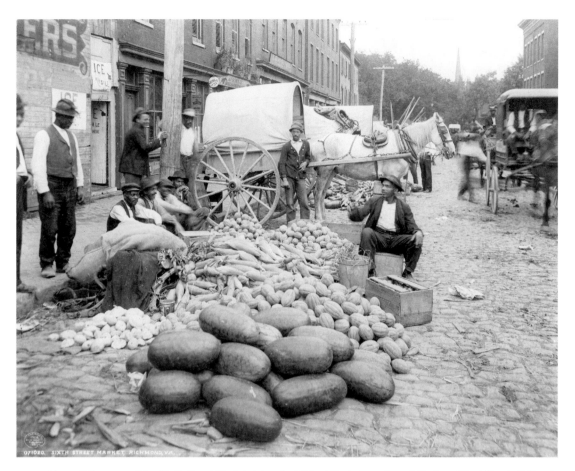

Above: This scene of the Sixth Street Market, taken in 1908 at the intersection of Sixth and East Marshall Streets (looking down East Marshall), shows African American vendors selling farm produce, including melons, corn and squash. A. F. Schultz Saddle & Harness Makers (left, visible over the first cart cover) is at 515 East Marshall and E. B. McGeorge, a hay, grain and feed dealer, is at 511 East Marshall (to the right of Schultz). According to the March 1910 edition of *Harness* magazine, Schultz had just moved his shop from the location shown here to 2300 West Main Street. Today, the area shown in this photograph is occupied by the Richmond Marriott Hotel, and across the street are the Greater Richmond Convention Center and the Richmond Coliseum, parking garages, retail and restaurants. *Library of Congress.*

Overleaf, above: According to the city's riverfront plan, throughout the city's history, Belle Isle formed one of the most dramatic natural spectacles along the entire Falls of the James River. Geologically, the core of the island is a large granite outcropping that gave the island its original name, Broad Rock. This granite island divided the James River into two deep gorges. The rush of the James River around the island, particularly when the river was in flood, created a roar that could be heard for miles around and a sight considered to be majestic and sublime. The rapid descent of the river at Belle Isle drew industrial development to the island in the nineteenth century that shaped the present island landscape. The beauty of the river spectacle at Belle Isle prompted the preservation of vantage points on the opposite banks of the river and led to the incorporation of the island into the James River Park system in 1972. Belle Isle and James River Falls are shown in this 1908 photograph, made into a postcard. To the right is the Old Dominion Iron and Nail Works, the 1895 successor to the old Belle Isle works; it completely covered the eastern end of the Belle Isle and during its operations expanded the island's footprint by dropping slag over the banks of the island.

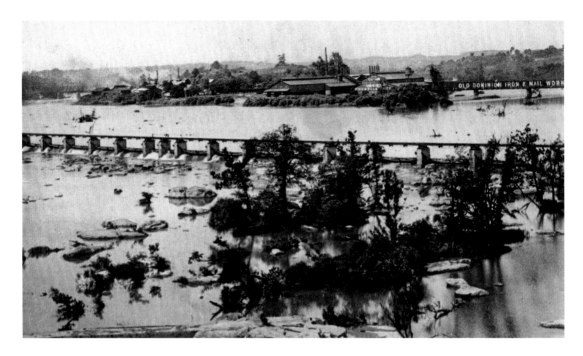

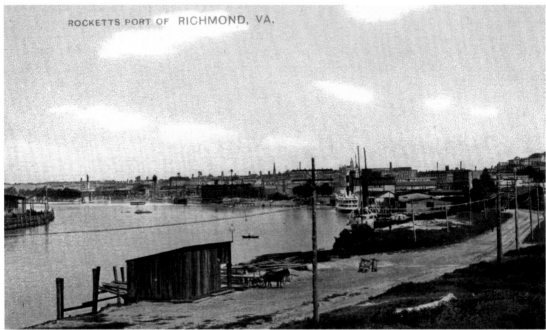

Rocketts Port (shown on this period postcard) at what is also called Rocketts Landing has a history that goes back to Captain Christopher Newport's first exploration of the James River when the *Godspeed* landed there in 1607. In 1730, Robert Rocketts started operating a ferry service to transport goods from this location; it was, in fact, once considered the busiest inland port in America. During the Civil War, the Confederate Navy Yard occupied this area and it fast became home to ironclad warships and torpedo vessels of the James River Squadron, and vital to the Confederate naval defense of Richmond. After the yard burned on April 2, 1865, when retreating Confederate troops fired the city, much of what had been Rocketts Port had to be rebuilt. By the time this postcard was printed, much of the area's port traffic was gone, taken away by the growing network of rail and highway bypasses in and around Richmond. During the 1970s much of the original fabric of Rocketts Landing was razed. Today, Rocketts Landing has been revived as an area of upscale condominiums, restaurants and meeting places.

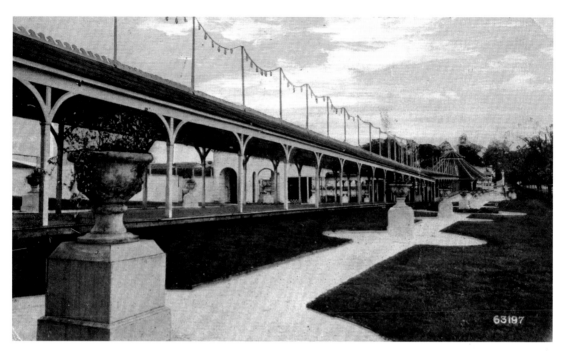

The Idlewood Amusement Park opened near Byrd Park on May 30, 1906, as "the finest amusement park south of Philadelphia." The park was the idea of Richmond Amusement Company president Jake Wells, who wanted to bring the nationally popular "pleasure park" to the city, and as was the practice at that time, site it at the end of a streetcar line, in this case, the Boulevard. Wells bought property near the intersections of Idlewood Avenue, South Davis and Meadow Street. The park featured two Philadelphia Toboggan Company rides: a figure eight roller coaster billed as "the biggest in the country," and a carousel number ten, both delivered in time for the park's grand opening. There was also a swing ride. Though attendance figures were high, Wells overspent and the park was in debt within a year and went into bankruptcy on September 1, 1908. While the city council ordered it closed the following year, the Virginia Railway and Power Company bought part of Wells' operation and tried to save the major rides. The park limped along until 1914, when the city council ultimately ordered it razed for residential development. According to the Philadelphia Toboggan Company records, the roller coaster was dismantled, not destroyed.

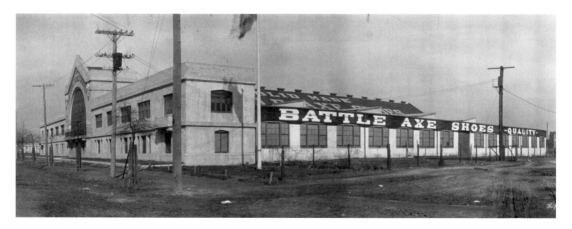

The Stephen Putney Shoe Company, manufacturer of Battle Axe shoes and boots (a brand that started in 1817), was located at 2200 West Broad Street, in a 133,000 square foot warehouse that covered an entire city block. This picture, taken on April 21, 1909, shows the company during a period of peak popularity and profit. Note that Broad Street is not yet paved in front of the building. The old shoe company plant is still standing and was most recently vacated by the Virginia Department of Taxation. Situated on the north side of the city's Fan District, the historic property is part of the Sauer Center mixed-use development. *Library of Congress.*

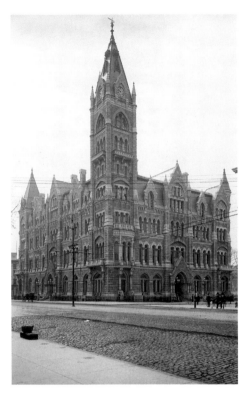

The Richmond City Hall (today the old city hall) was built over the period September 1, 1886 to February 15, 1894, from the design of nationally-known architect Elijah E. Myers. The building occupies an entire city block near the Virginia Capitol grounds and measures 170 feet by 140 feet. Stylistically, the structure is High Victorian Gothic, four stories in height; its rugged silhouette has four corner towers of varying designs culminating at the northwest corner with the clock tower which rises to 195 feet. Constructed of stone, brick and cast iron, the exterior effect of the style is achieved by contrasting the texture of the locally quarried granite. The main façade of the building faces north while the interior is organized to be entered from the west. The most notable interior feature of the structure is a rectangular sky-lighted courtyard, bridged across the center and surrounded by arcaded galleries. The west light well is open through the full four stories while the east is filled with the grand staircase. Almost all the original fixtures remain intact. According to the National Historic Landmark Forum: "Among American municipal buildings of its size and style, the Richmond City Hall has no superior in similarly unaltered condition." The building (shown here in 1910) is listed on the National Register of Historic Places and is a National Historic Landmark. *Detroit Publishing Collection, Library of Congress.*

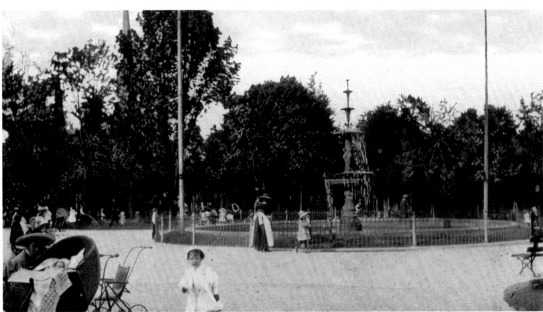

Monroe Park, named for James Monroe, the nation's fifth president, is a seven-and-a-half acre park one mile northwest of the Virginia State Capitol. The pentagonal shaped park unofficially marks the eastern point of the Fan District and is Richmond's oldest park (the only public green space prior to 1850 was in Capitol Square). Monroe Park is situated on land acquired in 1851 by the city. Though it was planned to serve as a park for the city's stylish western suburbs, it was first used as the site of an agricultural exposition and, later, as a camp site for Confederate troops before being developed for recreational use. The park design, which dates from the 1870s, is an example of axial formal planning, with sidewalks radiating from each major entrance to other entrances. The architectural focus of the park is a four-tier, cast-iron fountain in the middle of the open space (shown here on this period postcard).

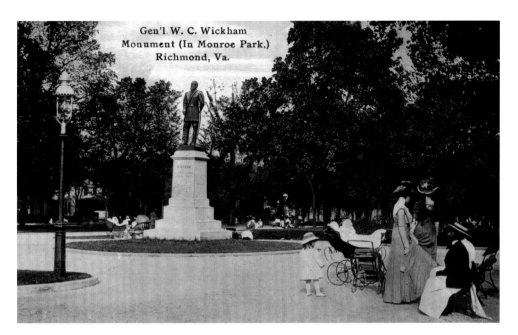

The Wickham Monument (shown here, on a period postcard) is a bronze statue on a gray granite pedestal that was sculpted by Edward V. Valentine in 1891 and cast by the Henry Bonnard Bronze Company, of New York and located as a focal point in Monroe Park. The standing figure of General William Carter Wickham is in his Civil War uniform. Valentine, Richmond's best known sculptor, specialized in Civil War subject matter.

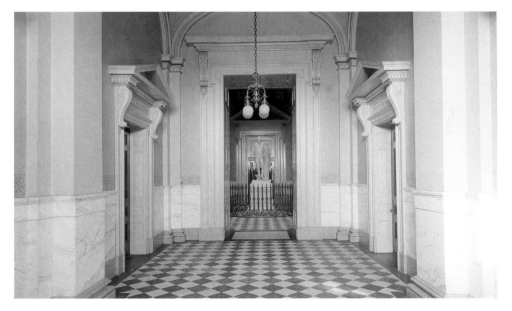

The main entrance hall of the Virginia State Capitol (shown here, 1915), leads to the Rotunda and a life-size statue of George Washington. In Thomas Jefferson's original design of the Capitol Building, the Rotunda was a two-story central space, which he called a "conference room," and included a balcony supported by enormous columns, a large skylight and a space in the center for a marble sculpture of George Washington. Samuel Dobie, the actual builder of the Capitol, adjusted Jefferson's plans by placing the balcony on brackets rather than using columns. While Jefferson made no reference to a dome in his first written description of the Rotunda, a dome was added to the building in 1794, six years after it was first occupied. The thirty-foot dome in the Rotunda is directly under an exterior skylight on the gable roof. Whether adding the dome was a later idea of Jefferson's or another modification made by Samuel Dobie remains unknown. *Detroit Publishing Collection, Library of Congress.*

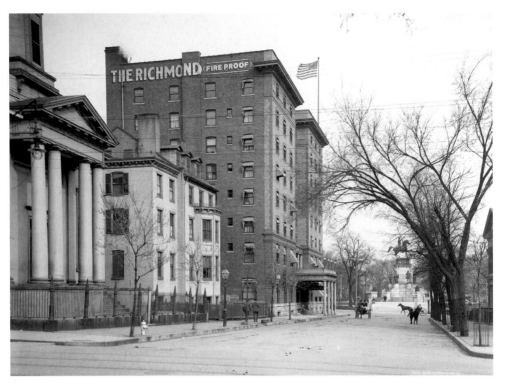

Grace Street, looking east from Eighth Street, is shown in this 1910 photograph. Saint Peter's Roman Catholic Church (left, foreground) and the Hotel Richmond (large building center, flag flying) are identifiable. *Detroit Publishing Collection, Library of Congress.*

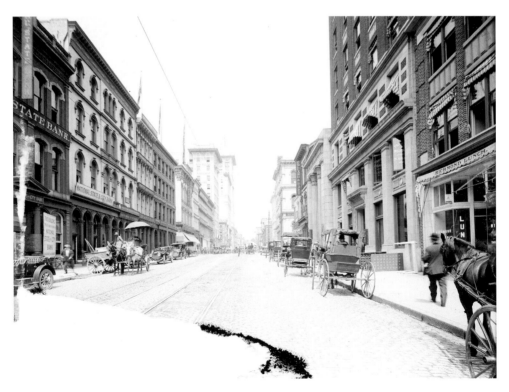

Main Street from Eleventh Street, 1910. *Detroit Publishing Collection, Library of Congress.*

Richard Green (right, with the hat), age five, and Willie Hutchinson, age six, were among many young newsboys who sold Richmond newspapers on the street, day and night, for very little money. Lewis Wickes Hine took this picture in June 1911. When Hine first asked Hutchinson how old he was, the boy said eight; when pressed, he admitted to seven until, finally, he confessed to Hine he was only six years old. In 1908, the National Child Labor Committee (NCLC) hired Hine to document child labor in American industry. Over the next ten years he would publish thousands of photographs designed to show the average American an otherwise unavailable window into the somber working conditions facing America's youth, including that of Richard and Willie. *Library of Congress.*

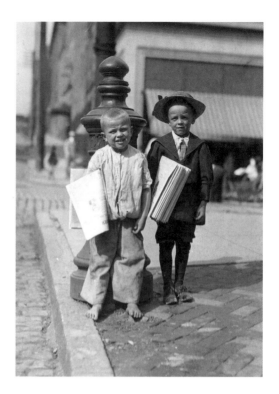

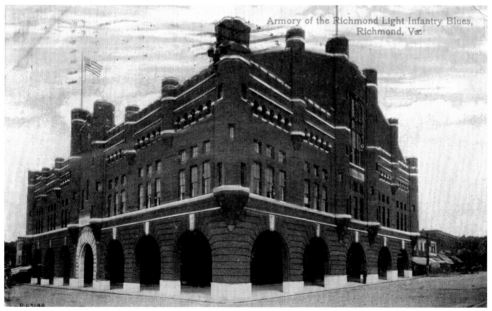

The armory of the Richmond Light Infantry Blues, designed by the Washington, D.C., firm of Averill & Hall and completed in 1910, is located at the corner of Sixth and Marshall Streets. The castellated design was not entirely whimsical, as the structure was designed to withstand attack during riots. The ground floor was entirely separated from the military upper floors. The structure extends over the sidewalks, forming an arcade at ground level, with five bays on the Marshall Street side and seven bays on the Sixth Street exposure. The Blues were the oldest military company in Virginia, organized on May 10, 1789, and one of the oldest in the United States, ranking with the best of the Virginia National Guard; the Blues were disestablished in 1968. The Blues Armory, renovated in 1985 as part of the Sixth Street Marketplace project, is today part of a new arts and entertainment district. This image of the armory appeared on a postcard mailed May 24, 1913.

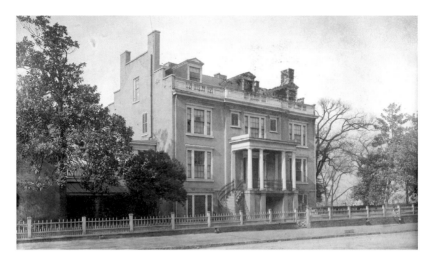

The home of Union spy Elizabeth Van Lew, born in Richmond on October 25, 1818, and who died destitute in the same on September 25, 1900, was located on the south side of Grace Street between Twenty-Third and Twenty-Fourth Streets. Van Lew was a diehard abolitionist who chose to build and operate an extensive spy ring for General Ulysses S. Grant during the Civil War. During the war, the home was a meeting place for Richmond Unionists and for escaped prisoners. Grant made her the city's postmistress after the war but she was never again accepted in Richmond society. The house (shown in 1910 with a sign for Chimborazo Sanatorium for Pulmonary Tuberculosis, established in 1907, on the building) was razed in 1911 and an elementary school built in its place. *Detroit Publishing Collection, Library of Congress.*

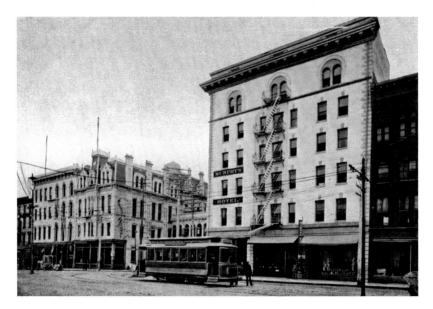

Murphy's Hotel at Eighth and Broad Streets, shown on this 1905 postcard, was the postwar enterprise of Confederate colonel John Murphy, who grew his establishment into one of the important gathering places in the city. The original hotel was built in 1872 (shown left). In 1886 the buildings shown here replaced the original, and the elevated walkway over Eighth Street was added to connect the hotel and annex. Then this version (left) was torn down in 1913 and replaced with a larger eleven-story building designed by John Kevan Peebles. The annex was sold and the pedestrian bridge torn down in 1939. The hotel was later sold to the state, and in 1969 was converted to offices. The annex was razed in 2000. The eleven-story hotel building was deconstructed in late 2007 to make way for the new federal court building.

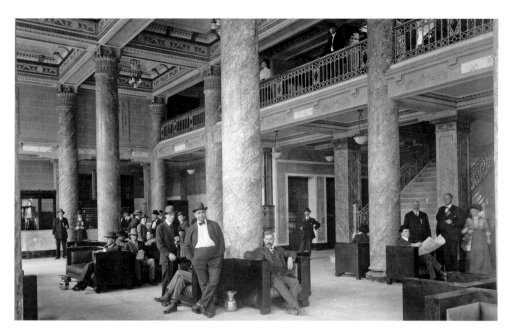

Murphy's Hotel was the place for "legislators, lobbyists and citizens" to gather and debate issues concerning the 1901 General Assembly session; most importantly, whom to appoint to the State Supreme Court and modifications to the state constitution, thus it is one of history's ironies that the hotel would eventually be torn down and replaced by a federal courthouse. The hotel's lobby, shown here in 1910, was an important gathering place for the most important men in Richmond business and government. *Detroit Publishing Collection, Library of Congress.*

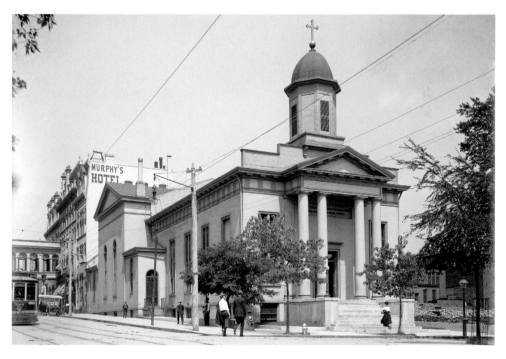

Saint Peter's Roman Catholic Church, located at Grace and Eighth Streets and shown here as it appeared in 1910, was built in 1834 and was the first church built on what is now Grace Street; it is the oldest Roman Catholic church in Richmond. From 1850, when Richmond became a separate diocese, to 1906, when the Cathedral of the Sacred Heart was consecrated, Saint Peter's served as a cathedral church. Murphy's Hotel is visible (left) behind the sanctuary. *Detroit Publishing Collection, Library of Congress.*

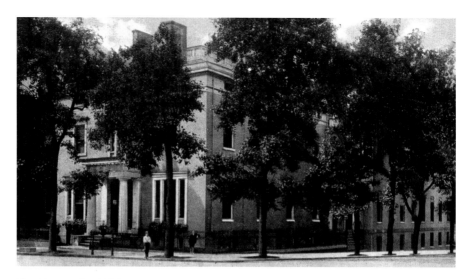

The Westmoreland Club was established in 1877 by a group of gentlemen in search of a convivial place to share a drink and reminiscences of their Civil War service. Named in honor of Westmoreland County, birthplace of both George Washington and Robert E. Lee, it offered its members a restaurant, bar, athletic facilities, library, laundry and valet service, barber shop, and sleeping rooms for out-of-town members and guests. First located in the Norman Stewart house at 707 East Franklin Street, in 1879 the club moved to a Greek Revival mansion (shown here at 601 East Grace Street on a 1910 postcard) at Sixth and Grace Streets, also known as the Stanard-Lyons House, built between 1835 and 1839, with a 1902 addition. Here the club remained until 1937, when the Great Depression and the deaths of many longtime members led to an attrition that no longer supported the club as an independent establishment. Through an arrangement with the Commonwealth Club, founded in 1889, interested Westmoreland Club members were allowed to transfer their membership with a waived initiation fee. The club was dismantled for a parking lot.

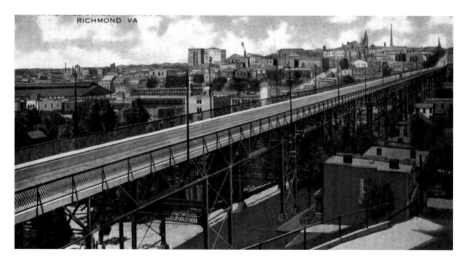

The Richmond & Henrico Railway Company built this toll bridge, called the Marshall Street viaduct, spanning the Shockoe Valley to Fourteenth to Twenty-First Streets to connect the populous eastern section of the city known as Church Hill with its central or business section. The bridge, as constructed, was 2,800 feet long, and at its highest point ninety-five feet above the seventeen railroad tracts that it spanned; it opened to traffic on February 12, 1911. This view shows many of the most important and historic buildings in the city, including Monumental and Saint Paul's churches, the City Hall, the Capitol Building, and the Main Street train depot. The Marshall Street viaduct, which in the end spilled out to the Medical College of Virginia campus, was closed on June 26, 1970.

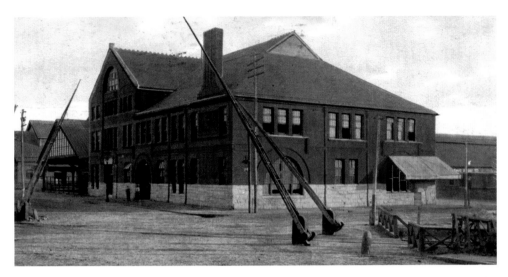

Though the Richmond, Fredericksburg and Potomac Railroad and the Atlantic Coast Line Railroad initially used the Byrd Street Station, built between 1885 and 1887, located at the corner of Seventh, Eighth and Byrd Streets (where the Federal Reserve Bank of Richmond is today), by the time this postcard was published in 1910, freight rail was using a bypass around this station. Byrd Street Station was relegated to passenger service only via the Richmond Connection Railroad. After the Richmond, Fredericksburg and Potomac Railroad opened the new Union Station, also called the Broad Street Station, in 1919, Byrd Street Station was phased out as a passenger depot but remained in use as the Atlantic Coast Line's office headquarters until 1958.

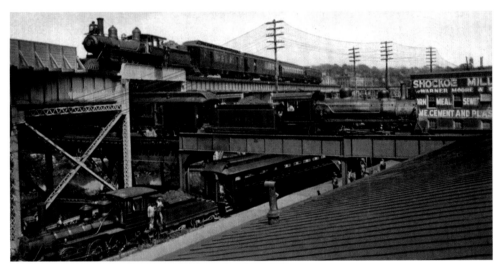

Triple crossing, located south of Main Street at East Byrd, Sixteenth and Dock Streets along the canal walk, is believed to be the only place in the United States (still in existence) where three Class I railroads cross at different levels at the same spot. This scene, in 1911, was the first such photographed occasion of a photographer getting the picture (there have been less than a handful of times since that it has happened). The ground level track belonged to the original Richmond and York River Railroad that was extended after the Civil War to connect with the Richmond and Danville Railroad, later part of Southern Railway, now part of Norfolk Southern. The line runs east to West Point, Virginia. The middle level was the main line of the Seaboard Air Line Railroad, now part of CSX Transportation known as the "S" line, just south of Main Street Station. At the top level is a three-mile long viaduct parallel to the north bank of the James River built by the Chesapeake and Ohio (C & O) Railway and which opened on opened June 24, 1901, to link the former Richmond and Allegheny Railroad with C & O's Peninsula subdivision to Newport News and export coal piers. The viaduct, now owned by CSX Transportation, provided an alternate path to the notoriously unstable Church Hill Tunnel.

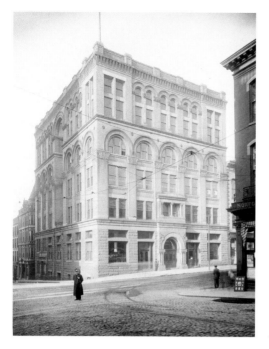

The Chamber of Commerce building at 823-827 East Main Street (shown here in a 1910 view) was designed by architect Marion J. Dimmock. Built between 1891 and 1892, when completed the Chamber's new home was one of the finest buildings in the city and a strong example of Richardsonian Romanesque architecture popular from 1880 to 1900. Despite the buildings outstanding features, it was razed in 1912 to make way for the First National Bank Building, completed in 1913. *Detroit Publishing Collection, Library of Congress.*

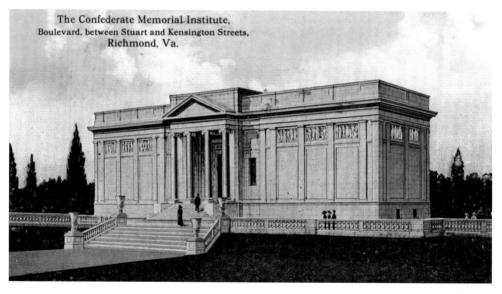

The Confederate Memorial Association laid the cornerstone for the first phase of the Confederate Memorial Institute – Battle Abbey – on May 20, 1912, and it was completed on Boulevard between Stuart and Kensington Streets in 1913 (shown here). The institute, the brainchild of Charles Broadway Rouss, a Virginia veteran of the Confederate army who later made his fortune in New York, was to serve as a shrine to Confederate dead and a repository for the history of those engaged in the Lost Cause. The first portion of the building, including the marble entrance hall and two flanking monumental galleries, was designed by the Philadelphia firm of Bissell and Sinkler and was constructed on land donated by the Commonwealth of Virginia. In 1921 the first addition to Battle Abbey was completed, and in 1946, the Confederate Memorial Association merged with the Virginia Historical Society (VHS). In 1959, when the large, four-story west addition was completed, it enabled the institution to move its offices, book and manuscript stacks, processing areas, and reading room into the Battle Abbey building. Since moving to Battle Abbey, the VHS continued to enlarge its collections. As a result, additional space was needed, and building expansions in 1992, 1998, and 2006 greatly increased the size of the headquarters building to nearly 200,000 square feet.

Right: In 1904, the United Daughters of the Confederacy selected a site several blocks west of the General Robert E. Lee statue on Monument Avenue for a memorial to president of the Confederacy Jefferson Davis. The site of the Davis monument was chosen because it was the former location of the Star Fort, the innermost and major protection for the city from the west during the Civil War. The existence of these defenses is commemorated by a cannon located just east of the Davis monument (shown here, 1915). The statue, designed by sculptor Edward Valentine and architect William Noland, was unveiled on June 3, 1907. *Detroit Publishing Collection, Library of Congress.*

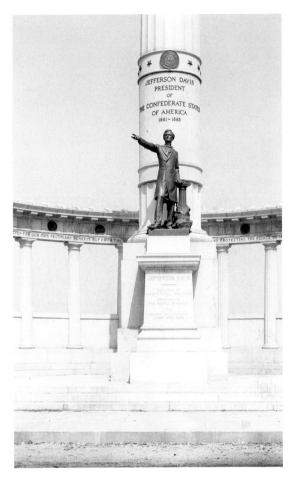

Below: The statue dedicated to Confederate major general James Ewell Brown "J.E.B." Stuart, chief of the cavalry in the Army of Northern Virginia, is located at Monument and Lombardy Avenues in the Fan District, in the center of the intersection. Mortally wounded at the Battle of Yellow Tavern in 1864, Stuart died in Richmond just a few blocks away from where his monument was erected. Designed by Fred Moynihan, it was unveiled by Virginia Stuart Waller, the general's granddaughter, on May 30, 1907. *Detroit Publishing Collection, Library of Congress.*

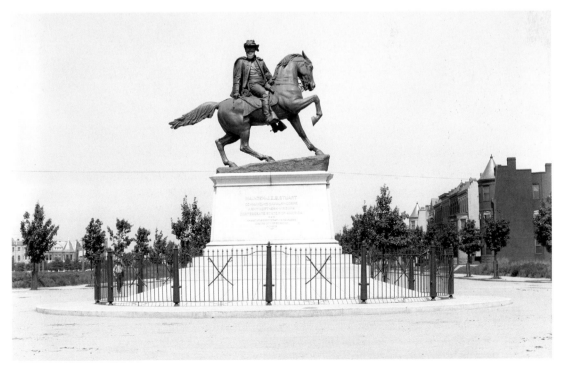

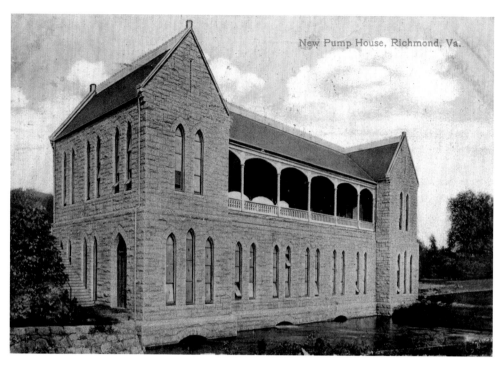

The 1883 James River and Kanawha Canal Pump House, also known as the Byrd Park Pump House, replaced an earlier one which pumped water to the reservoir above. The two-story Gothic Revival stone building consists of a long central block with flanking cross pavilions which project slightly at either end of the long façades. The basement area once housed the pumping machinery and the large open room above was used for many of the city's social events. Offices and twin curving stairs flank these two large rooms. Details of this structure include a slate roof with iron cresting and reinforced concrete window arcade on both sides of the social hall. The view on this postcard, postmarked May 29, 1913, is the southern wall of the building.

This is the 800-block of West Franklin Street at North Laurel Street; none of the buildings shown on this postcard, postmarked May 22, 1915, are still standing. Monroe Park is on the right.

Pratt's Castle, the house of William Abbott Pratt on South Fourth Street at the summit of Gamble's Hill (shown here, 1915), was the city's most curious, commented upon and photographed residence upon its completion, sometime between 1853 and 1854. Pratt, an architect, practiced in Richmond before being hired in 1858 to serve as the University of Virginia's first superintendent of buildings and grounds. The home was a Gothic masterpiece, complete with decoration, hidden staircase and secret passageways that sated the curiosity of thousands who toured "the castle" before it was razed. Pratt's home was described as having an "air of mystery," especially given the secret tunnels, as some suggest, that ran to the river. Pratt had his home built on a foundation of James River granite with a wooden structure covered by rolled sheet iron, purportedly from Tredegar Iron Works, that Pratt scored and painted to resemble stone. Sources suggest the final owner of the property, Albemarle Paper (subsequently Ethyl Corporation, now NewMarket), systematically dismantled the castle in 1958 to make room for the company's expanding corporate campus. *Detroit Publishing Collection, Library of Congress.*

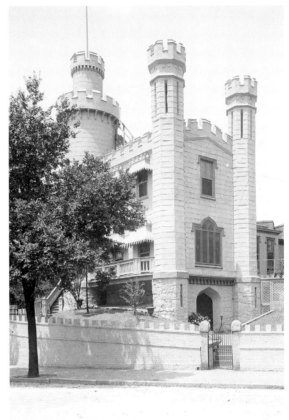

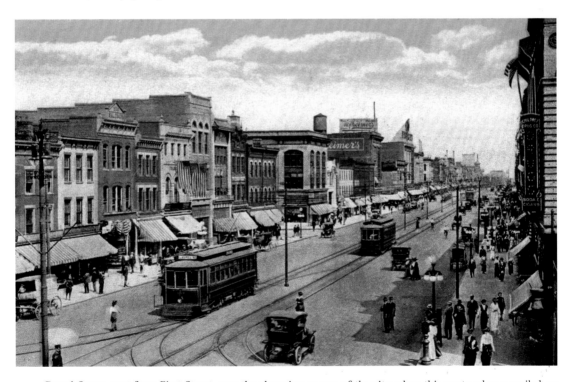

Broad Street, east from First Street, was the shopping mecca of the city when this postcard was mailed on September 5, 1917.

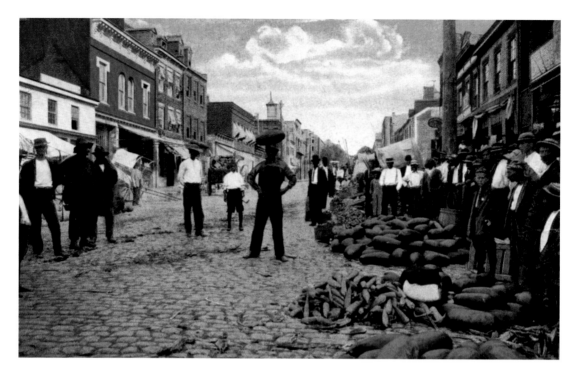

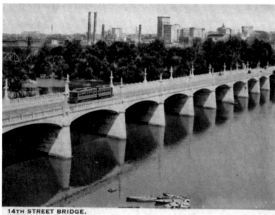

14TH STREET BRIDGE.

Your Friends in

Richmond

Would Like a Glimpse of You

Above: The open air market at Franklin Street, east from Seventeenth Street, is shown on this 1915 period postcard.

Left: The Mayo Street Bridge (also called the Fourteenth Street Bridge), transports U.S. Route 360 across the James River. The bridge is actually in two sections, separated near the middle by Mayo Island. The total length is 1,374 feet (north and south sections combined). The current structure was built in 1913 and accommodated heavy streetcar traffic (a streetcar is shown in this 1917 view of the bridge); it is Richmond's oldest highway bridge across the James River. Of note, it was built on the site of the city's first bridge completed in 1788 by John Mayo Jr., the grandson of the man who first laid out Richmond's grid pattern. Mayo operated it as a toll bridge. Just thirty feet above the water line, the bridge is presently the city's only bridge structure subject to flooding.

The Gamble's Hill Monument, a bronze replica of the wooden cross planted by Captains Christopher Newport, John Smith and others as they reached what became Richmond on the James River on May 24, 1607, was erected at the south end of Third Street on Gamble's Hill on June 10, 1907, by the Association for the Preservation of Virginia Antiquities. Gamble's Hill Park was situated at the southern end of Third and Fourth Streets, and commanded a magnificent panoramic view of the James River Falls. The city of Richmond removed the cross monument in 1983 from Gamble's Hill when the former park was acquired by what was the Ethyl Corporation (now NewMarket) in a land swap: Gamble's Hill for Brown's Island. Sometime in the 1980s, the cross was transplanted to a small park in the 100-block of Shockoe Slip. The original base is still at that location; in fact, one large river rock shows where the plaque was removed. In 2000, the cross was moved again to its current location at Twelfth and Byrd Streets, along the Canal Walk. *Detroit Publishing Collection, Library of Congress.*

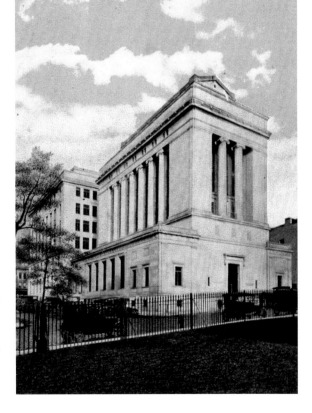

In 1916, the Federal Reserve Bank of Richmond acquired land facing Capitol Square as the site for building a structure to house all bank operations. Ground was broken in June 1919 and the cornerstone was laid on April 13, 1920; it opened in 1922 (shown on this period postcard). The bank was located at Ninth and Franklin Streets until 1978.

The First National Bank Building, also known as the old First and Merchants National Bank Building, is located at 825-827 East Main Street and is shown here as it looked in 1920. The tallest building in Richmond when it was completed between 1912 and 1913, the First National Bank Building remains one of the city's finest examples of Neoclassical commercial architecture; it was designed by Alfred Charles Bossom, an associate of the New York architectural firm of Clinton and Russell. Nineteen stories in height, it was the first high-rise tower to be built in Richmond. Today, it has been converted to luxury apartments. *Detroit Publishing Collection, Library of Congress.*

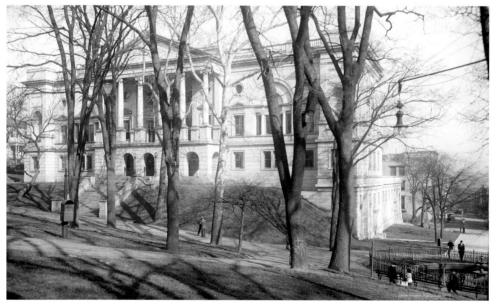

The original portion of the Oliver Hill Building (shown here, 1920) was commissioned in 1892 and completed in 1894; it was built to house the Virginia State Library collections, the Virginia Supreme Court, and the Office of the Attorney General. Architect William Poindexter departed from his signature Queen Anne-style and produced a dignified classical work, characteristic of the American Renaissance movement that started at the end of the nineteenth century. In 1908, the south wing was commissioned, a project that gave the building a symmetrical west front. Designed by Richmond architect Marion J. Dimmock, it was completed in 1910, and included a low wing that extended along the south base of the building. The low wing was built as a natural history museum, a purpose it continued to serve until it closed in 1964. *Detroit Publishing Collection, Library of Congress.*

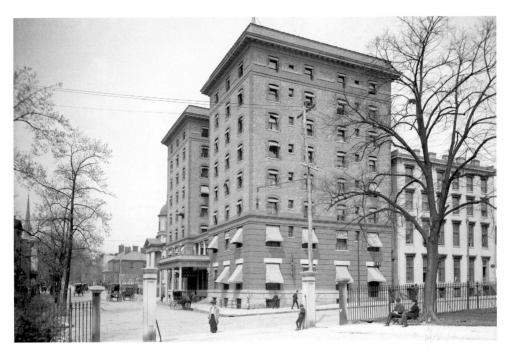

Above: The Hotel Richmond, shown here (original hotel, 1910), overlooks the State Capitol in Capitol Square; it is one of the rare gilded-age hotels built by a woman entrepreneur, Adeline Detroit Atkinson, and is today owned by the Commonwealth of Virginia, which uses it as the Ninth Street Office Building. The Italianate eight-story first phase of the hotel, opened in April 1904 with the main entrance on Grace Street, was designed by Charleston, West Virginia architect Harrison Albright, and the eleven-story 1911 second phase by Norfolk, Virginia architect John Kevan Peebles; Peebles was also the architect of the wings of Virginia's State Capitol. As a result of the 1911 addition, a new two-story main lobby was created fronting on Ninth Street. Today, the combined mass fronts onto Ninth Street, facing east. The hotel sits across Grace Street from Saint Paul's Church, and next to Saint Peter's Church. As the largest hotel immediately adjacent to Richmond's Capitol Square, it had a central place in the political history of the city. *Detroit Publishing Collection, Library of Congress.*

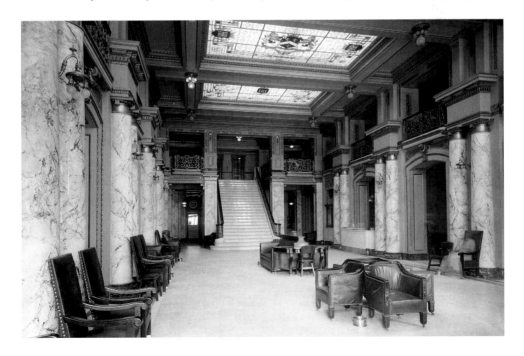

Previous page, below: Soon after it opened, the Hotel Richmond became a home to Richmond and Virginia politics second only to the halls of the Capitol itself. The hotel was used as headquarters for the Democratic Party's gubernatorial candidates. It was also where Harry Flood Byrd, head of the Democratic Party and leader of the highly influential "Byrd Machine," oversaw the campaigns of five winning candidates for governor: William Tuck in 1945, Thomas B. Stanley in 1953, James Lindsay Almond Jr. in 1957, Albertis S. Harrison in 1961, and Mills E. Godwin in 1965. The campaigns were run from Room 370 which had an excellent view of the Capitol and its entry drive. Beyond its political importance, the hotel was a unique source of music and information for the city of Richmond because the headquarters and studios of Richmond's first radio station, WRVA, were housed in a mezzanine-level suite from 1933 until 1968, when the station moved to its own building. The third commercial radio station in Virginia, WRVA had the largest audience share and the highest number of broadcast hours of any other radio station in the state. This is the Hotel Richmond's lobby in a period 1920 photograph. *Detroit Publishing Collection, Library of Congress.*

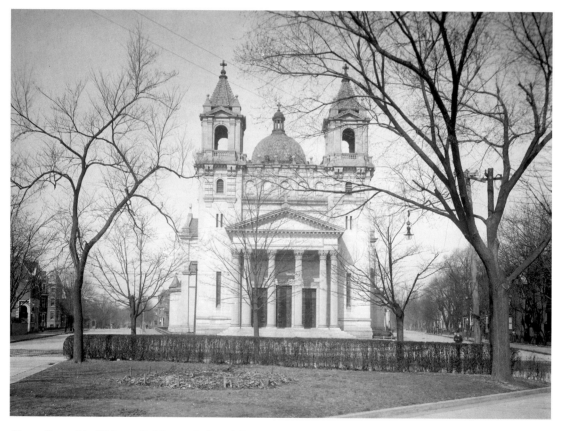

Above: Framed by Richmond's Monroe Park and forming the visual pivot between the city's commercial area and the residential Fan District, the Cathedral of the Sacred Heart, shown here in a 1920 period photograph, is Virginia's most distinguished ecclesiastical representation of the Italian Renaissance Revival style. The domed and porticoed limestone structure, with its cloisters, diocesan gardens, and episcopal residence, is the work of Joseph Hubert McGuire, a New York architect whose practice centered on Roman Catholic churches and institutional buildings. Begun in 1903, it was completed in 1906, and regarded at once by contemporaries as the most ornate and beautiful church edifice in the South, this Cathedral was the gift of financier, promoter, and philanthropist Thomas Fortune Ryan, of Virginia and New York, and his wife, Ida Barry Ryan. The Ryans' largest single gift to the Catholic Church, it is representative of the monumental benefactions given to churches and universities by the barons of American industry and finance at the turn of the century. Also, significant as a landmark in the growth of the Catholic Church in Virginia, Sacred Heart supplanted Saint Peter's Church, Richmond's first cathedral, as the seat of the Catholic Diocese of Richmond. The consecration ceremonies held on November 29, 1906 – Thanksgiving Day – brought together the most eminent Catholic churchmen in the country for one of the most colorful and impressive ceremonies in Richmond's history. *Detroit Publishing Collection, Library of Congress.*

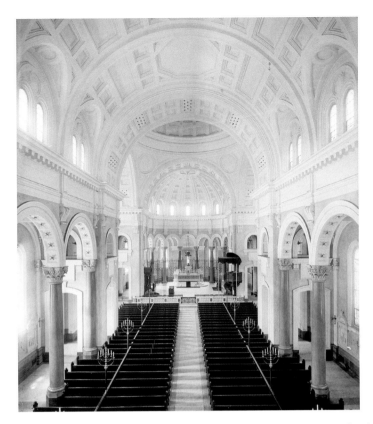

Above: Ida Barry Ryan was responsible for donating the Cathedral of the Sacred Heart's handsome interior furnishings, also expressly designed by architect Joseph McGuire, including the confessionals, altars, bishop's throne, pulpit, gas and electric fixtures, bronze work and baptismal font. The Cathedral's cornerstone, which had been cut and wrought years before in the Garden of Gethsemane, was officially laid on June 5, 1903. Construction of the Cathedral was completed three years later. This interior photograph of the Cathedral dates to 1920. As for McGuire's patron, Thomas Fortune Ryan, whom William C. Whitney called "the most adroit, suave, and noiseless man" that American finance had ever known, controlled corporations valued at one and a half billion dollars. A native of Nelson County, Virginia, born in 1851, Ryan started his career in Baltimore before establishing himself on Wall Street in 1874, when he launched his first great business venture, in 1883, organizing a syndicate for the consolidation and extension of street railway projects in New York, Chicago, and many other cities. The syndicate's Metropolitan Traction Company of New York, was one of America's first holding companies. Among his most famous financial transactions were his formation of the American Tobacco Company, his struggle for control of Seaboard Railway, his acquisition of the Equitable Life Assurance Society, and his promotion of a syndicate to develop the Belgian Congo. Ryan died in 1928. *Detroit Publishing Collection, Library of Congress.*

Overleaf, above: Richmond's Masonic Temple, shown here in 1920, is located at a conspicuous intersection in a busy urban district of the city's West Broad Street. The temple was designed by Baltimore architect Jackson C. Gott and erected between 1888 and 1893; it is considered Virginia's finest and decidedly impressive example of the American Romanesque style. Sophisticated, logical and progressive in design, the structure was dubbed by Gott's contemporaries as the most "magnificent examples of modern architecture in the South," and was published in national magazines as such. This was the largest building erected by Virginia's Masons in the nineteenth century, and served as the site of many balls, concerts and banquets during the eighty years it was used as a Masonic temple; the most important of these was a banquet held for Theodore Roosevelt in 1905. Vacated by the Masons in 1971, the temple was acquired by the Richmond Foundation for the Arts in 1982 for conversion to use as an art center for the Richmond area. Today, the old temple, now called the Renaissance Building, has been converted to a conference center with office space and loft apartments above. *Detroit Publishing Collection, Library of Congress.*

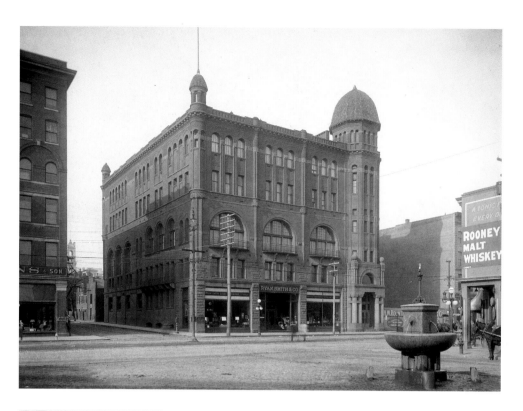

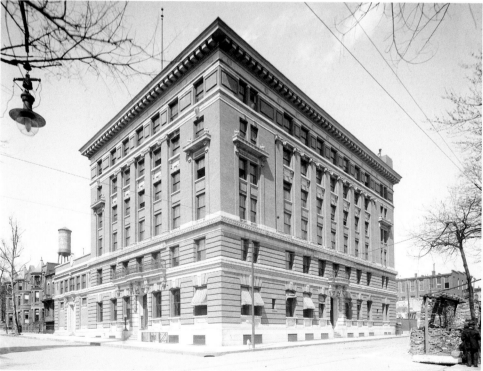

In 1910, the Richmond Central Young Men's Christian Association (YMCA) expanded and opened a new building at the corner of Seventh and Grace Streets, shown here as it appeared in 1920; this building contained the Richmond YMCA's first pool. In 1942 the YMCA moved to its present day location on East Franklin and North Foushee Streets. *Detroit Publishing Collection, Library of Congress.*

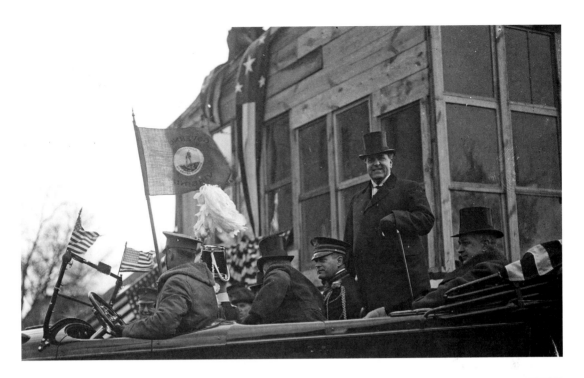

Above: Virginia governor Elbert Lee Trinkle, the commonwealth's forty-ninth governor, is shown in this Harris & Ewing photograph dated February 22, 1923, a little over a year into his term. Trinkle was born on March 12, 1876, in Wytheville, Virginia, the youngest son of the prominent Trinkle family. After graduating from Hampden-Sydney College, he studied law at the University of Virginia, and later opened a Wytheville law practice. Trinkle served as the chairman and an elector of the Democratic Party in 1916, and he also served two terms in the Virginia Senate before his election as governor. Trinkle was governor from February 1, 1922, until February 1, 1926; he died on November 25, 1939, in Richmond and was interred in Wytheville. *Library of Congress.*

Right: The Hotel Rueger, located at Ninth and Bank Streets, shown on this period postcard, was built in 1912 as a ten-story structure; in 1956 an eleventh floor was added. The hotel got its name from Louis Rueger, who originally opened a three-story establishment at the same location in 1846; this was nothing more than a three-story bootlegging saloon with rooms conveniently on site to accommodate patrons too intoxicated to drive home their carriages. When retreating Confederate forces set fire to the navy yard and warehouses along the James River, the flames traveled up to Ninth Street and burned the first Rueger; it took nearly fifty years for the second Hotel Rueger to be built. Today, the Hotel Rueger is the Commonwealth Park Suites.

HOTEL RUEGER – RICHMOND, VIRGINIA

TWENTY-FIVE
UNFORGETTABLE YEARS

By 1925 the pace of progress had picked up for Richmond as the city began to modernize, albeit slowly. "From the suburbs to the state house, filling stations to literary salons," wrote Marie Tyler-McGraw, "Richmond felt the impact of the 1920s. While the symbols of that decade became the flapper and the college boy, the flivver and the hip flask, the decade's transformations reached far beyond Jazz Age collegiates," she continued. "Much of Richmond's modernizing in the twenties was a highly visible adaptation to national trends in technology and marketing." This was the era in which the automobile started to change everything about the traditional city center, from the configuration of streets downtown and to nearby suburbs to areas opened up for development that were far removed from streetcar access.

The city's first radio station, which began operation on November 2, 1925, was a barometer for how far the city had come since the salad days of the century. Known originally as "Edgeworth Tobacco Radio," it was owned by Larus and Brother, a tobacco company known as the House of Edgeworth and was only the third commercial radio station in Virginia at that time. The radio station transmitted from a studio inside the Edgeworth Smoking Tobacco Company plant, located at Main and Twenty-first Streets, and was originally operated as a public service two nights per week. By 1930, WRVA was on-the-air seven days a week, 24 hours daily. WRVA built a new 5,000-watt transmitter in Mechanicsville, a small community located northeast of Richmond in Hanover County, in 1935. The new tower for the antenna at this location was the first all-wood self-supporting radio tower in North America. A series of antenna upgrades would eventually make WRVA the most powerful radio station between Washington, D.C., and Atlanta. WRVA would move to a new studio inside the Hotel Richmond, located at the corner of Ninth and Grace Streets in May 1933. Thirty-five years later, in 1968, WRVA moved again to a new studio designed by renowned architect Philip Johnson. Overlooking downtown Richmond, the new location on Church Hill symbolically represented WRVA's status as the Voice of Virginia; this studio remained the home of WRVA until 2000 when the station moved to the West End of Richmond.[1]

The Great Depression that followed the stock market crash of 1929 did not impact the city's tobacco and textile industries. According to McGraw, "Although drought-plagued tobacco farmers saw their income drop by half, the price of processed tobacco fell only slightly in 1930." She continued, "Cigarette production dipped slightly between 1930 and 1932, then rose. The sales of

leading brands – Luckies, Camels, and Chesterfields – dropped, but cheaper brands sold more. The DuPont rayon plant south of Richmond expanded as the market for synthetics increased across the nation." But other businesses, where downsizing of staff and closure of facilities had already begun couldn't claim the same good fortune. Service and industrial workers were among the first to lose their jobs, McGraw would observe, and the number on relief was always higher in industrial centers like Richmond. "Flour milling and automobile shops were hard hit. Railroads and textile mills cut shifts, sawmills and coal mines closed. Maids were [let go] by families who could not afford them. By the end of 1931, construction in Richmond was down, relief expenses were up, and the Social Service Bureau was taking care of one thousand families,"[2] and farming was in steep decline. But to provide perspective, most working women across Virginia at that time were engaged in domestic service, so the depression hit them particularly hard. In Richmond, 8,011 or 28 percent of white and 7,253 or 64 percent of black women were working in the domestic industry.[3] Tobacco overall remained strong, tobacco factories employing four percent of the female workforce throughout the state, second only to textile mills of all types as an employer of women. In Richmond, cigar and tobacco factories employed 4,068 white and 1,560 black women, which translates to roughly fourteen percent of each respective workforce, as well as 3,159 or six percent white males and 1,641 or eleven percent of black males.[4]

Franklin Delano Roosevelt's (FDR's) election in the fall of 1932 was as much cause for relief as celebration; Richmond and other cities across the country were quickly losing the capacity to provide aid to those in need. History tells us that Roosevelt's promise of the New Deal couldn't have come soon enough for cities like Richmond, and the deal of all deals got immediate support from Virginia senators Harry F. Byrd and Carter Glass. "The New Deal legislation passed by the United States Congress under Roosevelt provided an important link between the New South vision of industrialization and the metropolitanism of the so-called Sunbelt South of the 1970s and 1980s, because its policies favored large farms and suburban areas," observed McGraw. Within five years of the city's initial slump, it began to bounce back as new industries relocated to Richmond, steady industries continued to perform above expectation and, as was clear to all, New Deal programs helped restore and rebuild the city's aging public infrastructure, putting people back to work in the process. The population of the city had grown to 255,426 by 1936, and the value of new construction to the region was 250 percent over that of 1935. Three years later, by 1938, Reynolds Metals moved its executive office from New York City to Richmond, but one example of one of the most important relocations that took place in this period by companies for the northernmost cities – of which Richmond is – in right-to-work states.

Franklin Roosevelt's Public Works Administration (PWA), created by the National Industrial Recovery Act, shared the cost of local projects and provided financing for the remainder of those in progress. In a six-year time frame, the PWA financed the most ambitious building program ever undertaken in the United States, and that program was especially important in the new urban South, according to McGraw. Virginia did not initially embrace the PWA because the state opposed paying the minimum wage required and was reluctant to borrow any money against construction. The PWA, however, offered the city grant funding for a public housing project, an addition to the Medical College of Virginia, and a large, modern state library that was hard to pass up. Later, the PWA would provide funding for Richmond's deepwater terminal, and a Works Progress Administration (WPA) loan provided money to build a new black high school, to be named Maggie Walker High School.[5] The Works Progress Administration (WPA) was instituted by presidential executive order under the Emergency Relief Appropriation Act of April 1935, to generate public jobs for the unemployed. Four years later, in 1939, the WPA was restructured and reassigned to the Federal Works Agency (FWA).

Virginia was the greatest beneficiary of FDR's Civilian Conservation Corps (CCC), which did more service to the Commonwealth than it did to any other state. Historians indicate that the CCC's objective was to provide jobs to men, most of them, but not all, out of work youth, who would be employed in soil and landscaping projects in the state's expansive forests; the program also put them to work on historic site restoration projects and flood prevention along the James River. During the course of the New Deal, Virginia's United States senators, Byrd and Glass, would gradually lose enthusiasm for various programs, including the PWA, WPA and CCC, and the city's two major newspapers – the *Times-Dispatch* and *News Leader* - took what McGraw dubbed a more "selective" approach, supporting some but panning others; Richmond's newspapers concurred with the Supreme Court in 1935, when the Court declared the sweeping powers of the National Industrial Recovery Act unconstitutional. The Act had done little, in truth, to help the black worker. The New Deal was no deal for them, and, in truth, the New Deal fell short in almost all respects when it came to black Americans and was accused thusly of Jim Crow practices by the National Association for the Advancement of Colored People (NAACP); this aspect of Roosevelt's landmark program was the significant downside to the New Deal, observed McGraw. One of the most marked examples of the economic disparity between black and white during the peak of the New Deal were female black stemmers in the city's tobacco industry who worked for as little as three dollars a week in squalid conditions, some putting in as much as eighty-hour weeks, some more. Four hundred black female stemmers initiated a strike and protest on May 6, 1937; they would go on to win an increase in pay and better working hours and conditions.

Work performed on Richmond's historic sites during the Great Depression would continue to pay dividends in the decades to follow. Though the last Confederate reunion was held there in 1932, Richmond continued to draw tourists with an interest in the many and varied buildings, statuary, parks and open space associated with the city's rich past. From the late 1920s, with the development of the Williamsburg, Virginia, historic area, an interpretation of a Colonial America city, with exhibits including dozens of authentic and recreated buildings related to colonial and American Revolutionary War history, Richmond also seized upon opportunities to benefit from doing much the same.

By the end of the nineteen thirties, the boon of the New Deal had evolved to retooling for war. Richmond was the center of the cigarette-making industry, with warehouses full of Virginia Bright, Burley, Maryland, and Turkish tobacco, and the sweet scent of tobacco continued to waft through the city. The city's big tobacco companies were infused with cash in 1939 when the federal government bought much of that year's crop in order to sell it to Great Britain on credit. The year 1939 was the start of the Second World War in Europe and the Allied demand for cigarettes led to rapid expansion of Richmond's tobacco production.[6] Even after the United States entered the Second World War, tobacco remained the city's most important industry.

Richmond's deepwater terminal, with its 1,200-foot wharf wall and two fireproof warehouses, was dedicated in October 1940, just in time to become a reconsignment depot for the army. In early 1941, less than a year before the United States entered the war, the city's streets were flush with servicemen attending dances on the weekends, especially those held at the Mosque, downtown on Monroe Square.[7] Richmond was a city abuzz with servicemen training for a fight that was only months away, and like many cities with centralized rail and water access, the foundation was laid for the city's protracted participation as a supply hub for the United States military.

Richmond was engaged in the national war preparedness movement that had begun two years before, in 1939, when the war in Europe broke out. A Virginia civil defense council

was established in 1940 with Douglas Southall Freeman as chairman, and the first national peacetime conscription act required all men aged twenty-one to thirty-six to register for a possible draft into the armed forces.[8] The first response to this act in the Commonwealth went out from local draft boards in November 1940. A month prior, in October 1940, the War Department ordered the construction of another Camp Lee on the site of the earlier installation that had been constructed during the First World War. Built as rapidly as the first, construction was still ongoing when the quartermaster Replacement Training Center (QMRTC) started operation in February 1941; their number grew to 25,000 in 1942, and peaked at 35,000 in 1944. Camp Lee was also the home of a Medical Replacement Training Center (MRTC), but as the quartermaster training increased, it was decided to relocate the MRTC to Camp Pickett. Later, the QMRTC was redesignated as an Army Services Forces Training Center, but it retained its basic mission of training quartermaster personnel. While the QMRTC was getting underway, the quartermaster School was transferred to Camp Lee. A full program of courses was conducted, including officer candidate school. By the end of 1941, Camp Lee was the center of both basic and advanced training of quartermaster personnel and held this position throughout the war.

Everything in the city changed after the Japanese attacked Pearl Harbor on December 7, 1941, and the United States entered the war. The war years kicked industrial production into high gear and vaulted the number of servicemen present in the city and outlying military bases. From a population of 38,710 and an area of 4.9 square miles in 1867, the city had developed by 1940, about a year before the war, to a community of 193,042 an area of 22.96 square miles. The Supreme Court of Appeals of Virginia, in a decision handed down on June 9, 1941, upheld a previous decision of a special annexation court granting the city the right to annex approximately 9.6 square miles of adjacent suburban land from Henrico County. On November 6, 1941, another special annexation court similarly granted the city the right to annex approximately 7.3 square miles from Chesterfield County. Effective December 31, 1941, and executed in January 1942, these decrees added more than 20,000 to the population of the city, most of them white and of financial means to relocate outside Richmond's urban core; the suburbs that became part of Richmond with these annexations included Windsor Farms, among others, which all became part of the city within weeks of America's entry in the war. McGraw would observe that the percentage of black Richmonders, now collocated to the city center and in northern suburban areas beyond Virginia Union University, declined to just over one-fourth of the total population.

During the war, though tobacco remained on top, it was closely followed by the manufacture of paper and paper products, the related industries of printing, publishing and engraving, and iron and steel manufacturing, at the peak of wartime production, Reynolds Metal Company and the DuPont Company were the city's two largest industries, McGraw wrote later, and in the middle of the war, the *Richmond News Leader* announced that 34,000 servicemen visited Richmond every weekend. Of note, although many Richmond companies converted to war production, no new military industries were set up in the city. War work centered on the redirection of existing industry, the deployment and direction of supplies, and the training of servicemen.[9]

At Bellwood Farm, near Drewry's Bluff, the Richmond General Depot, later renamed the Richmond Armed Service Forces Depot, which subsequently became the Richmond Quartermaster Depot[10], and located nine miles south of the city, received and dispatched trainloads of supplies, and a reconsignment depot was established in due course at the deepwater terminal. Byrd Airport became Richmond Army Air Base, training airmen. By

war's end, in 1945, more than 350 million pounds of supplies were shipped through the Bellwood depot. A year later, in 1946, Richmond's economy was at yet another turning point. During that year, the highest level of business activity was recorded in the history of the city. Within one year, Richmond was the fastest growing industrial center in the United States. Defense money that infused the city's industrial base during the war would provide a solid foundation for postwar prosperity.

Three years after the war, in 1948, Oliver Hill became the first black person elected to the city council since the Reconstruction era. Also in 1948, WTVR-TV, billed as the South's first television station, began broadcasting in Richmond. As roads improved in the early twentieth century, streetcars succumbed to the automobile and busses. By 1939, of course, the Richmond-Petersburg area interurban services were gone, and the last of the city's streetcars ran in 1949 on the Highland Park line, when they, too, were replaced by busses. This was the era, notably, of the "all-bus" movement that swept the country postwar. Further, as the National Auto Trails system grew into a national network of highways, the area was served by the Jefferson Davis Memorial Highway, the busy north-south corridor in central Virginia shared by U.S. 1 and U.S. Route 301 through the cities of Richmond, Colonial Heights, and Petersburg; it crossed the James River on the Robert E. Lee Memorial Bridge. After the Second World War, with only four traffic lanes and long stretches of undivided roadway, the Jefferson Davis Memorial Highway became a major area of traffic congestion, as well as the site of occasional spectacular and deadly head-on collisions.

In concluding this section, it is of significance that the Second World War had interrupted the Richmond Planning Commission's work on the master plan originally called for in 1918, and which was in progress in 1940 when the United States entered the fight. But it also distracted from efforts to desegregate the city. The November 13, 1943 *Times-Dispatch* advocated abolition of segregation on streetcars and busses. The proposal received positive acclaim from press in the North, none at all in the South, with the exception, as historian Virginius Dabney would later document, of a favorable response in a small Kinston, North Carolina paper. Correspondence to the *Times-Dispatch* was overwhelmingly – three to one – in favor of the proposal. But as Dabney would further note, the General Assembly did nothing, and interracial tension was heightened by the inaction and subsequent legislation from the General Assembly that tried to curtail black businesses in the city, thwarted only by the venting of each legislative travesty by negative press.

The city's 1940 planning initiative led to the first Richmond master plan, adopted in 1946, and prepared by the renowned city planner Harland Bartholomew, whose work for Richmond stressed the importance of offering new, inner-city residential opportunities to cap the declining vivacity of the urban core. Bartholomew's plan recommended limited growth beyond the city's extant boundaries and focused attention on the city center to preserve it as a physically cohesive unit. The plan also addressed transportation, to include the street grid and modes of transportation, and the development of neighborhood based planning process.

Richmond's first planning department, now the Department of Community Development, was established in 1948, and planning functions were transferred from the Department of Public Works. The city, postwar, further adopted a city manager form of government with a one-chamber council that replaced the cumbersome two-chamber council and strong mayor model that nearly all other cities in the country had long since abandoned. Bartholomew noted that what Richmond had in common with other large American cities was growth dictated largely by the needs of the moment, land speculation and individual interests taking precedence over the community's best interest. The evolution of Richmond, evident

to him in the aftermath of the war, was an old city that had come about from haphazard and misdirected development, often attributed to the city's bunglesome two-chamber and strong mayor system; in the intermingling of heterogeneous and incompatible uses such as stores and industries in residential neighborhoods, and scattered residences in industrial sections.

The failure of American cities, Bartholomew wrote just then, to coordinate and control the various elements comprising the urban community had brought about not only depreciated and unsatisfactory neighborhoods but increased difficulty and waste in the provision of essential urban services. Thus, he concluded, the population of the city center had fanned out to the suburbs, looking both for relief from increasing taxes and a better home environment. The automobile had everything to do with this flight further from the city center. The advent of the modern, low-priced automobile, which became increasingly popular by 1920, tested the traditional development pattern of all American cities; it was no longer necessary to live within easy walking distance of one's place of employment or proximal to a streetcar line. Where the streetcar had extended the effective radius of the city from two to about five miles, the automobile pushed it to ten and even fifteen miles. The potential area for urbanization had jumped from 300 percent to 800 percent. A decade before the start of the Second World War, Richmond's urban growth was palpable.

Bartholomew advocated Euclidean[11], also called single-use, a practice of urban planning where everyday uses are separated from each other and where land uses of the same type are grouped together. Shops are concentrated in one area, housing in another area, industry in another. "Bartholomew's plan blamed the mix of industrial, commercial and residential usage found in many Richmond neighborhoods for the deterioration of those neighborhoods and for residential flight to the suburbs," observed McGraw. After the war, Bartholomew's plan called for stiffer zoning laws that separated these uses and advocated the city's new planning department set about with other departments to lay out planned streets, improve the transit system, expand parks and school facilities, construct a civic center and come up with a comprehensive housing program.

Streets, parks, playgrounds and other public and semi-public uses occupied a little more than one-fourth of the total city area at the time Bartholomew's plan was published. Residential property made up nearly two-fifths of the developed area of Richmond, including streets and other public property, and more than two-third's of the city's private development. The Bartholomew call for realignment and reordering of transportation, housing and public space was a tall order as the city moved into the second half of the twentieth century. Planners who followed the 1946 plan loathed the fact that three-fifths of the city's housing was classified low rent and they noted, in accordance with Bartholomew's findings, that much of it was rented by blacks in low wage domestic service and menial labor in the city's still booming industrial core. Bartholomew's plan called for the rehabilitation of low-rent housing but did not go so far as to suggest alternatives to segregated downtown housing that was the fallout of city and state policy, federal home loan policies[12] and the advent of federal slum clearance via newly created redevelopment and housing authorities, most especially those in Richmond and Norfolk[13], that razed large swaths of commercial and residential structures in the urban core, invoking the government's declaration of eminent domain to do it. In Richmond, the working-class Jackson Ward fell victim to the wrecking ball to facilitate the construction of a new Richmond-Petersburg toll highway, approved by the Richmond city council in 1953, a project that also came with a new civic center and master plan for the Medical College of Virginia. The swath carved out of the Jackson Ward forced ten percent of the city's black population to relocate.

Endnotes

1 Radio in Virginia http://www.lva.virginia.gov/exhibits/radio/voice.htm

2 McGraw, Marie Tyler. *At the Falls: Richmond, Virginia, and Its People.* Chapel Hill: University of North Carolina Press, 1994.

3 Perdue, Nancy J. and Charles L. Perdue Jr. *Talk About Trouble: A New Deal Portrait of Virginians in the Great Depression.* Chapel Hill: University of North Carolina Press, 1996.

4 Ibid.

5 McGraw, Ibid.

6 Ibid.

7 Ibid.

8 Ibid.

9 Ibid.

10 This depot later became the Defense Supply Center, Richmond (DSCR), and serves as the aviation Demand and Supply chain manager for the Defense Logistics Agency; it is located on the Interstate 95 corridor in Chesterfield County, Virginia, in the southside area of Greater Richmond Virginia.

11 Single-use zoning is often called Euclidean zoning by urban planners and other professionals, a reference to the court case that established its constitutionality, *Village of Euclid, Ohio v. Ambler Realty Co.* 272 U.S. 365 (1926).

12 The Federal Housing Administration (FHA) made possible loans and credit for home construction to builders with tracts of land on which the intent was to build affordable housing. Houses bought in these outlying tracts was attractive to first time white home purchasers but discriminated against black, ethnic residents who were determined to be "not as worthy" of the program. Such discriminatory loan policies further prohibited loans to black families in white neighborhoods, thus deepening the segregation of Richmond suburbia. The U.S. Supreme Court decision *Brown v. Board of Education of Topeka*, 347 U.S. 483 (1954) was a landmark United States Supreme Court case in which the Court declared state laws establishing separate public schools for black and white students to be unconstitutional. The decision overturned the *Plessy v. Ferguson* decision of 1896, which allowed state-sponsored segregation, insofar as it applied to public education. Handed down on May 17, 1954, the Warren Court's unanimous (9–0) decision stated that "separate educational facilities are inherently unequal." As a result, *de jure* racial segregation was ruled a violation of the Equal Protection Clause of the Fourteenth Amendment of the United States Constitution. This ruling paved the way for integration and was a major victory of the civil rights movement.

13 With the passage of a new public housing act in 1937 and organization of the United States Housing Authority, the federal government undertook a program of financial assistance to local housing authorities for the purpose of slum elimination and low-rent housing stock. This slum clearance initiative allowed the federal government via the local redevelopment and housing authorities, such as those in Richmond and Norfolk, to clear large swaths of city center buildings, including entire downtown commercial and residential corridors.

Left: Nancy Witcher Langhorne Astor, Viscountess Astor, Companion of Honor (CH), shown here at the governor's ball in Richmond, October 21, 1928, was an American socialite born in Danville, Virginia, whose second marriage to Waldorf Astor would lead to a remarkable political career in England. After Waldorf Astor succeeded to the peerage and entered the House of Lords, she entered politics, in 1919 winning his former seat from the Conservative Party in Plymouth Sutton and becoming the first woman to sit as a member of Parliament in the House of Commons, a position she retained until 1945, when she was persuaded to step down. Lady Astor once said: "Real education should educate us out of self into something far finer; into a selflessness which links us with all humanity."

Right: Frances Benjamin Johnston photographed the garden path leading to Reveille, located at 4200 Cary Street, in 1929. This Federal style house, once part of a large plantation facing the James River, is the second oldest home in Richmond. The land surrounding it was part of a grant by the King of England to the Kennon family, whose Virginia holdings amounted to 50,000 acres; they built the house here as early as 1720. By 1800, what is known as the "The Brick House Tract" was a landmark along the Westham Plank Road (now Cary Street). The house did not get its "Reveille" name until after 1842, the year it was acquired by Phillip Mayo Tabb and his wife Martha. Family legend tells that Martha insisted everyone in the household awake before sunrise and the term "reveille call" became all too familiar to their children; it later came to be applied to the estate, as Henrico County records from 1852 indicate the purchase of "...the Brick House Tract, now called Reveille." After the Civil War, the home was acquired by Confederate veteran and tobacco magnate Dr. R. A. Patterson; it was his daughter Elizabeth Patterson Crutchfield who inherited the house from her father and restored the gardens Johnston photographed. Crutchfield died in 1949 and Reveille United Methodist Church acquired the property in 1951. Reveille is listed on the National Register of Historic Places. *Frances Benjamin Johnston Collection, Library of Congress.*

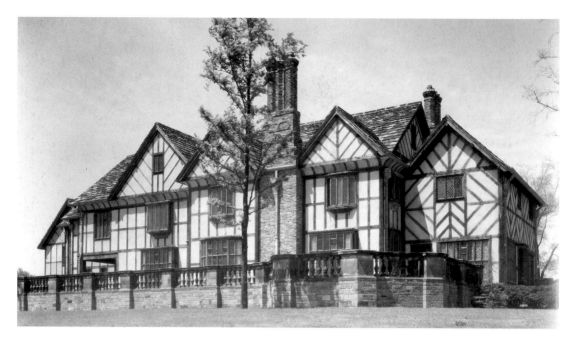

Agecroft Hall, which once stood in Lancashire, England, had its beginnings in the late fifteenth century. For centuries, it was the home of the distinguished English Langley and Dauntesey families, during the tempestuous yet brilliant Tudor and Stuart ages, when England was taking its place among the major powers of Europe and the New World. Agecroft stood proudly during the reigns of Henry VIII, Elizabeth I, and James I, the namesake of the river that flows past Agecroft's banks here in Richmond, Virginia. By the mid-1920s, the building in Lancashire had deteriorated largely due to coal mining in its vicinity, and the structure was bought by the successful Richmond businessman Thomas C. Williams Jr., dismantled, and shipped across the Atlantic to Richmond, where it has stood since 1926/27. After decades of service as a private residence, it then became a house museum with glorious gardens, all of which pay tribute to the Elizabethan Age. Frances Benjamin Johnston photographed the home in 1928. *Frances Benjamin Johnston Collection, Library of Congress.*

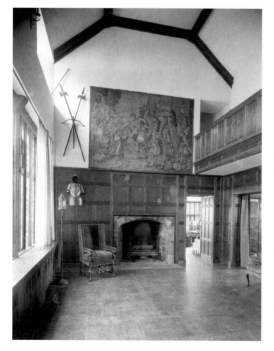

Thomas C. Williams Jr., of Richmond, Virginia, a wealthy entrepreneur, purchased Agecroft Hall upon the advice of architect Henry G. Morse. Williams, whose financial interests included tobacco, banking, and shipping, wished to build a true English manor house on his twenty-three acres overlooking the James River. Agecroft was dismantled, crated, transported across the ocean, and reconstructed in the city's Windsor Farms neighborhood. Frances Benjamin Johnston photographed the home's great hall in 1928, shortly after the home was completed that spring. Williams died in 1929. *Frances Benjamin Johnston Collection, Library of Congress.*

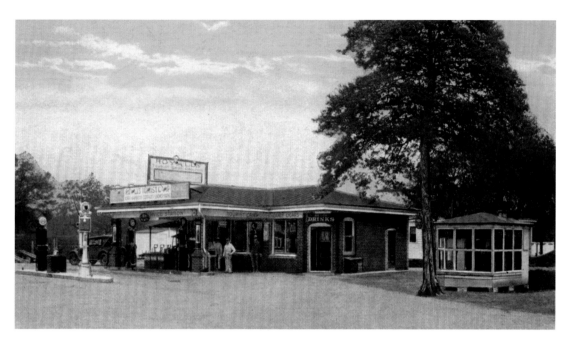

Royall's Tourist Camp and Cottages was located at Norwood Avenue and the corner of Washington Highway (Highway No. 1) on the north side of the city. The postcard dates to the 1920s. Today, the location of Royall's camp is an empty lot next-door to a trailer park.

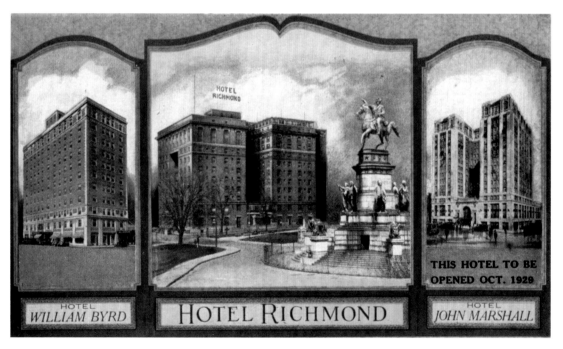

This advertising postcard for Richmond Hotels, Inc. (of the period) features three of the city's iconic hotels: Hotel Richmond, overlooking the Washington Monument in Capitol Square, Saint Paul's Church across the street, at which Jefferson Davis and Robert E. Lee attended church; Hotel William Byrd, opposite the Broad Street Union Station and overlooking the Jefferson Davis, Stonewall Jackson, Robert E. Lee and J.E.B. Stuart monuments, located on Monument Avenue; and Hotel John Marshall, set to open in October 1929 at the corner of Fifth and Franklin Streets, in the Center of Prosperity, overlooking the entire city, and just six blocks from the home of Chief Justice of the Supreme Court John Marshall. When it opened, the Hotel John Marshall was the largest hotel in Virginia.

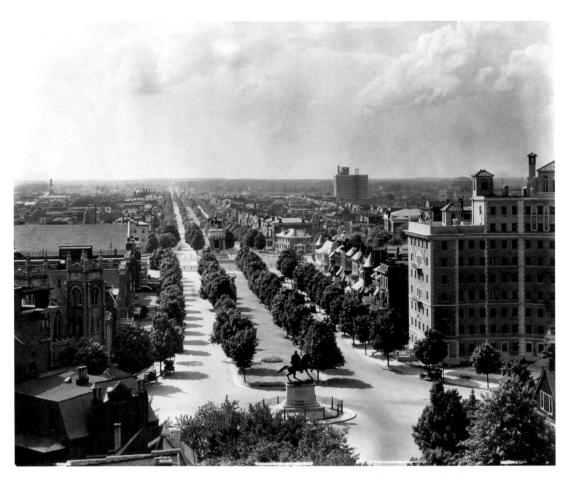

Monument Avenue is an outstanding example of the Grand American Avenue city planning style. The first monument and the largest on the avenue, a statue of Robert E. Lee, was unveiled on May 29, 1890, with an estimated crowd of 100,000 looking on. From 1900 to 1925, the avenue exploded with architecturally significant houses, churches and apartment buildings. A tree-lined grassy mall divides the east- and westbound sides of the street and is punctuated by statues memorializing Virginian Confederate participants of the Civil War, including General Robert E. Lee, Major General James Ewell Brown "J.E.B." Stuart, Confederate States of America president Jefferson Davis, Lieutenant General Thomas Jonathan "Stonewall" Jackson, and Confederate States Navy commander Matthew Fontaine Maury. This photograph of Monument Avenue was taken on June 11, 1929, from the Saint James Episcopal Church steeple; the J.E.B. Stuart statue is in the foreground.

Right: The Mason's Hall (shown here at 1807 East Franklin Street between Eighteenth and Nineteenth Streets in 1934) was the first building erected in the United States as a Masonic meeting place and continuously used for that purpose; it is also one of the few surviving eighteenth century buildings in Richmond. The cornerstone was laid on October 12, 1785, and the building erected and completed on December 10, 1787. The hall is home of Richmond-Randolph Lodge No. 19. The lodge derives its name, in part, from Edmund Randolph, former Virginia governor and Past Grand Master Most Ancient and Honorable Fraternity of Free Masons, Richmond-Randolph Lodge No. 19. Charters for nearly all lodges in Virginia have come from this building. The Mason's Hall was used as a hospital during the War of 1812. *Library of Congress.*

Below: Virginia House is a transplant to Richmond, a country house on a hillside overlooking the James River in the Windsor Farms neighborhood of the city, brought to its present location in 1925. The house was constructed from the materials of the sixteenth century Warwick Priory in Warwickshire, England, and shipped over and reassembled, completed several months before the stock market crash of 1929. Virginia House is in the Tudor architectural style but incorporates a range of designs from other English houses and has modern facilities such as seven baths and central heating. The home belonged to Alexander Wilbourne Weddell, a wealthy Richmond native and United States consul general, and Virginia Chase Steedman Weddell, an interior designer, who created a lavish interior for the house, salvaging many materials from the priory and other old English manor houses and adding further elegant English and Spanish antiques, oriental carpets, silks and silverware. Today Virginia House is operated by the Virginia Historical Society as a museum, although it largely remains as it was in the 1930s except for gradual crumbling sandstone replacement. Immediately to the west of the property is Agecroft Hall. Frances Benjamin Johnston photographed the home in 1930. *Frances Benjamin Johnston Collection, Library of Congress.*

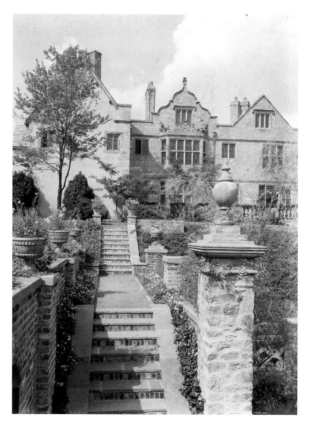

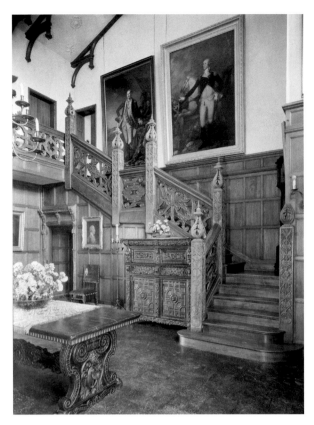

The main entrance hall of Virginia House is a grand, high-ceilinged room using oak panelware from the Warwickshire priory. The ornate, L-shaped staircase is actually a reconstruction of the original sixteenth-century staircase of the priory repurchased from an antique shop in London and includes an acanthus leaf newel cap and overscaled newel posts in its design. The floor in the entrance hall is made from a composite made up of terracotta, asphalt and wood shavings known as zenitherm, with tiles arranged in an irregular rectangular formation. Frances Benjamin Johnston took this photograph of the great hall in 1930. *Frances Benjamin Johnston Collection, Library of Congress.*

This Federal style double house at 2501-2503 East Grace Street (shown in a 1930 period photograph) in Church Hill was built in 1809 and is the earliest surviving duplex in Richmond. Built by Dr. John Adams, who helped initiate development in this area through his real estate holdings, it was saved from the wrecking ball by the Historic Richmond Foundation on April 29, 1960. The porches are Victorian additions as is the shop entrance in the basement wall. *Library of Congress.*

Above: This double house at 311-313 College Street (foreground) was across the street from the Egyptian Building and around the corner from the old First African Baptist Church, part of which is visible on the corner. The church building, located at the corner of College and East Broad Streets, was designed in the Greek Doric temple style by Thomas Ustick Walter. The congregation of the church moved from this location in 1955, and the building was sold to the Virginia Commonwealth University School of Medicine. The residences in this Depression-era picture were razed and the site eventually occupied by the university's Massey Cancer Center. *Library of Congress.*

Right: Richard L. Hilliard (standing in the white apron, right) had a grocery store at 808-812 Brook Road, originally a tavern on what historically had been the oldest road into Richmond, when Frances Benjamin Johnston took this picture in 1930. *Library of Congress.*

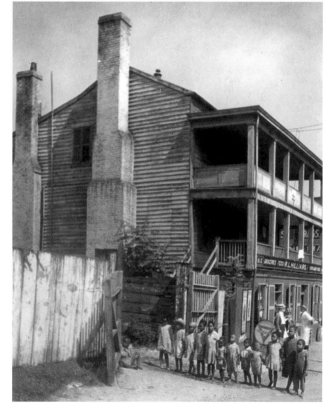

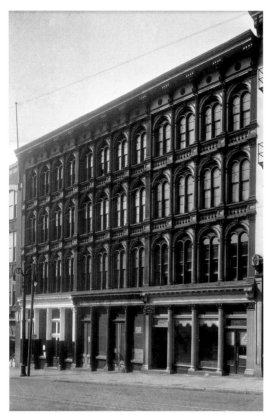

The Donnan-Asher Iron Front Building at 1207-1211 East Main Street, shown here in period 1930 photograph, dated by the businesses occupying the building at the time it was taken, is located on the southside of Main between Twelfth and Thirteenth Streets, and was constructed in 1866 during the rebuilding of the area following the torching of Richmond by evacuating Confederate troops in April 1865. The building is one of the finest and most ornate cast-iron front rows surviving in the city; it is named for the two Richmond businessmen who bought lots to build it in 1866: William S. Donnan and John Asher. The four-story façade, in pure Italianate style, is reminiscent of Venetian Renaissance palaces. Until 1966 the façade survived almost completely unaltered (as shown in this picture), but at that time a modern entrance was inserted along the central ground floor shop front, resulting in the removal of all original architectural decoration in four bays. Despite this unfortunate alteration, the building remains an excellent example of Victorian elegance and character in the construction of an otherwise utilitarian commercial building. *Library of Congress.*

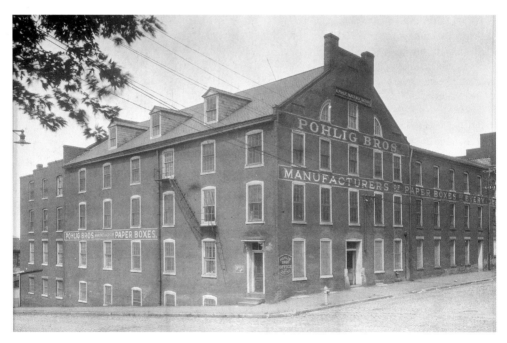

The Pohlig Brothers Paper Box Factory, located on the southwest corner of Twenty-Fifth and East Franklin Streets, was a reclaimed tobacco factory built in 1853 and first occupied by William Yarbrough and Miles Turpin, partners from 1841 to 1870 at Yarbrough-Turpin, a tobacco enterprise that specialized in leaf processing. The leaves were cut with a hand knife, packaged and sold as chewing tobacco. Pohlig Brothers acquired the building in 1909 and occupied it for nearly 100 years. This photograph dates to the 1930s. *Library of Congress.*

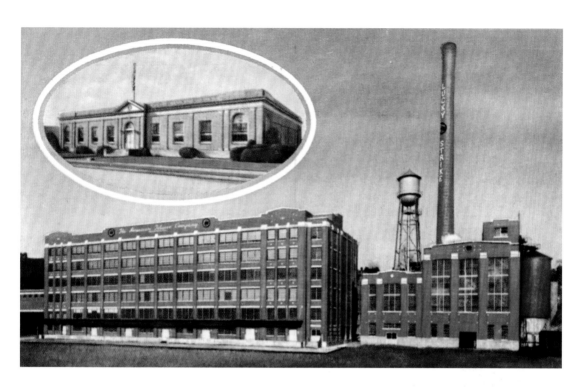

Above: This 1930 period postcard of the Lucky Strike plant, where millions of carefully-controlled, precision-made cigarettes were made every day, also shows the American Tobacco Company Research Laboratory, which was also in Richmond. This was, at that time, the most modern and fully-equipped tobacco research laboratory in the United States.

Right: A thousand-pound hollow bronze statue of Confederate general Robert E. Lee was unveiled on January 19, 1932, Lee's birthday, in the Old Hall of the Virginia House of Delegates by the general's descendants on the exact spot where Lee took command of Confederate forces in 1861. Sculpted by Rudulph Evans, a Virginia native and artist of the Jefferson Memorial in Washington, D.C., the Lee statue was paid for by a fund-raising campaign initiated by Governor Harry F. Byrd in 1929. In the photograph (left to right) are Charles B. Fourqurean, color bearer of the Third Richmond Howitzers; Dr. George Bolling Lee, of New York; his daughter, Mary Walker Lee; son, Robert Edward Lee IV, who unveiled the statue; and his wife, Helen Keeney Lee.

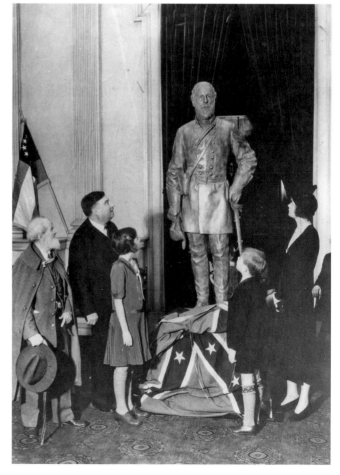

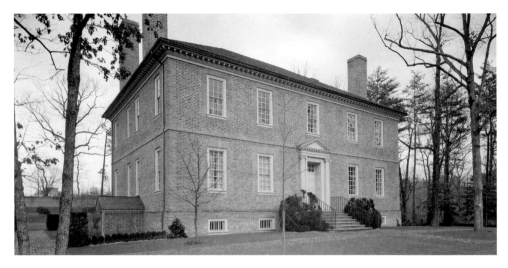

William Randolph III, one of Virginia's great colonial landowners and son of William Randolph II of Turkey Island, purchased two thousand acres along the James River in eastern Henrico County in 1747, and it was there that he and his wife, Ann Carter Harrison, of Berkeley, built a mansion they named Wilton, completed about 1753. The center of a bustling tobacco plantation, the house remained in the Randolph family until 1859, and then through a succession of owners was left virtually intact, although losing much of its original grandeur as a prime example of Georgian architecture. The increasing industrialization of Richmond pushed its boundaries further east early in the twentieth century, threatening Wilton's survival and leading both to its acquisition by the National Society of the Colonial Dames of America in the Commonwealth of Virginia in 1933 and to its move to a new site on a bluff overlooking the James in the Westhampton section of western Richmond, where it was carefully rebuilt at 215 South Wilton Road. The photograph shown here is post-1933 move. *Library of Congress.*

Wilton's chief distinction lies in its being the only completely paneled house in Virginia. Throughout the entire dwelling, including the closets, the walls are sheathed in a handsome, though somewhat dry and predictable pattern of vertical raised panels above and below a molded chair rail. This interior photograph of Wilton was taken after the 1933 move and re-erection of the house in the west end of Richmond. *Library of Congress.*

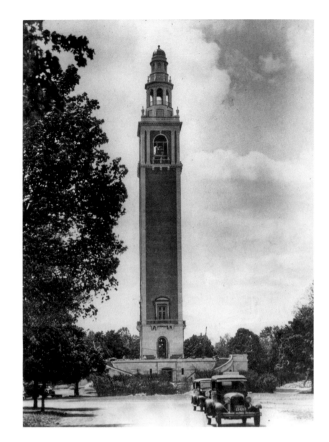

The Virginia World War I Memorial in Byrd Park, also called The Carillion for the set of fifty-three (originally sixty-six) stationary bells hung in the tower and sounded by a musician at a keyboard four stories up in the tower, is an eight-story, 200-foot bell tower designed in the Georgian Revival style; this edifice dominates the skyline of western Richmond. This tower is the sole structure erected by the commonwealth to memorialize the "patriotism and valor of the soldiers, sailors, marines and women from Virginia" who served in World War I. After much controversy over the design of the memorial tower, Boston architect Ralph Adams Cram was chosen to redesign the tower as a carillon. The Carillion is shown here on September 22, 1932, several weeks before the October 15 unveiling.

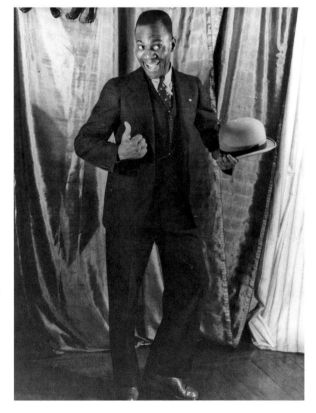

Bill "Bojangles" Robinson (born Luther Robinson), shown in this Carl Van Vechten January 25, 1933 photograph, was born in the city's Jackson Ward on May 25, 1878. After his parents died in 1885, he was raised by his grandmother but by this time he was already dancing for change in the streets of Richmond, where he was first discovered by a minstrel show promoter. Robinson, a tap dancer and actor, was the best known and most highly paid African American entertainer in the first half of the twentieth century. His long career expectantly mirrored changes in American entertainment tastes and technology, starting in the age of minstrel shows, moving to vaudeville, Broadway, the recording industry, Hollywood radio, and television. Despite being the highest paid black performer of his time, he died penniless on November 25, 1949, in New York City. *Library of Congress.*

Born in Boston on January 19, 1809, Edgar Allan Poe was the second child of two actors. After his father abandoned the family in 1810, and his mother died the following year, the orphaned Poe was taken in by John and Frances Valentine Allan, of Richmond, Virginia. Although they never formally adopted him, Poe was with them well into his young adulthood. The Allan home, where Poe lived as a boy, was on the west side of Fourteenth Street between Franklin and Main Streets and is shown here in a 1933 photograph taken by Frances Benjamin Johnston. The house was only a block away from the Southern Literary Messenger building where Poe served as an editor and directly behind it the offices of Ellis and Allan where he worked occasionally as a clerk in his salad days, before the fame of his own poet work took him away from Virginia's capital city. *Frances Benjamin Johnston Collection, Library of Congress.*

This is an undated composite photograph of Rosalie Poe (left) and a halftone reproduction of a painting of Frances Keeling Valentine Allan, Edgar Allan Poe's sister and foster mother, respectively. Frances Allan died on February 28, 1829, and is buried in Shockoe Hill Cemetery. *Library of Congress.*

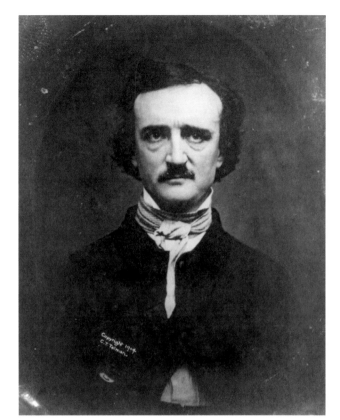

Right: Edgar Allan Poe, photographed by W. S. Hartshorn in 1848, a year before his death, spent much of his youth in Richmond. The daguerreotype was published as a photograph by C. T. Tatman in 1904. *Library of Congress.*

Below: In 1936, historian Mary Winfield Scott documented this house at 804 East Clay Street where Edgar Allan Poe once lived, at least for a brief period. The house was built in 1823 for Maria Wiseham; it was demolished in 1937. *Library of Congress.*

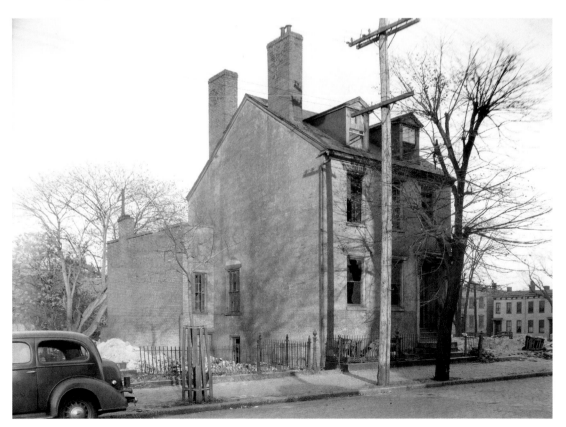

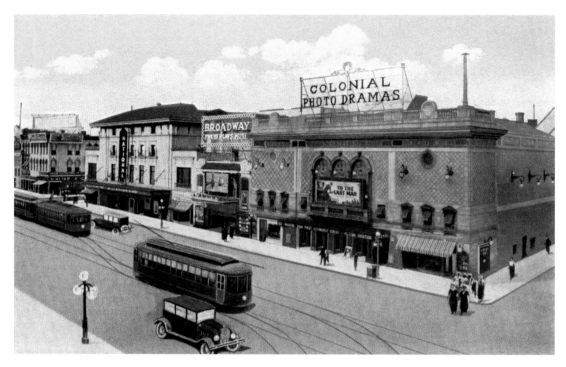

The Richmond Theater District, shown here in the 700-block of East Broad Street, was promoted on this 1933 postcard, dated by the movie playing at the Colonial Theater (foreground) – *To the Last Man*, starring Randolph Scott – which did not open nationally until September 15, 1933. In 1920, Jake Wells demolished the original Colonial Theater and built a new one; it opened on October 21, 1921, as the largest movie house – it could seat 1,900 – south of Washington, D.C.. Far left (with the reddish brown roof) is what many consider to have been Richmond's finest theater, the National, which opened on November 11, 1923, at the northeast corner of East Broad and Seventh Streets; it is the only surviving theater on the row (the others exist today in façade only). The National, built by the First National Amusement Company, is an exceptional example of the picture palace era that boomed during the 1920s and 1930s; it was added to the National Register of Historic Places in 2003, and is located in the Grace Street Commercial Historic District. Like each of the former theaters on the block, the earliest history of the National, Broadway and Colonial included everything from early vaudeville and musical comedies to silent and talking motion pictures.

Architect William Lawrence Bottomley received his last commission to work on a Monument Avenue residence in 1929, when he was retained by Robert Miller and Elizabeth Gwathmey Jeffress to design this residence at 1800 Monument Avenue. Robert Jeffress, a lawyer, inherited from his father Thomas extensive tobacco, paper production and real estate holdings and by the time he engaged Bottomley to design this home, he was president of Union Camp Corporation, one the nation's largest manufacturers of paper products; he was also a well-known Richmond – and Virginia – philanthropist. *Continues on page 78.*

Richmond children are shown mailing their letters to Santa Claus in this Acme News Photograph dated December 16, 1933.

Tuckahoe, located at 12601 River Road, was photographed by Frances Benjamin Johnston from Thomas Jefferson's schoolhouse to the boxwood maze in April 1936. The H-plan, Georgian, white wood-framed house was first built by Thomas Randolph, from about 1720, with additions by William Randolph III, completed around 1740. Tuckahoe was acquired by Nehemiah Addison and Isabelle Baker in 1935. The home is preserved today as a National Historic Landmark; the boxwood maze (shown here) is no longer in existence. *Frances Benjamin Johnston Collection, Library of Congress.*

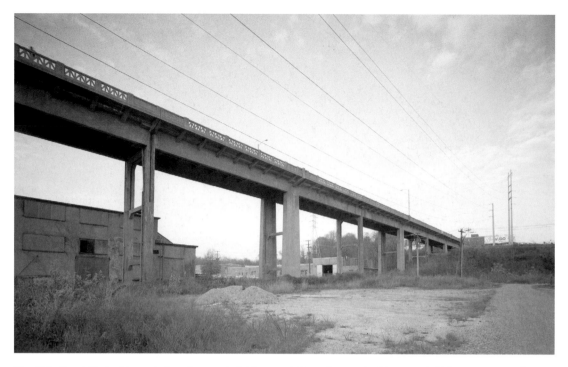

The Fifth Street Viaduct is a reinforced concrete bridge consisting of seven double-span rigid frames supported on expansion piers and stiff towers. Built in 1933 by the Richmond Bridge Corporation with aid from the U.S. Reconstruction Finance Corporation, the viaduct carries Fifth Street over Bacon's Quarter Branch Valley to link the Richmond neighborhoods of Highland Park and Jackson Ward. A representative rigid frame reinforced concrete viaduct of the 1920-1940 period, the Fifth Street Viaduct is a significant multiple-span bridge designed by the prominent New York City bridge engineer Alfredo C. Janni. This view, photographed by Robert C. Shelley in November 1992, shows a partial elevation from the southeast spanning Bacon's Quarter Branch Valley on Fifth Street. *Library of Congress.*

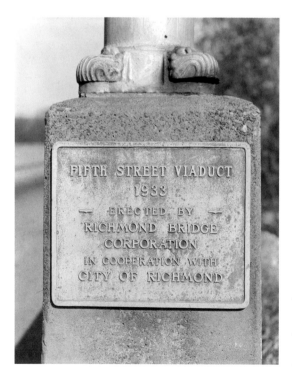

Robert Shelley photographed the metal bridge plate at the south end block of the east parapet in November 1992; this plate records the 1933 construction of the Fifth Street Viaduct by the Richmond Bridge Corporation in cooperation with the city of Richmond. *Library of Congress.*

Continued from page 76:
The Jeffress residence is on the circle dominated by the statue of Robert E. Lee. Frances Benjamin Johnston photographed the Jeffress home in June 1933. *Frances Benjamin Johnston Collection, Library of Congress.*

Above: The double house built at 2216-2218 East Main Street in 1814 by Richard Adams was in serious disrepair when this photograph was taken for a June 26, 1936 historic survey and eventually torn down. The building originally had a pitched roof with gabled ends that were removed about 1908 and replaced with a flat roof due to the weight of the original roof and with it went the attic with dormers. In the old days this building was called the "Actors' Boarding House" because it served its purpose for actors who stayed in that section of Richmond known as the "Bird-in-Hand," which got its name from Richmond's first tavern, opened by the first eighteenth-century Jews to settle in Shockoe Bottom Isaiah Isaacs and partner Jacob I. Cohen, both German-born, at the corner of what is now East Main and Twentieth Streets. *Library of Congress.*

Right: The Hampton-McCurdy House, shown here in a 1936 photograph, was built in 1845 on the southwest corner of Eighteenth and Main Streets in Shockoe Bottom. Restored and enlarged, it is still there today. *Library of Congress.*

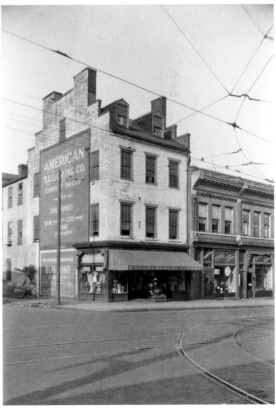

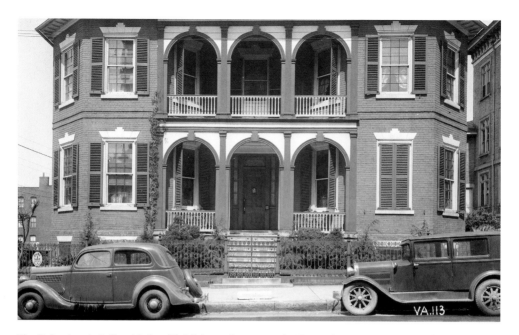

The Federal period, Flemish-bond brick house known as the Hancock-Wirt-Caskie House (also called the William Wirt House) at 2 North Fifth Street was built between 1808 and 1809 by Michael W. Hancock, who lived there until 1814. In 1816 William Wirt bought the house (shown in this 1936 photograph) and lived in it until 1817, when he moved to Washington, D.C., to become attorney general of the United States under James Monroe. The home was last owned privately by the Emma Palmer Caskie, who lived there until her death in 1941. The Hancock-Wirt-Caskie House is the city's only surviving double-bowed residence built during the Federal period; it was once part of a group of twenty-five double-bowed houses of that era in the capital. The "bow" had multiple windows that accomplished two objectives: more light to the interior, and an expansive view of the surrounding gardens, streets and, often, the James River. The house has a strong relationship to Point of Honor in Lynchburg, Virginia. Today, this National Register of Historic Places property is the headquarters of the Richmond Chapter of the American Red Cross. *Library of Congress.*

The Johnston-Willis Hospital, organized in 1909, was located on the corner of Franklin and Sixth Streets. In 1923, the hospital moved to the corner of Kensington and Colonial Avenues (shown here, on this postcard postmarked December 7, 1937), in the heart of Richmond's residential section, where it had spacious grounds and overlooked the gardens of the Battle Abbey. The building was designed by Richmond architect Marcellus E. Wright; it was renovated in 2000 to become the Kensington Court apartment building.

Above: The best laugh of the year was enjoyed by these delighted children as they watched a puppet show. The photograph is dated December 30, 1938.

Right: The original photograph shown here was a promotional shot taken by noted Hollywood glamour photographer John E. Reed. The picture is one of many noted and would be starlets who danced at the famed Florentine Gardens and Club Rhumboogie in Hollywood, California, and features advertising for the legendary Chesterfield Records, a well-known Wilshire Boulevard music shop, along with "Miss Virginia Richmond II" on the airplane held high above the dancer's head. The picture was taken between 1939 and 1944. The advertisement was included in national and state publications and was one of Reed's most popular photographs of the period.

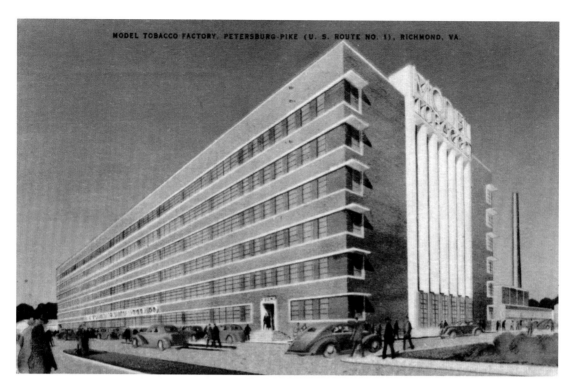

MODEL TOBACCO FACTORY, PETERSBURG-PIKE (U. S. ROUTE NO. 1), RICHMOND, VA.

Above: Richmond was the most important tobacco manufacturing center in the United States through most of the twentieth century. Located on Jefferson Davis Highway (U.S. Route 1), this Art Deco style tobacco plant on the southern approach to the city (formerly Petersburg Pike) was built between 1938 and 1940 and was the primary six-story building in a six-building complex, known best for the nine-foot tall Moderne MODEL TOBACCO letters which dominate the north end of the building (shown here, 1949). Robert Vale Faro, of the Chicago architectural firm of Schmidt, Garden and Erikson, designed this and other buildings in the complex for the United States Tobacco Company.

Left: The three ladies in this Acme Newspictures photograph brought their old pots and pans as contributions to a "sample" aluminum drive that opened in Richmond on May 30, 1941, and lasted until June 6. The drive was run simultaneously in Madison, Wisconsin, in an effort by the federal government's Office of Production Management to determine how much of the valuable "defense material" could be collected up in a nationwide drive.

The Rutherfoord-Hobson House at 2 West Franklin Street, pictured here just prior to demolition in 1941, was originally built between 1842 and 1843 by Alexander Hawksley Ruthersfoord, born in Richmond on August 30, 1807; the house was enlarged to include the mansard roof in 1872. Ruthersfoord, who drew his wealth from Ruthersfoord Mines Nos. 1, 2 and 3 in the vicinity of Amelia Courthouse, Virginia, and other business pursuits, had not lived in the home for many years at the time renovations were made; he died in Baltimore, Maryland, on July 6, 1886, and is buried in Richmond's Hollywood Cemetery. The house was razed to make way for a new YMCA. *Library of Congress.*

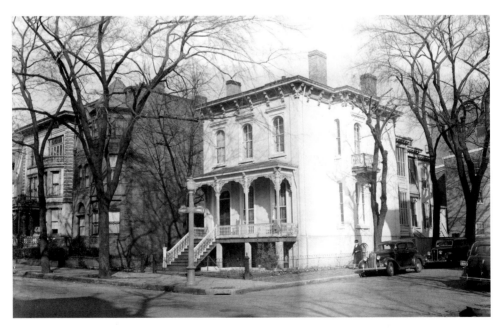

This Italianate residence at 400-402 West Franklin Street (shown here in a 1940 period photograph) was built in 1870 and demolished in 1974; the cross street is North Monroe. Though this property is now a parking lot, the cast-iron fence that belonged to the house remains in place. The home was located across the street from the Commonwealth Club at 401 West Franklin Street, the architecturally luxuriant club founded January 3, 1890, and designed by Carrère and Hastings of New York. *Library of Congress.*

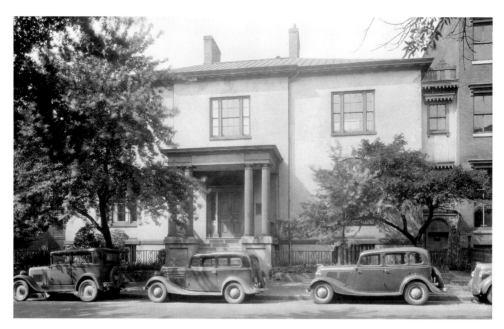

The Wickham-Valentine House at 1015 East Clay Street, is one of the finest domestic expressions of early Neo-classical architecture in America. The design of the mansion, which was built in 1812 for John Wickham, was executed by Alexander Parris, a New England architect who also planned the nearby Virginia Governor's Mansion. John Wickham was said by his contemporaries to be the most eminent Richmond lawyer of his time; he was lead counsel in the defense of Aaron Burr. Wickham was a man of great wit. There were so many distinctive homes being built in and around the Wickham home that the area became known as the "court-end" of town. Among them were the homes of Chief Justice of the Supreme Court John Marshall, Albert Gallatin, John Allan, Benjamin Watkins Leigh, Dr. John Brockenbrough, and many others. Of these homes, other than the Wickham-Valentine, the only survivors are those of Marshall, Leigh and Brockenbrough (the White House of the Confederacy). *Library of Congress.*

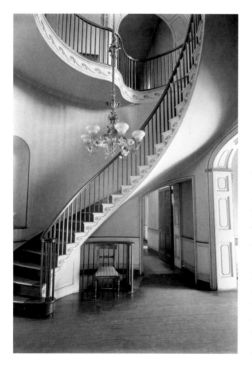

Among the Wickham-Valentine house's most notable features are the sophisticated plan and the elegant curved staircase with its delicate dogwood leaf and swag ornamentation. In 1854 the house was sold by the Wickhams, and subsequent owners completely redecorated the interior. In 1882, Mann S. Valentine purchased the house, and in 1892 left it, along with his collection of historical artifacts and an endowment, as the Valentine Museum. In the 1920s adjacent buildings were purchased for the growing museum collection, and the mansion was restored and furnished as a house museum. *Library of Congress.*

Since the Wickham-Valentine House was first built, successive owners have made changes to it. Between 1853 and 1858, it was completely redecorated in the grand manner of the Victorian era. Over its chaste simplicity was laid a fulsome veneer in keeping with French Second Empire and English Victorian styles of the day. The decoration of this period was most noticeable in the drawing room (shown here in a 1940 period photograph). Artificial paneling, decorated ceiling, gilt cornices and mirrors, brass gas chandelier, and an Italian marble mantel almost obliterate the cleanness of the home's original line and spacing. Later, there were other changes, chief among them being the introduction into the front hall of stairs that go down to the basement. *Library of Congress.*

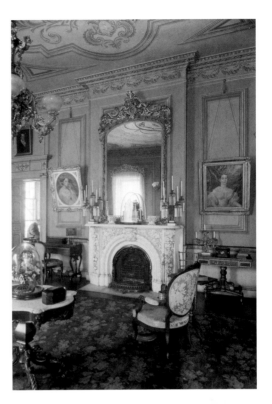

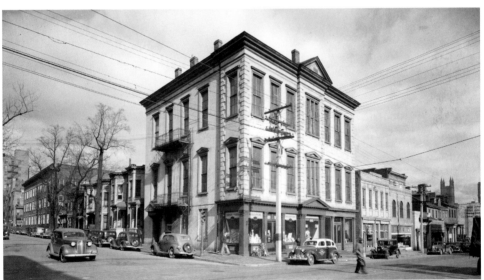

Construction of Saint Alban's Hall (shown in this 1940 period photograph) started two years after central Richmond burned at the end of the Civil War and marked the beginning of the city's revival. The hall consisted of shops, a concert hall, as well as Masonic meeting rooms, and served as an important focus of postwar Richmond's social and political life. The combination of commercial, cultural and Masonic facilities in one building provided the prototype for later Masonic buildings in the city. The architectural style of the hall shows the influence of the Renaissance Revival or Tuscan Palazzo mode widely used in the urbanizing North in the 1850s and 1860s, but rarely found in the South due to the war. The style is the forerunner of the more exuberant High Victorian Italianate that achieved popularity in the 1870s. The hall (also called the Crenshaw Building) at 300-302 East Main Street was completed in 1869 as a Masonic hall; the building remains an important historic structure in the Fifth and Main Downtown Historic District. *Library of Congress.*

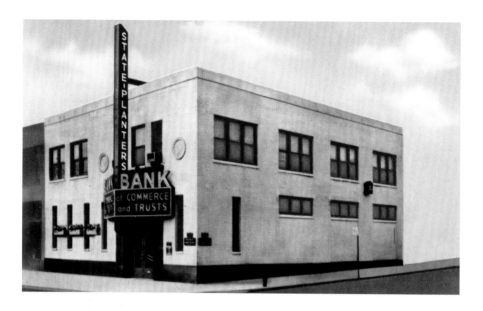

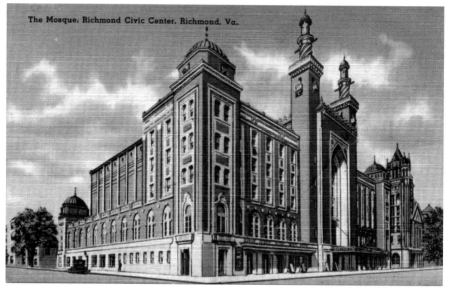

The Mosque, Richmond Civic Center, Richmond, Va.

Above: The groundbreaking for The Mosque, Richmond's most iconic entertainment center, took place on February 27, 1926, at the corner of Laurel and Main Streets, facing Monroe Park. The Moorish Revival building was designed by Marcellus Wright in association with Charles M. Robinson and Charles Custer Robinson in 1925 as an ACCA Temple, Ancient Arabic Order of the Nobles of the Mystic Shrine (AAONMS), a headquarters and convention center for the Shriners. Wright and the Robinsons designed a building that would be 176,000-square feet with a 4,600-seat theater, forty-two hotel rooms, a banquet hall for 2,000 people, a gymnasium, an 18 by 75-foot pool, a three-lane bowling alley, four billiard rooms, six lobbies, eighteen dressing rooms, a roof garden, a kitchen and restaurant, and offices. The building's exterior would incorporate Arabic aesthetics, just like other AAONMS buildings. Since Richmond did not have a big performing arts venue at that time, the Shriners offered performances starting on October 28, 1927. When the Shriners defaulted on the building note during the Great Depression, the city purchased the property in 1940 (the same time frame as the postcard). During World War II the Mosque was headquarters to an anti-aircraft command; it went back to an entertainment venue after the war. The theater was refurbished between 1994 and 1995, and the name changed to the Landmark after Richmond Muslims petitioned the city council. Today, it is the Altria Theater, named for the parent company of Philip Morris USA, the nation's largest cigarette maker, which graciously donated ten million dollars with naming rights in May 2012 to bring the Mosque-now-Altria back to its former glory.

Opposite above: The building at 1517 to 1521 West Broad Street at the corner of North Lombardy Street has been significantly altered so that today it would appear to be two buildings, one at 1517 and the other at 1519-1521. The original two-story brick structure on the site was built in 1910 at 1517 West Broad Street. In 1922, 1517 was torn down and five new two-story brick stores at 1517-1521 West Broad Street and 613-615 North Lombardy Street were constructed. The original building at 1517 West Broad Street was occupied by the Tom Jones Hardware Store. Early tenants of the 1922 structure included a restaurant at 1519, and the Dawson-Goodin Rubber Company and the Whitten Motor Supply at 1521. By 1930, Whitten was gone, replaced by a grocery store. In 1941, the city directory indicates that the space at 1521 West Broad Street was occupied by the State-Planters Bank and Trust Company (shown in this period postcard). The conversion to use as the bank precipitated remodeling of the building to the Art Deco style, popular at that time.

Right: Robert Browne Wallace (right), then twenty-three, son of vice president of the United States Henry Agard Wallace, was among 133 Washington, D.C., men who reported for military service at the Richmond, Virginia induction center on August 6, 1941. The man on the left is army corporal and Richmond native Frank Edward Moriconi, shown fingerprinting Wallace. Moriconi eventually retired from the army as a chief warrant officer first class.

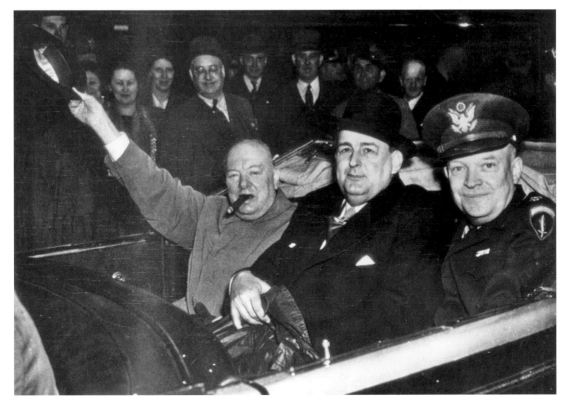

Previous page, below: British prime minister Winston Churchill was in Richmond on March 8, 1946 (shown in this Acme press photograph from that date). Rain failed to dampen the enthusiasm of thousands of Virginians as Churchill (left) visited the city accompanied by Virginia governor William M. Tuck (center) and General Dwight D. Eisenhower (right), United States Army chief of staff. Churchill delivered a speech to the Virginia General Assembly that day, in which he said (in reference to his forthcoming visit to the restored Williamsburg historic area): "This was the cradle of the Gt. [*sic*] Republic in which more than 150 years afterwards the strong champions of freedom were found to have been nursed."

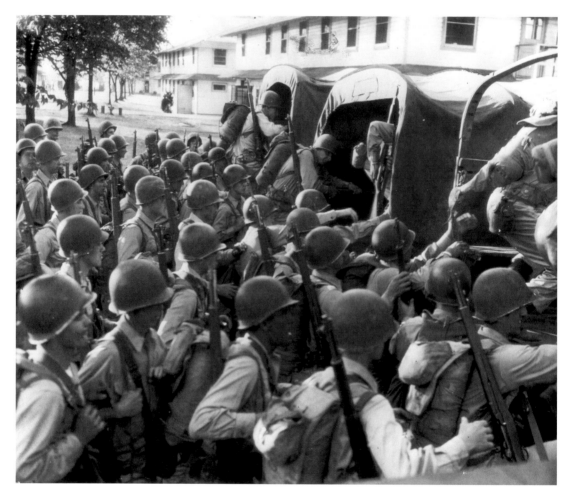

The United States Army's closest training base to Richmond during the war was Camp Lee (now Fort Lee), located in Prince George County, Virginia. In October 1940, the War Department ordered the construction of another Camp Lee on the site of the earlier installation. Built as rapidly as the first, construction was still ongoing when the Quartermaster Replacement Training Center (QMRTC) started operation in February 1941. Their number grew to 25,000 in 1942, and peaked at 35,000 in 1944. After the war, in 1946, the army made the decision to retain the camp as a quartermaster training center. Soldiers are shown here boarding trucks at Camp Lee on May 28, 1946.

Looking to the Future

As Richmond entered the second half of the twentieth century, the city's boosters would optimistically describe their city as progressive and prosperous. The 1950s saw many firsts, some new to the city, and extending to an uptick in urban renewal, the birth of the historic preservation movement in the city, and continued expansion of the city's strong industrial base, among them the introduction of natural gas to Richmond in 1950 to meet the growing energy demand, and, in 1952, cigarette production reached an all-time high for Richmond at 110 billion per year, a record that would be broken many times over in the decades to come. But outward signs of Richmond's prosperity in the 1950s masked an inner city decay that threatened the goals of a vibrant metropolitan expansion. Planners moved to execute the master plan's recommended public improvements, such as expansion of the central business district at the expense of downtown housing and older central city neighborhoods, and transportation improvements intended to improve downtown to suburban access, but all of it actually did more to destabilize the city of Richmond as a whole.[1] Urban renewal became the preferred mechanism to keep offices, retail, industry, and white Richmonders in the city center. "Reading the Bartholomew Plan through the lens of business progressivism and New Deal precedents," observed Marie Tyler-McGraw, "city officials reasoned that shabby neighborhoods had to be removed in order to renew the center city. Rehousing strategies were secondary to this concern. The city," she continued, "envisioned using its newly acquired power of eminent domain for slum clearance rather than revitalization of existing neighborhoods." Bartholomew's suggestion that Richmond widen streets was employed not just to relieve congestion and connect the urban core to the city suburbia, but to raze large swaths of working-class black and white residential areas. Major highway construction took the first of these neighborhoods. The Jackson Ward had already become the poster project of the city's targeting of a working-class black neighborhood when it cut an expressway through the ward and displaced ten percent of the city's black population. More of this approach was in store for other city neighborhoods as Richmond continued to use the bulldozer to clear land for new development.

Prior to the creation of the U.S. Interstate Highway System, the Virginia General Assembly, in 1955, created the Richmond-Petersburg Turnpike Authority as a state agency to administer the new turnpike of the same name. The new toll road was planned with only fifteen exits, and most of these were well away from the highly developed commercial areas along parallel U.S. 301. The new expressway opened on July 1, 1958, and in August, the State Highway Commission designated it as part of Interstate 95. A piece of the highway near

Petersburg was designated Interstate 85, and the turnpike became a grandfathered part of the U.S. Interstate Highway System even though no federal aid was used to build it. The new roadway achieved the intended diversion of long distance traffic. As earlier feared, hotels, motels, tourist homes and cabins, and restaurants along the bypassed highways suffered tremendous loss of business, and many failed. However, due to the relatively high rate of tolls on the turnpike, the blow was softened by a continually increasing traffic flow and patronage of motorists wanting to avoid the tolls, who continued to use the old roads. This practice of avoiding roads and bridges with tolls in and around Richmond was called "shunpiking." By 1959, not only had the turnpike been completed, but the Belvidere Street connection to Chamberlayne Avenue was finished, a comprehensive zoning ordinance had been adopted, and work on the civic center had started.

Earlier efforts to preserve the historic sites in and around Richmond had begun as early as the 1920s when historic neighborhoods, such as Church Hill, and other early buildings were in jeopardy of demolition. At that time, a group of Richmond activists led by Mary Wingfield Scott intervened to preserve them as the wonderful neighborhoods and places they are today. In 1935, the group formed the William Byrd Branch of the Association for the Preservation of Virginia Antiquities (APVA) to save the Adam Craig House. This organization would later spawn the Historic Richmond Foundation in 1956. Elizabeth Scott Bocock and Louise Catteral formed the foundation to work with state and city governments to create the city's local old and historic district ordinance, which protects certain neighborhoods from demolition and architectural change.[2]

In the early 1960s, the downtown expressway linked the city center to Richmond's southern and western suburbs, and also sliced through the working class neighborhoods of Oregon Hill, Randolph, and Byrd Park. Organized urban renewal efforts undertaken in the Fulton and Randolph neighborhoods, in particular, were intended to achieve slum clearance and blight elimination, but had the secondary effect, according to the history of the city's planning department, of exacerbating middle class "white flight" to the suburbs as displaced blacks were relocated to historically white neighborhoods. Urban renewal further came under fire in the summer of 1963 from historic preservationists, opposed to the urban renewal plan that would have razed the remainder of the Jackson Ward in the name of blight eradication.

Among the organized preservation groups fighting hardest to stem the tide of demolition was the Historic Richmond Foundation, which argued the historical and architectural significance of residential and commercial structures in the city's most threatened urban renewal tracks. Often, despite preservationists' best argument to save and restore the city's irreplaceable historic resources, a combination of urban renewal, annexation and new development under the cover of commercial revitalization continued the march of the wrecking ball; this was much the same result in old cities all over the United States from the 1920s to the 1970s. Between 1963 and 1965, there was a significant construction boon in the city's urban core that led to the erection of more than 700 buildings in the city. Three years later, in 1968, Virginia Commonwealth University was created by the merger of the Medical College of Virginia with the Richmond Professional Institute.

Though the 1946 master plan anticipated an increase in the city's population by 17,000 by 1960, Richmond experienced a marked decline in the decennial population between 1950 and 1960. According to government records, 30,000 primarily white, middle class residents moved out of the city. By the 1960s, fifteen years after adoption the Bartholomew plan, annexation proceedings were being considered in response to this population decline. After a lengthy court fight, 23 square miles of Chesterfield County were annexed in 1970, thus adding

47,000 largely white residents to the city's population. Changing demographics immediately following this annexation impacted the 1977 special city council election, which brought a black majority to power on council for the first time in the city's history, and the election of the city's first black mayor[3], Henry L. Marsh III, who had been active in the civil rights movement. Of course, by the time Marsh took over as mayor, white flight had taken its toll on the city's urban core. During the 1960s and 1970s, as blacks moved into the city center, whites moved out and this impacted the public school system, including busing, a program that did little to facilitate integration of core public schools, most of which, in a twenty-year period, had gone from 60 percent white in 1950 to 64 percent black in 1970, and just five years later, the black percentage had leapt to 78 percent. Individual schools, like Thomas Jefferson and John Marshall high schools, had been completely transformed by racial composition.

In the late 1960s and early 1970s, public policy broadened from strict application of urban renewal to resolve decay in the urban core to include a strong commitment to neighborhood conservation and revitalization. The establishment of the historic preservation ordinance, shepherded by the Historic Richmond Foundation, in 1957, allowed city planners and preservationists to create old and historic districts, further prompting private investment in rehabilitation of several of the city's most historic neighborhoods and making conservation of the same a new investment opportunity for developers. "Richmond is a city of neighborhoods," wrote McGraw, "but some of the neighborhoods fared better than others during the changes of the postwar decades." McGraw opined that neighborhoods of modest postwar brick houses, the more imposing residences of the West End, and the newest tracts and developments across the river in Chesterfield or further out in Henrico County prospered national branching and regional expansion of business located new employees to the Greater Richmond area. "The older city neighborhoods," she continued, "offered visual evidence of the variety of strategies used by the city in its efforts to vitalize the center." Privately funded restoration and renovation took place in the Fan District, one of the city's most architecturally diverse areas, with homes built between 1880 and 1920, and juxtaposed with Monument Avenue as its main thoroughfare. The same private initiatives that saved much of the Fan were also employed on Church Hill, which had the city's iconic, but divisive, Broad Street running through the middle. Restoration of Church Hill would continue from the 1950s to the 1980s, when the homes, many of them from the antebellum period, on the working class north side of Broad Street started getting the long overdue attention they deserved. As with nearly every historic district in the city, what started in Church Hill, as one example, is always a work in progress. But then, of course, there was what happened to Fulton at the beginning of the 1970s.

In the early 1970s, Richmond had started four separate urban development projects involving more than one thousand acres of densely populated streets and neighborhoods, at a projected cost of $100 million, according to McGraw, who wrote later that Fulton was a predominantly black working-class neighborhood built over the footprint of Richmond's earliest material history, and was the site of the city's "one neighborhood-wide urban renewal demolition." The section was commercially viable until the mid-twentieth century when the neighborhood housing stock began to fall into disrepair. Though almost half of Fulton's residents owned their homes, the Richmond Redevelopment and Housing Authority planned to raze the area to make way for an industrial park. Residents organized to fight the demolition of the neighborhood, and sought help from the Richmond Community Action Program, part of the federal antipoverty program, and developed a plan that encouraged spot clearance of dilapidated, beyond repair, homes, and the construction of new schools, parks and an improved traffic design.[4] Though Fulton residents believed they had protected

the neighborhood with a rehabilitation plan, the area was, as McGraw wrote, "consigned to demolition." There would be no rehabilitation and the property was seized by the redevelopment and housing authority. Nothing would be built there for another decade.

Historian McGraw pointedly wrote: "The year 1970 saw Richmond in the same social and political turmoil as the year 1870 had. Race and the control of space in the city were issues in both years. In the 1950s and the 1960s," she continued, "black Richmonders living in the neglected central city were displaced despite their protests, by highways and publicly financed projects like the Coliseum, finished in 1970. That same year," she reminded us, "a federal court order to integrate schools through busing drew angry resistance from white families." Richmond was sorely divided by redevelopment that had displaced a significant black population without an adequate alternative housing option.

Not to be forgotten, Richmond further suffered severe flooding on June 22, 1972, including significant damage to historically significant areas of the city, when Hurricane Agnes dumped 16 inches of rain on central Virginia, and drew the waters of the James River to 6.5 feet over the original 200-year old record, flooding Shockoe and Manchester. Hurricane Agnes happened three years after Hurricane Camille pushed the James River to a record peak crest of 28.6 feet but Agnes was worse, with a peak of 36.5 feet. Though Shockoe was particularly hard hit during Agnes, adoption of the Richmond Housing Action Plan that came about in 1976, an initiative that called for preservation of the city's existing housing inventory and which encouraged historic preservation, infused the area with private investment that transformed the section of Shockoe called "the Slip." Shockoe Slip warehouses were converted to upscale restaurants and retail shops. "The quaint Slip," wrote Virginius Dabney, "with its fountain for horses and its cobblestone paving, is one of Richmond's most historic spots, since it extends toward the canal and the river, and from it much tobacco and other produce was shipped in the seventeenth and eighteenth centuries." The action plan further led to conversion of the old city hall to an office building, the Main Street train station to a shopping arcade, and restoration of the Jefferson Hotel.[5]

In the third-quarter of the twentieth century, tobacco declined in Richmond, but the decline would not last. Philip Morris constructed a $200 million plant, even today, the largest cigarette factory in the world. Philip Morris was one of two Richmond corporations – the other was First and Merchants National Bank – that had become a prominent supporter of the city arts scene, as it continues to be today under the auspices of Altria. Tobacco may have experienced a slump but it came back stronger than ever at the close of the century. Richmond was in an extremely strong position overall regarding the number of companies that had located their headquarters in the city, making those businesses second only to Atlanta in sales volume, and ahead of those in Miami, Birmingham, Memphis and New Orleans, according to the July-August 1975 issue of *The South* magazine, a Tampa, Florida based publication. Of the 200 top corporations headquartered in ten southern states, twelve of them were in Richmond by the 1970s, including Reynolds Metals, Seaboard Coast Lines, Ethyl Corporation, Universal Leaf, A. H. Robins, Robertshaw Controls, Best Products, General Medical, Media General, Overnite Transportation, Thalhimers and Ward's.[6] Philip Morris was not on the list because the company's headquarters was still in New York at that time.

Richmond is a city of culture and refinement, largely defined by its educational institutions, libraries, art museums, performing arts organizations, and top-notch institutions of higher learning, to include extraordinary health care and scientific research facilities. Certainly, the concentration of colleges and universities in the Greater Richmond area drove the city's momentum before the end of the 1970s, among them Virginia Commonwealth University,

the University of Richmond, Virginia Union University, Union Theological Seminary[7] (now Union Presbyterian Seminary) and the Presbyterian School of Christian Education (today part of the Union Presbyterian Seminary), J. Sargent Reynolds and John Tyler community colleges, and located nearby, in Ashland, Virginia, Randolph-Macon College.

"Richmond in the mid-seventies [was] an intriguing blend of the old and new, of Charleston and Savannah, on the one hand, and Atlanta and Dallas on the other," observed Dabney of the former capital of the Confederacy, transformed in the twentieth century by the lockstep of planning and politics. Dabney saw a city starting to show its élan and drive in business and industry, though still clinging, sometimes tentatively, to its distinctive eighteenth- and nineteenth-century heritage. "The city's reputation for stodginess and stuffiness," he continued, "often exaggerated, is fading steadily. Will Rogers, the cowboy humorist, said half a century ago: 'The Prince of Wales was born in Richmond – Richmond, England, of course. He didn't have enough ancestors to be born in Richmond, Virginia.'" To many, this was amusing, good-natured banter that Dabney opined may have worked just then but no longer reflected the city that Richmond had become during the course of the twentieth century.

Endnotes

1 City of Richmond, master plan and other documents www.richmondgov.com/
 planninganddevelopmentreview/PlansAndDocuments.aspx
2 Historic Richmond Foundation http://historicrichmond.com/
3 Of note, in the election of 1969 from the city at large, attorney Lawrence Douglas
 Wilder was elected to one of Richmond's two state senator seats in the Virginia
 General Assembly. Wilder was the first black state senator in the twentieth century;
 he was later the first black politician to be elected governor of Virginia and first black
 governor of any state since Reconstruction. Wilder served as the sixty-sixth governor
 of Virginia from 1990 to 1994. When earlier elected as lieutenant governor, he was
 the first black elected to statewide office in Virginia. More recently, Wilder was mayor
 of Richmond from 2005 to 2009.
4 McGraw, Marie Tyler. *At the Falls: Richmond, Virginia, and Its People.* Chapel Hill:
 University of North Carolina Press, 1994.
5 Silver, Christopher. *Twentieth Century Richmond: Planning, Politics, and Race.*
 Knoxville: University of Tennessee Press, 1984; McGraw, Ibid.
6 Dabney, Virginius. *Richmond: The Story of a City.* New York: Doubleday, 1976.
7 As a result of efforts undertaken together by the Synod of Virginia and the Synod of
 North Carolina, Union Theological Seminary was founded in 1812 as the theological
 department of Hampden–Sydney College, located near Farmville, Virginia, and
 housed in Venable Hall. In 1898, the school was relocated to its current campus
 location on the north side of Richmond. The general assembly's training School (ATS)
 for lay workers was founded in Richmond in 1914 as a complementary institution
 intended to train "workers outside of the regular ordained ministry." In 1959 ATS
 was renamed the Presbyterian School of Christian Education (PSCE). PSCE offered
 a master's degree in Christian education, and operated across the street from Union
 Seminary until 1997, when Union and PSCE were joined in federation, becoming
 Union-PSCE. In 2009, Union's board of trustees voted to change the name of the
 institution to Union Presbyterian Seminary, partially as a means of distinguishing it
 from Union Theological Seminary in the city of New York.

The terminal building (shown here) at Richard E. Byrd Airport, designed by Marcellus Wright & Son, architects, of Richmond, was completed in 1950.

The Harmonizing Four (plus the guitarist) was an American black gospel quartet organized in 1927 to sing for school functions at Richmond's Dunbar Elementary School; the quartet reached peak popularity during the decades immediately following World War II (shown here from the cover of their 1950-1955 album). According to Robert Sacré, the group recorded for Decca Records in 1943 and toured in the postwar years, performing at such high-profile events as the 1944 National Baptist Convention, to an audience of 40,000, and for the funeral ceremony of President Franklin Delano Roosevelt in 1945. During this period the group recorded for different labels, including Chicago company Religious Recording, Coleman, and MGM. In the early 1950s, the quartet had signed with Philadelphia's Gotham Records, where they recorded some forty songs before moving on in 1957 to Chicago's Vee-Jay Records, where Sacré observed they experienced their greatest popularity. At the time this picture was taken, the quartet included Joseph "Gospel Joe" Williams, Lonnie Smith, Thomas "Goat" Johnson, and Jimmy Jones.

Right: The Southern Bank and Trust Company's building at Grace and Second Streets was new when this picture was taken for this 1950 era postcard.

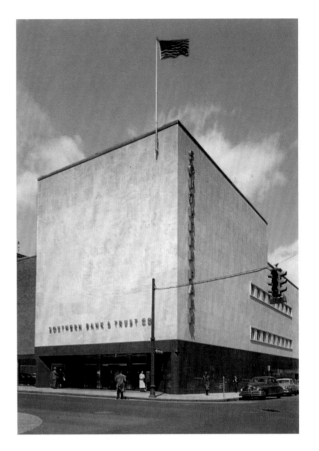

Below: The poster in the window of Pinnell's storefront at 701-703 West Broad Street touted upcoming national championship motorcycle races at the Atlantic Rural Exposition Fairgrounds (formerly the Strawberry Hill Speedway) track on May 27-28, 1950. The riders posed in front of Pinnell's, Virginia's first Harley-Davidson dealership (the store sold boats, motorcycles and lawn mowers at the time), were among some 4,500 motorcycle enthusiasts gathered to attend the event. Store owner Charles Wellford Pinnell was a nationally known motorcycle race promoter. Race fans parked their rides in front of Pinnell's on race day and rode to the track together en masse. The speedway began hosting motorcycle rallies and races in 1946 on a half-mile dirt track, a far cry from the modern paved facility that is now called Richmond International Raceway.

Upper: Broad Street Methodist Church is located at Tenth and Broad Streets in the downtown section of the city. The church was built in 1859 as Broad Street Methodist Episcopal Church. Note that there is no steeple on the church. Henry P. Beck, Richmond's first building inspector, from 1907 to 1912, determined that while most of the city's church spires had withstood the ravages of weather and worms for years, too many were rotting and likely to fall in a heavy storm. Beck declared the big steeple on Broad Street Methodist Church "a menace to the public life and limb," observing that the tall wooden structure "is unsound and unsafe from its base to its apex, 180 feet skyward." According to an October 27, 1911 *Richmond Times-Dispatch* article, he ordered that there would be no further services at the church nor at First Presbyterian and the Seventh Street Christian Church until their spires, which he had recently condemned, were either removed or reinforced. The city bought the church property (shown on this 1950 era postcard) in 1961 and the congregation relocated to what is today River Road United Methodist Church.

Lower: The General Assembly of Virginia first authorized what would become the Virginia War Memorial in 1950 and Governor John S. Battle made the initial appropriation toward getting the project underway. Architect S. J. Collins of Staunton was chosen to design the memorial (shown here in a period photograph). Before the memorial planning was finished, the United States was engaged in the Korean Conflict. After the 1953 ceasefire, plans were made to include the service and sacrifice of those who had served in Korea as well as World War II. Construction was completed in 1955, and the memorial dedicated on February 29, 1956. Today, the memorial, located at 621 South Belvidere Street, now honors all veterans and particularly those nearly 12,000 Virginians killed in World War II, Korea, Vietnam, the Persian Gulf, and the Global War on Terror. The memorial features the inspiring Shrine of Memory, with the names of Virginia veterans who made the ultimate sacrifice engraved on its stone and glass walls; the majestic statue Memory (shown here); the E. Bruce Heilman Amphitheater, and the Paul and Phyllis Galanti Educational Center.

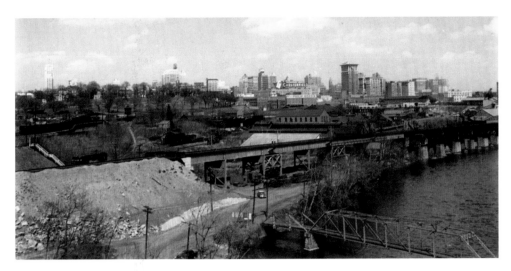

This is a period view of the Richmond skyline from the Robert E. Lee Memorial Bridge, which today carries U.S. Route 1 and U.S. Route 301 across the James River at the fall line. The city acquired the original bridge, then named James River Bridge, from Richmond Bridge Corporation in 1933; this name was changed to Lee. The bridge was initially constructed as a four lane toll facility when it opened to traffic in 1934. In the 1980s, a replacement structure was built including a substantial realignment of the approach roadways at the south end. Work was completed in 1989. Today, it is toll-free and includes three lanes in either direction. An on-ramp and an off-ramp for South Second Street connect to the bridge over the north shore of the James River. The Virginia War Memorial is located adjacent to its northern end.

When this United Press photograph was taken on October 25, 1956, of Thomas Coleman Andrews Jr. and his grandchildren, Thomas Coleman Andrews III, age two, and Deborah Andrews, age five, in Andrews' Richmond home, it ran with the line that he was probably "the happiest candidate in the upcoming presidential election." Andrews ran as a candidate of the Conservative States and other minor parties with no expectation of winning presidential office, "...but his platform is great," read the caption on the original picture. Andrews believed that federal income taxes should be abolished. Once the commissioner of Internal Revenue, he began denouncing the nation's tax laws after stepping down from his post in 1955. While Andrews was on the ballot in only fourteen states, he observed the election would prove his point that the two major parties were erring in ignoring the large body of conservative voters around the nation who also decried the nation's tax code.

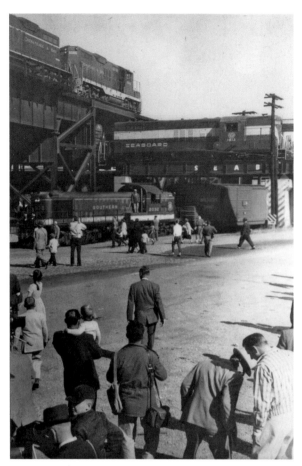

Left: Trains lined up three-deep on Richmond's triple railroad crossing on October 12, 1958. The lineup, only the fourth in history, was arranged for a meeting of the National Railway Historical Society members.

Below: The Miller & Rhoads department store at Grace, Fifth and Sixth Streets was announced on October 24, 1921, and opened on March 24, 1924. The New York architectural firm Starrett and Van Vleck designed the original five-story building (three floors were subsequently added, including seven and eight in 1948). The opening of Miller & Rhoads ended Grace Street's residential character and permanently transformed the street into Richmond's Fifth Avenue. The store (shown in this period promotional card) closed in 1990.

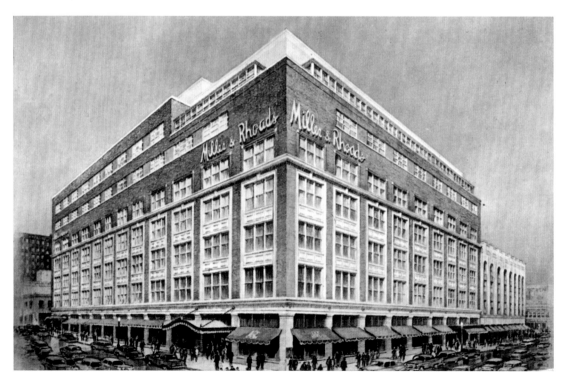

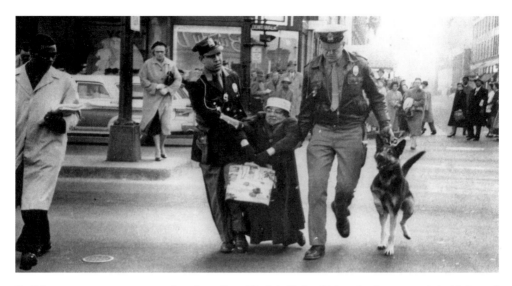

On February 22, 1960, a group of students from Virginia Union University, later named the Richmond 34, staged a protest against racial segregation at Thalhimer's Richmond Room. Some 34 were arrested as part of the city's first mass arrests of the Civil Rights Movement. The case of *Raymond B. Randolph Jr. v. Commonwealth of Virginia* (202 Va. 661, 665 (1961)) would test whether trespassing laws constituted a violation of free speech. Two policemen and a police K-9 dog removed a black woman identified as Ruth E. Tinsley, then fifty-eight, of Richmond, from the protest at Thalhimer's after she refused to leave.

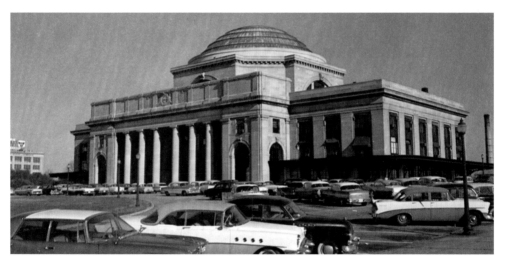

Richmond's Union Station (also called the Broad Street Station) was photographed by T. L. Rowe for this 1960 period postcard. The Richmond, Fredericksburg and Potomac Railroad and the Richmond and Petersburg (the Atlantic Coast Line) Railroad awarded the design of this station to New York architect John Russell Pope, to be built on the site of the city's fairgrounds. The station's innovative rail yard and track system was designed by Harry Frazier. A groundbreaking was held on January 6, 1917, but due to America's entry into World War I and the short supply of materials and skilled workers to complete the work, the station did not open for business until January 6, 1919. The station also served the Norfolk and Western Railway and, eventually, the Seaboard Air Line Railway, which had formerly used Richmond's "other" Union Station (the Main Street Station), switched to the Broad Street Station. Amtrak took over passenger service in 1971; the station was served by Amtrak's *Carolina Special, Champion, Silver Meteor,* and *Silver Star.* The station was added to the National Register of Historic Places on February 23, 1972, and Amtrak passenger service ceased on November 15, 1975. Governor Mills Godwin presided over the opening of the Science Museum of Virginia in the substantially remodeled and expanded former Broad Street Station on January 6, 1977.

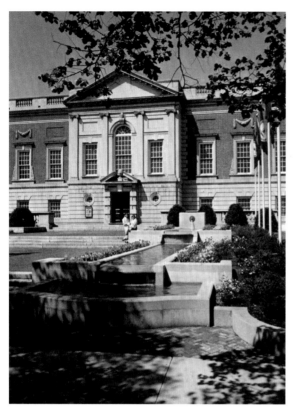

The Virginia Museum of Fine Arts has its origins in a 1919 donation of fifty paintings to the Commonwealth of Virginia by judge and prominent Virginian John Barton Payne. Payne, in collaboration with Virginia governor John Garland Pollard and the Federal Works Projects Administration, secured federal funding to augment state funding for the museum in 1932. Eventually, a site was chosen on Richmond's Boulevard. The site was toward the corner of a contiguous six-block tract of land which was then being used as an American Civil War veterans home, with additional services for their wives and daughters. The main building was designed by the architectural firm of Peebles and Ferguson of Norfolk, in what has been described as both Georgian Revival and English Renaissance, the architects taking cues from Inigo Jones and Christopher Wren. Construction began in 1934. Two wings were originally planned, but only the central part was constructed; the museum (shown here in 1960) opened on January 16, 1936, as the first state art museum in the nation.

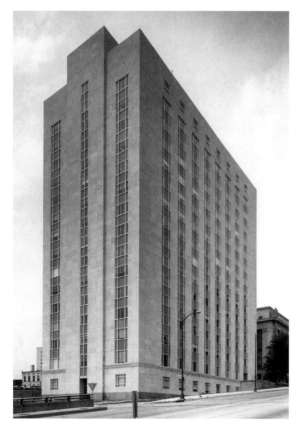

The Virginia Department of Transportation (VDOT) Annex, located at 1401 East Broad Street, was completed in 1961 (shown here) and stands seventeen floors above ground. The annex was built on an end of Broad Street where the Medical College of Virginia campus and other hospitals have flourished since the early nineteenth century, and where state government buildings, especially buildings of the VDOT, have stood since the middle of the twentieth century.

The modern 600-bed, eighteen-story Medical College of Virginia Hospital (shown here) was completed by 1941, located adjacent to the landmark Egyptian Building. Today, this building, renamed MCV West Hospital, is at the heart of the much larger VCU Medical Center, Virginia Commonwealth University's medical campus located in downtown Richmond's Court End neighborhood. The VCU Medical Center used to be known as the Medical College of Virginia, which merged with the Richmond Professional Institute in 1968 to create Virginia Commonwealth University. In the 1990s, an authority controlling MCV Hospitals was created called the Medical College of Virginia Hospitals Authority. In 2004, the name of this authority was changed to VCU Health System and the MCV Hospitals and surrounding campus were branded VCU Medical Center. At present, the VCU Medical Center is composed of the hospitals and five schools and is located on the MCV campus, adjacent to the Virginia BioTechnology Research Park.

Eleanor Parker Sheppard, the city of Richmond's first woman mayor, was trying out a gold-framed mirror to straighten her hat when this picture was taken on July 5, 1962, just days after her election. Democrat Sheppard served as the city's mayor until June 30, 1964. Sheppard was a woman of "firsts." She became Richmond's first female city council member in 1954, and was later a member of the Virginia House of Delegates from 1968 to 1977 and while in the House, it was Sheppard who sponsored the bill that created Virginia Commonwealth University. The Richmond newspapers, unaccustomed to women in political office, did not know how to cover Sheppard and it shows in this photograph; no one, however, who knew her, would take her entering a political campaign lightly; Sheppard never lost an election.

Left: The Virginia Fire and Marine Building at 1015 East Main Street was designed by George H. Johnson and completed in 1869; it is an exceptional example of a post-Civil War iron-fronted Richmond commercial building. The cast-iron front was manufactured by Hayward Bartlett and Company of Baltimore. Edward F. Heite took this picture for a historic survey conducted between July 1967 and October 1969 of the city's iron front buildings. *Library of Congress.*

Below: The Columbian block at 1301-1307 East Cary Street (on the southeast corner of East Cary and Shockoe Slip) was photographed by Edward F. Heite between July 1967 and October 1969. Built about 1870 on the site of the well-known Columbian Hotel, it served Richmond for some years as a commodity exchange and is a distinctive late nineteenth century building in downtown Richmond. Fully restored, with its stucco façade and cobblestone piazza to the west, it is the picturesque center of the commercial area of lower East Cary Street and remains one of the major contributing structures to the revival of what is today a colorful, vibrant part of the city. *Library of Congress.*

Right: Franklin Stearns bought the property at 1007-1013 East Main Street in 1865, and the following year broke ground on the four-story iron front building shown here in this July 1967 to October 1969 period photograph by Edward F. Heite. Together the Donnan-Asher and Stearns buildings are called "the Iron Fronts." Richmond's iron fronts were not only a technological achievement in their day, but remain important surviving examples of the city's commercial architecture from the late nineteenth century. Completed in 1869, the Stearns occupies more than half a city block and a historically significant place in the Main Street Banking Historic District, once known as "Richmond's Wall Street" for the number of banking institutions on the street. *Library of Congress.*

Below: Liggett and Myers had a cigarette production plant at Sixth and East Cary Streets, shown on this 1963 advertising card, dated by two of the cigarette lines promoted: L&M filter cigarettes introduced in 1953, and Lark charcoal filter cigarettes, introduced in 1963.

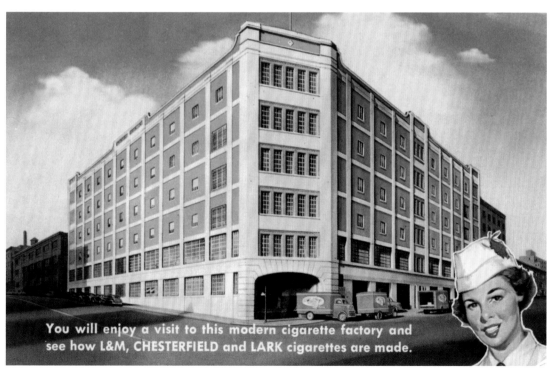

You will enjoy a visit to this modern cigarette factory and see how L&M, CHESTERFIELD and LARK cigarettes are made.

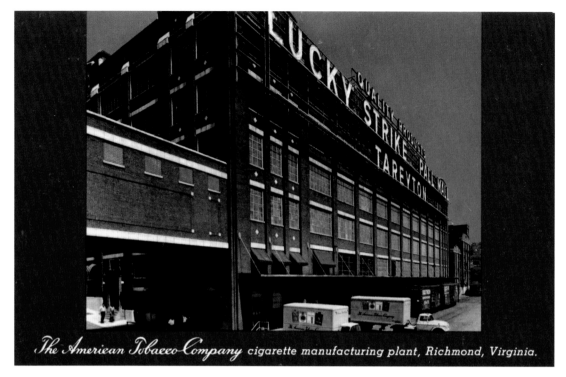

The American Tobacco Company cigarette manufacturing plant, Richmond, Virginia.

The American Tobacco Company cigarette manufacturing plant in Richmond was producing millions of precision-made cigarettes, including Lucky Strike, Pall Mall, and other famous brands when this advertising card was printed in 1967.

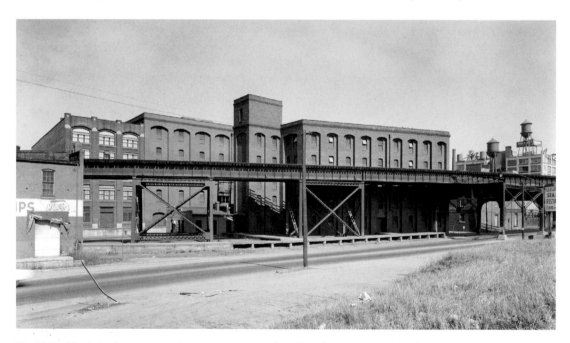

The Philip Morris leaf storage warehouse at 1717-1721 East Cary Street, acquired by the company in 1962, is located in the busy commercial district of Shockoe Valley. Built as a warehouse in the early twentieth century, this building stands as an excellent example of the sparingly ornamented yet functionally designed commercial structure of the turn-of-the-century that served as both the forerunner and inspiration for the International Style. An elevated railroad and a highway pass very close to the building, shown in this photograph, taken by Edward F. Heite between July 1967 and October 1969. *Library of Congress.*

From the late eighteenth century until the 1880s, an important and far-flung canal system gradually emerged on the Richmond scene. Envisioned by George Washington and others, the James River and Kanawha Canal system eventually included over 200 miles of canal as well as a steamboat route on the Kanawha River and a turnpike over the Alleghany Mountains. During the nineteenth century, it was to play an important role in the economic and social life of Virginia. In Richmond, the agricultural produce of the James River Valley was brought and unloaded for market or transported to the docks for shipment along the East Coast or abroad. The canals also carried manufactured goods from Richmond for distribution throughout the state and transported passengers to their homes or to the West. Edward F. Heite took this picture of Haxall Mills (a beneficiary of the locks system no longer standing) from Thirteenth Street, south of the canal on April 20, 1968; this portion of the system is called the Haxall Canal. *Library of Congress.*

The Twelfth Street basin looking southeast at the James River and Kanawha Canal, Locks 1-5, Tenth to Thirteenth Streets, north of Canal Street, was photographed by Edward F. Heite on March 23, 1968. The buildings here belonged to Reynolds Aluminum's North Plant, where Reynolds Wrap was made. Built from the late 1800s to the early 1900s, the buildings, including those shown here, were strategically sited on the Haxall Canal between South Tenth and Twelfth Streets and used to package aluminum foil. Reynolds Consumer Products continued to operate from these buildings until mid-2009, when they were sold for development into a mix of apartments, commercial and retail space.

This is the view from the James River and Kanawha Canal, Locks 1-5, Tenth to Thirteenth Streets, north of Canal Street, photographed by Edward F. Heite on April 20, 1968. Of note, with the stone locks being essentially completed by 1854, the Tidewater Connection was at its peak. The James River and Kanawha Canal finally had a reliable water route to the lower James; however, with the development of the railroad system, the canal began to shrink in popularity due to steep rail competition. In 1880 the canal system was sold to the Alleghany Railroad Company, precursor of the Chesapeake & Ohio Railroad (the C & O), and tracks were laid on the towpath, thus blocking canal boat traffic. With the disappearance of canal traffic, an important and colorful means of transport vanished from the Virginia scene. *Library of Congress.*

Edward F. Heite took this picture of dedication placard on the wall of the James River and Kanawha Canal Locks 1-5 (the Tidewater Connection) between Tenth and Thirteenth Streets, north of Byrd Street, on April 20, 1968. The canals represented more of an engineering feat with great historical value than an architecturally viable structure. The care taken by the stonemason in chiseling the rough finish of the stone blocks (seen here) of the walls and the precise fit of the fine ashlar stonework do justify the canal company's reference to the locks as "works of art." The effect of the canals as open space on Richmond's downtown area was evident into the second half of the twentieth century as the old turning basin between Eleventh and Twelfth Streets was retained as a parking lot and the Great Basin served as a Chesapeake and Ohio rail yard. These reminders fast disappeared largely, in the first phase, to the Richmond Metropolitan Authority's expressway that removed the upper three of the five original Tidewater Connection locks. *Library of Congress.*

Tobacco baron Lewis Ginter planned the development of the Jefferson Hotel as a premier property in the city of Richmond; it was designed in the Beaux-Arts style by Carrère and Hastings, noted national architects based in New York, who later designed the New York Public Library. Construction began in 1892 and the hotel opened for business on October 31, 1895. After a fire gutted the interior of the hotel in 1901, it had a lengthy restoration and a Main Street section designed by Norfolk architect John Kevan Peebles when it reopened in 1907. The hotel is shown in this Edward F. Heite photograph taken as part of a historic survey between July 1967 and October 1969. In its early history, the hotel was "the only" place to stay for any important person visiting Richmond. Notable guests included Benjamin Harrison, William McKinley, Theodore Roosevelt, William Howard Taft, Woodrow Wilson, General John J. Pershing, Calvin Coolidge, Franklin D. Roosevelt, Charles A. Lindbergh, and F. Scott Fitzgerald. *Library of Congress.*

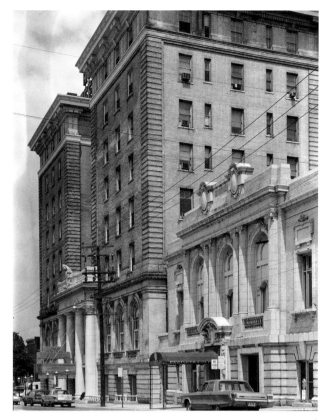

The Rotunda, the main lobby and grand staircase on the south or lower half of the Jefferson Hotel, was radically altered in style by John Kevan Peebles after the 1901 fire. Originally, a large skylight supported by slender iron columns illuminated the Rotunda, providing a contrast to the broad arcade directly behind the ironwork. Peebles retained the mezzanine format around the large open space but handled it differently by using massive columns papered to imitate marble; it made the skylight (now blocked) smaller. The picture was taken by Edward F. Heite between July 1967 and October 1969. *Library of Congress.*

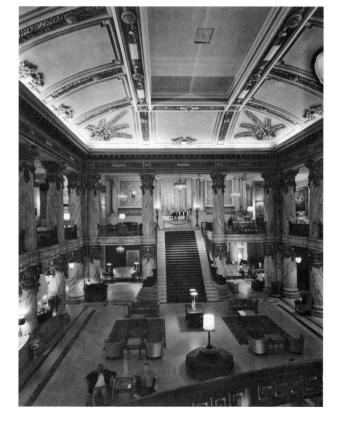

Jack Boucher took this picture in 1971, looking west, standing in the right-of-way of the former Richmond and York River Railroad (later the West Point Branch of the Southern); the Chesapeake and Ohio Bridge, which opened June 24, 1901, passes overhead, and off in the distance is the Seaboard Airline Railroad Bridge. This is Richmond's famous triple railroad crossing located south of Main Street at East Byrd, Sixteenth and Dock Streets along the canal walk. *Library of Congress*.

Richmond's famous triple railroad crossing was photographed (also by Jack Boucher in 1971) looking east, showing the intersection of the three railroads at three levels. At ground level is the former Richmond & York River Railroad (later the West Point branch of the Southern); the viaduct structure at the upper left corner of the photograph was completed by the Chesapeake and Ohio Railroad in 1901; it passes over the Seaboard Airline Bridge. *Library of Congress.*

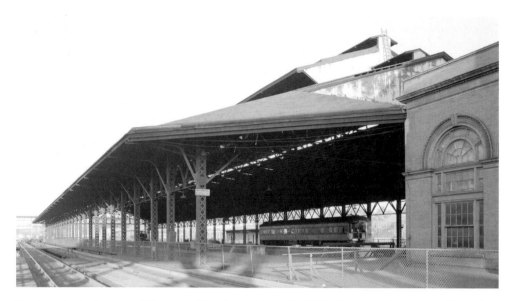

The train shed adjacent to Richmond's Main Street (also called Union) Station, photographed by Jack E. Boucher in April 1971, was one of the last gable type sheds to be built in America. Extending from the north side of the station, the train shed measures 123 x 517 feet; its gable roof is supported by a series of riveted steel trusses resting on riveted steel columns 18 feet on centers. Each truss is a modified Warren type with a 123-foot span; they are approximately 24 feet above the level of the platform and have a maximum depth of 14 feet at the peak. A central monitor running the length of the shed is supported by smaller Warren trusses on top of the principal ones. A second monitor, much smaller than the first, runs the length of the former. The shed covers six sets of stub end tracks and overhangs of 13 feet 6 inches on each side. The station's train shed is an early example of riveted steel in roof construction. This form of rigid roof construction marked the end of the "American System" of pin connected construction in roof trusses and has become the standard in modern trussed structures of all types. *Library of Congress.*

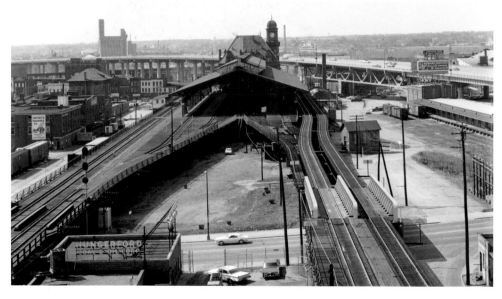

The Main Street Station is located on the north side of lower Main Street in Shockoe Valley. Railroad tracks extend on either side of the building across bridges over Main Street. On the west side of the building is an elevated interstate highway that passes within seventy-five feet of the building at the level of the clock tower. Jack E. Boucher took the picture in April 1971. *Library of Congress.*

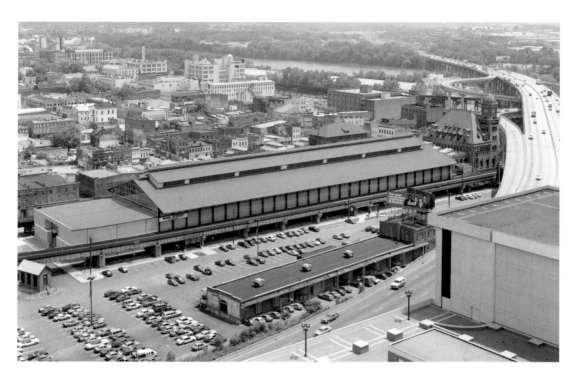

This photograph of the Main Street Station and train shed at 1520 East Main Street, taken by Jack E. Boucher in April 1971, also shows the modern interstate system that closely edges around the building and train yard. From the time it was built, the station marked the crossroads for the major north-south railroad, the Seaboard Airline Railroad, and the big east-west line, the Chesapeake and Ohio. *Library of Congress.*

This view looking west along the north elevations of 1109-1113 East Main Street, three structures with cast iron façades at the first floor level, were being demolished when this picture was taken in 1971. The entrance to 1113 is in the foreground, the first and second stories of 1111 in the middle, and cast iron elements from 1109 are on the sidewalk. These buildings were once part of several blocks of similar iron front buildings. Built from 1866 and later, 1109 was the first to go and was in an advanced state of demolition when this picture was taken. *Library of Congress.*

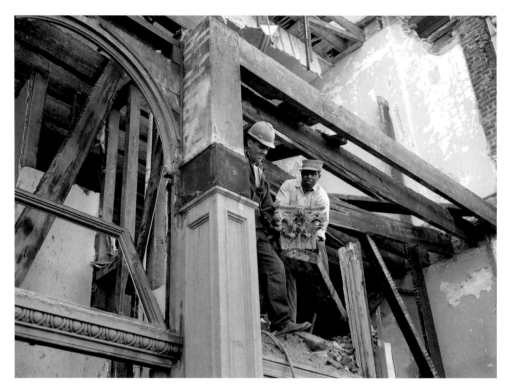

Workers are shown removing a cast iron capital from 1109 East Main Street in 1971. The cast iron from all three buildings was salvaged. *Library of Congress.*

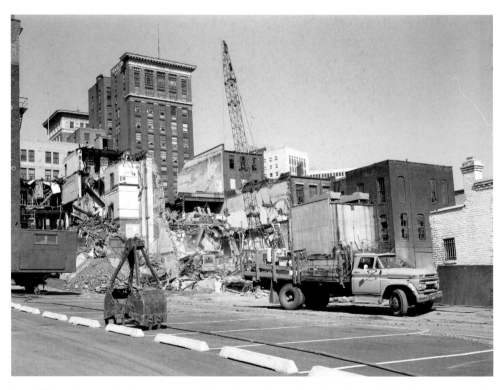

Demolition and removal of 1109-1113 East Main Street, shown here from the south (rear) elevations of the buildings, continued in 1971. *Library of Congress.*

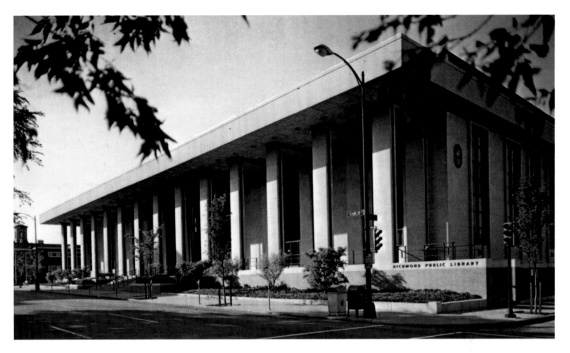

The main branch of the Richmond Public Library was expanded and renovated in 1972 on the site where Edgar Allan Poe and James Branch Cabell once lived.

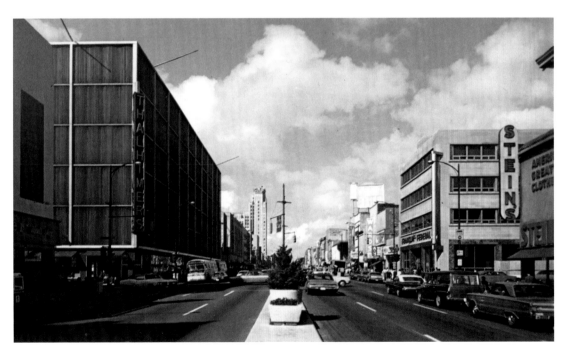

Broad Street in 1974 had transformed from buggy and streetcar to bus and automobile. The massive six-story flagship Thalhimer's department store between Sixth and Seventh Streets fronting Broad Street (left) had an addition made in 1939, and in 1955, the exterior of the store was covered with an aluminum curtain to give it a "modern" look. The store's famous restaurant, the Richmond Room, was the site of the Richmond 34 sit-in on February 22, 1960, the first big protest of the Civil Rights Movement in the city. The downtown flagship closed on January 22, 1992, after purchase by the May Company; it was the last major department store in the once-bustling Broad Street retail corridor of which Thalhimer's had been a part since 1842.

The Philip Morris Manufacturing Center off Interstate 95 on Commerce Road in South Richmond opened as the cigarette manufacturing plant in 1973, producing 200 million cigarettes per day. Today, this two-million-square foot plant produces 600 million cigarettes per day and is the company's only manufacturing facility.

These Clay Street houses (in the first block) are located in the city's Jackson Ward Historic District, bounded by Marshall, Fifth, and Gilmer Streets. The photograph was taken in 1979 by Walter Smalling Jr. *Library of Congress.*

Homes on the first block of Leigh Street, located in the Jackson Ward Historic Disvtrict, are shown in this Walter Smalling Jr. photograph, also taken in 1979. *Library of Congress.*

The Belgian Building, at Lombardy Street and Brook Road, was originally built as part of the Belgian exposition center for the 1939 New York World's Fair, then reconstructed in 1941 on the campus of Virginia Union University in Richmond. The building's architects, Victor Bourgeois and Leo Stijnen, worked under the direction of Professor Henry van der Velde, one of the most important architects of the twentieth century and a pioneer of the Modernist movement. The Belgian government planned to reassemble the building as a university library back in Belgium once the fair was over. Instead, because of the risk of shipping it in the midst of World War II while Belgium was under Nazi occupation, the Belgian government donated the building to Virginia Union University, a prominent African American institution. The original architects directed its reconstruction at Virginia Union University, where it was dubbed the Belgian Friendship Building. Walter Smalling Jr. photographed the building in April 1979. *Library of Congress.*

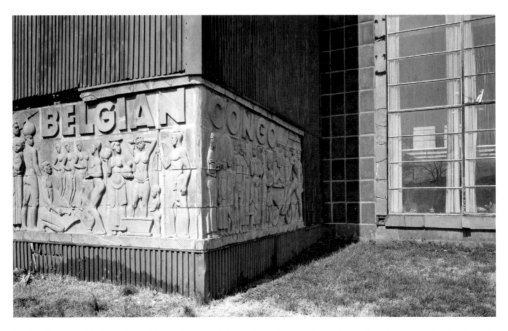

Walter Smalling Jr. took this picture of the sculpture at the base of the Belgian Building tower in April 1979. *Library of Congress.*

THE END OF THE CENTURY

In the first two decades of the twentieth century, we are reminded that Richmond was the "bastion of New South zeal" with what some historians would later dub an "illusory dream" of eclipsing Atlanta. By 1984, little had changed as boosterism continued to drive city leadership's development and investment strategy. "Richmond," the city manager told readers of Delta Air Line's August 1984 *Sky* in-flight magazine, "is experiencing a boom that will surpass that of Atlanta [...] This is a city in its prime and every facet of its character is blossoming."[1] Certainly, if there is a "theme" to attach to Richmond in the twentieth century, it is what observers called an "ebb and flow of optimism" that masked the intimate relationship between planning and politics, that for much of the century, including the end, avoided issues that might challenge the political consensus. Christopher Silver, a former Richmond housing administrator and urban studies professor at Virginia Commonwealth University and dean, University of Florida College of Design, Construction and Planning, Department of Urban and Regional Planning, concluded that "the failure of planning in Richmond to guarantee either sustained city growth or significant social reform stemmed, at least in part, from the planners' reluctance to chart a course apart from the local political mainstream." The dynamic observed by Silver had also happened in many other cities across the United States.

Though Richmond kept one foot firmly in the city's storied past, it moved forward in ways that those who led it at the beginning of the twentieth century perhaps tried to preclude altogether. The city adopted a new master plan in 1983, and the following year, a plan for downtown was adopted and over the decade to follow many of the city's development projects envisioned in this document were started and completed, including construction of the Diamond ballpark, and with this facility the Richmond Braves, a triple-A baseball team for the Atlanta Braves, began playing.

In an effort to ensure that the city's public and private development goals were on the same page, in 1981 Mayor Henry L. Marsh III and attorney T. Justin Moore Jr. organized Richmond Renaissance, the biracial public-private partnership established to develop downtown and foster racial harmony. In September 1985, Richmond saw the opening of Sixth Street Marketplace[2], a downtown festival marketplace and major convention center called Jackson Place, which was envisioned as a solution to the devolution of the urban core in the heart of the old downtown Jackson Ward.

Richmond Renaissance hired pioneering real estate developer, urban planner, civic activist, and later, free enterprise-based philanthropist James W. Rouse to draw plans for the new marketplace center, which when opened, extended from the old Richmond Blues armory

on the north side of Broad Street to the city's major department stores – the established Thalhimers and Miller and Rhoads – on the south side of the street. There was an enclosed pedestrian bridge built over Broad Street that, noted Marie Tyler-McGraw, "was intended to literally and symbolically bridge the divide between the white and black communities and to create a downtown retail hub." Rouse had started in the mid-seventies and continued well into the eighties to shift his professional focus to making some of America's most uninviting urban cities inviting, once again, to the public. The end result was what he called the festival marketplace, of which the Sixth Street complex was one, of many, he would development in some of the nation's most depressed waterfronts. Boston's Faneuil Hall Marketplace was his first and most successful example of this bold initiative. Finished in 1976, Faneuil Hall Marketplace, which also dovetailed Quincy Market with spaces adjacent to Faneuil Hall, was designed by architect Benjamin C. Thompson and was a financial success, an act of historic preservation, and an anchor for urban revitalization; however, it was considered by Rouse's critics to be a risky investment doomed to fail. Where Faneuil Hall Marketplace succeeded, the Richmond's Sixth Street Marketplace[3] and Norfolk's Waterside Festival Marketplace, both bold and welcomed at the time of their completion, had their respective boom years, then failed.

While downtown Richmond's retail scene worked to reinvent itself, to pull in shoppers from outlying suburban development, the financial and government sectors thrived. In a 1987 full-page *Wall Street Journal* advertisement, the large headline read: "What are 14 Fortune 500 Headquarters Doing in Quiet, Conservative Old Richmond?"[4] The characteristic Richmond answer, opined McGraw: "They were born here." There was truth to it, too. Going forward the number and significance of companies headquartered in the city would fluctuate, but it was the growth of small businesses in the late eighties that sustained the city, as they always had, in good and bad times, and continue to do today.[5]

According to a report prepared by a consortium at Virginia Commonwealth University (VCU) in 2013, the nineties saw continued revitalization leadership by Richmond Renaissance, corporate leaders and the city of Richmond, with accomplishments including construction of the Jackson Center Office Building and the Belle Isle Pedestrian Bridge and Environmental Center. The James River Flood Wall, discussed below, which paved the way for development of the Riverfront Canal Walk and new investment in housing, office, retail and entertainment uses in Shockoe Bottom. New office buildings, such as Riverfront Towers, with lead tenants such as Hunton and Williams and Wheat First Securities had been completed in 1990. The new

Media General headquarters and Times-Dispatch buildings, finished in 1998, effectively stopped the decline of Grace Street, and Crestar helped to kindle interest across the river in Manchester by building its new mortgage center near the Overnite Transportation headquarters. Virginia Commonwealth University began a decade of new construction on its academic and medical campus as well as launching the new Virginia Biotechnology Research Park.[6]

Completion of the aforementioned James River floodwall in 1995 resulted in the protection of over 650 acres of land in some of the city's oldest areas, otherwise susceptible, as they had been in the past, to the devastating effects of flooding. In Shockoe Valley and Shockoe Bottom, the floodwall has been a catalyst for private investment that has transformed an historic manufacturing center to a vibrant mixed-use center of entertainment, housing and commerce in an architecturally significant historic setting. South of the James River, the floodwall, in addition to providing protection to one of the oldest industrial sections of Richmond, also contains a public walkway that offers scenic views of the James River and

downtown. But the floodwall was intended to hold back the river, not a sudden deluge from the sky, which happened when the remnants of Hurricane Gaston stalled over Richmond and devastated Shockoe Bottom businesses on August 30, 2004.

Downtown's dynamism, according to the VCU report, has been complemented by the revitalization of many neighborhoods surrounding the central business district (CBD). "There, as in the downtown, public policy has combined with structural demographic shifts to produce dramatic improvements." Beginning in 1999, the city focused resources on stimulating home ownership in seven neighborhoods, three of which border downtown Richmond. Other developments included the blossoming of a first-class museum district and of Carytown, Virginia's largest independent retail corridor, both within two miles of the city center. Richmond had come to be seen as the cultural, financial and business center of a thriving metropolitan area, and as the capital of the Commonwealth, city, state and federal government offices, colleges and universities, a medical center, a symphony, museums, and vibrant theater scene added to the vitality of the city. The population of Richmond on the cusp of the twenty-first century was 197,000, the center of a metropolitan area of close to one million people.

As the sun set on the twentieth century, Richmond had become what historian Marie Tyler-McGraw characterized as an "old city by American standards and a mix of families long resident to the region and newcomers." The oldest part of the city, she would observe, had moved solidly toward a place of office towers, government buildings, tourist shops, and restaurants, and the city's history continued to be recounted, "casually or didactically, by many voices." McGraw came to realize what Virginius Dabney had come to understand many years before her: that Richmond was one of a just a "few cities that served as the capital of a defeated nation have been as thoroughly enshrined and enfolded into national history as Richmond has."

Endnotes

1 Silver, Christopher. *Twentieth-Century Richmond: Planning, Politics, and Race.* Knoxville: University of Tennessee Press, 1984; Rice, Bradley R., *"Twentieth-Century Richmond: Planning, Politics, and Race* by Christopher Silver," *Georgia Historical Quarterly,* Volume 68, Number 4, Winter 1984.

2 Though the project ultimately failed and the shopping center closed and demolished in 2004, new development would replace it.

3 Sixth Street Marketplace was not the only revitalization project that failed; in 1986, Richmond's convention and visitors bureau promoted the downtown as divided into four shopping sections connected via bus: Sixth Street Marketplace, Main Street Station and the adjacent old Farmer's Market, then the Broad-Grace retail section, and finally, lower Main at Shockoe Slip. But of the latter, Main Street Station closed up shop in 1988. The historic reopening of Main Street Station in 2003 marked the culmination of years of renovation to this landmark building, and the return of passenger train service to downtown Richmond. In the years to come, future upgrades to the station will integrate bus, trolley, airport shuttle, taxi and limousine services. As Main Street Station is further transformed into a significant multi-modal transportation center, it is once again ready to serve as a gateway to the city of Richmond and the metropolitan region. Main Street Station will showcase Richmond as a vibrant destination city.

4 McGraw, Ibid.

5 The Greater Richmond area was named the third-best city for business by MarketWatch in September 2007, ranking behind only the Minneapolis and Denver areas and just above Boston. The area is home to six Fortune 500 companies: electric utility Dominion Resources; CarMax; Owens & Minor; Genworth Financial; MeadWestvaco; and Altria Group; however, only Dominion Resources and MeadWestvaco are headquartered within the city of Richmond; the others are located in the neighboring counties of Henrico and Hanover. In 2008, Altria moved its corporate headquarters from New York City to Henrico, adding another Fortune 500 corporation to Richmond's list. In February 2006, MeadWestvaco announced that they would move from Stamford, Connecticut, to Richmond in 2008 with the help of the Greater Richmond Partnership, a regional economic development organization that also helped locate Aditya Birla Minacs, Amazon.com, and Honeywell International, to the region.

6 Accordino, John, Ph. D., AICP, *et al.* "Richmond, Virginia: a downtown profile 2013," Virginia Commonwealth University, L. Douglas Wilder School of Government and Public Affairs.

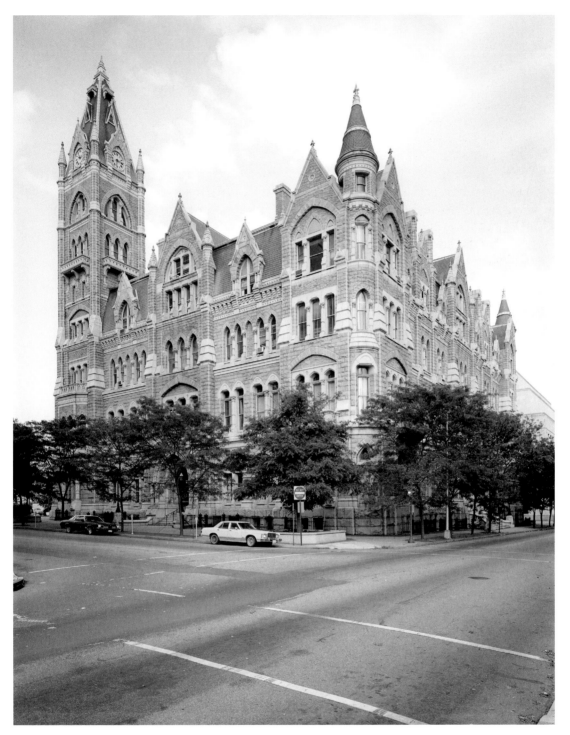

The old Richmond City Hall occupies an entire downtown block bounded on the west by Tenth Street, on the east by Eleventh Street, on the south by Capitol Street, and on the north by East Broad Street; it is shown in this Katherine Wetzel summer 1981 photograph looking at the west façade. Threatened by demolition in the 1970s, the old city hall was acquired by the state and leased to the Historic Richmond Foundation. Today, the old city hall houses offices for the Virginia Commonwealth University School of Medicine's Department of Internal Medicine and the VCU Center on Health Disparities, as well as some programs of the Institute for Drug and Alcohol Studies, including the Humphrey Fellowships. *Library of Congress.*

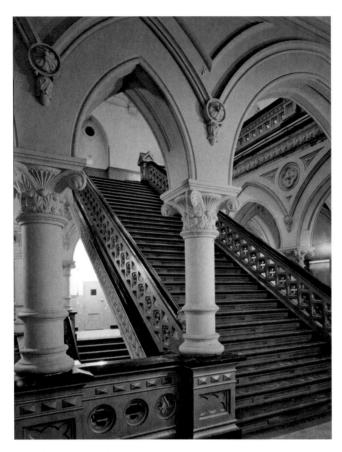

Left: The interior of Richmond's old city hall is as highly decorated as the exterior and contains cast iron stairs and arcades made by Richmonder Asa Snyder. The main staircase is shown in this Katherine Wetzel summer 1981 photograph. *Library of Congress.*

Below: The interior of the old Richmond city hall building centers around a large cortile sky-lighted atrium surrounded by four levels of cloister-like arcades, linked by a grand staircase (also shown here). Katherine Wetzel took this picture as part of a historic survey of the building in the summer of 1981. *Library of Congress.*

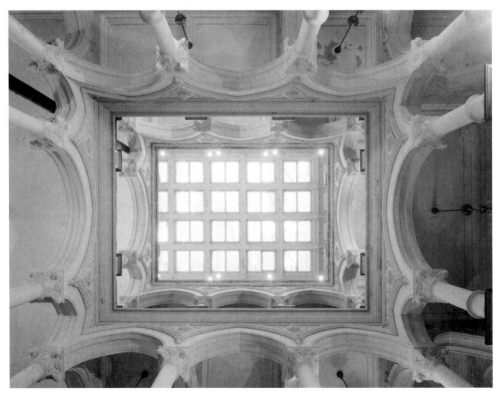

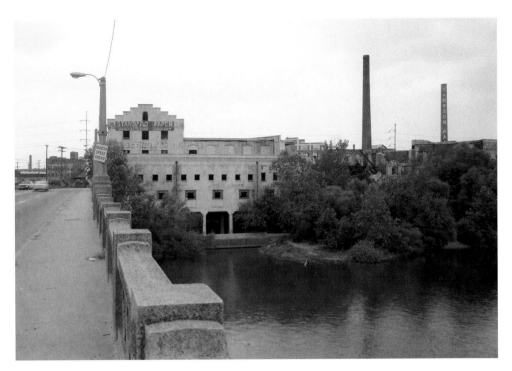

Above: Located on the southern bank of the James River at the Mayo Bridge, the Manchester Cotton and Woolen Manufacturing Company was among the first textile mills to operate in the Richmond area and represented one of the early efforts to diversify the predominately agrarian economy of antebellum Virginia. The Manchester company was the first to use the water power developed by the Manchester Canal, which later supplied power for grain, paper, sumac, and wood-working facilities. The original building operated as a cotton mill at this site from about 1837 until the early 1890s. This picture of the north elevation of the old Manchester mill – on the river side – was taken in August 1986 by Jet Lowe. *Library of Congress.*

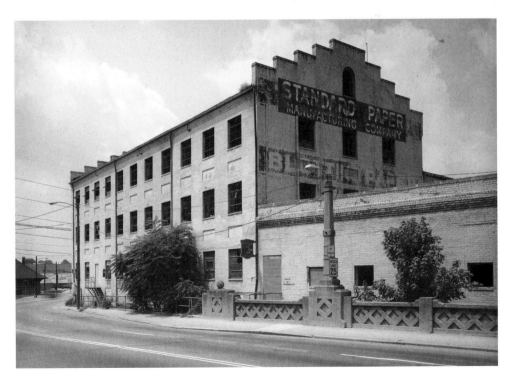

Previous page, below: The Standard Paper Company purchased the Manchester Cotton and Woolen Manufacturing Company property in 1901, shown in this August 1986 photograph by Jet Lowe of the north and east elevations from the Mayo Bridge. The original portion of the mill remained in use as a warehouse from 1901 until 1976. Today, the well-preserved exterior of the original mill, the canal, and the remnants of the water delivery system and the wheel housings are tangible evidence of pioneering efforts by southern industrialists to enter a market dominated by northern companies. *Library of Congress.*

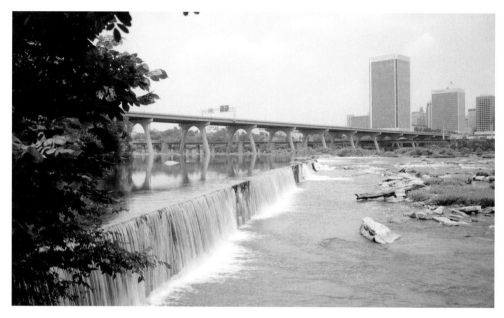

This is the stone dam – a jetty – extending from the western end of the Manchester Canal into the James River; the view is facing northwest from the old Manchester Cotton and Woolen Manufacturing Company property. The photograph was taken in August 1986 by Jet Lowe. *Library of Congress.*

Jet Lowe took this picture looking north to the city of Richmond from the canal headgate, located at the western end of the Manchester Canal, in August 1986. *Library of Congress.*

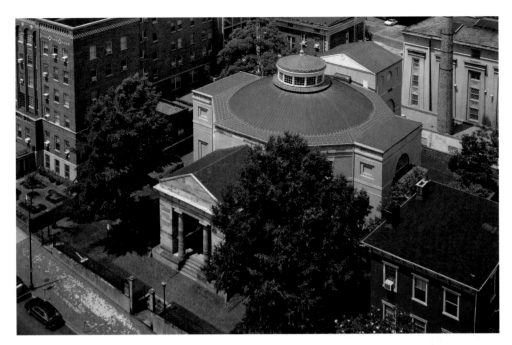

Jack Boucher took this picture of Monumental Church at 1224 East Broad Street in July 1987. Built on what was originally known as Academy Square, the structure is located three blocks southeast of the Virginia State Capitol (1785-1788) and adjacent to the Egyptian Building (1845). Former residential neighborhoods that once surrounded the church have now been largely replaced by structures serving the Medical College of Virginia campus. Among those remaining in the same city block as Monumental Church are attractive Greek Revival townhouses and churches such as the William Beers House (1839), First African Baptist Church (begun in 1802, demolished 1837, and rebuilt in 1876), and the First Baptist Church designed by Thomas Ustick Walter (begun 1839). Other notable houses from this era located in the vicinity include the White House of the Confederacy (1818) and the Wickham-Valentine House by Alexander Parris (completed 1812). *Library of Congress.*

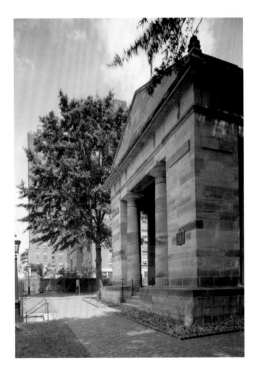

Monumental Church remains the real and symbolic final vestige of a series of central-plan churches – all others have been demolished – that architect Robert Mills designed, including those in Charleston, South Carolina (1804-1806); Philadelphia, Pennsylvania (1811-1812 and 1812-1813); and Baltimore, Maryland (1816-1818). Based on the so-called "auditorium plan," they reflect an important shift in early nineteenth-century Protestant liturgical practices that affected the church design. The southwest portico of Monumental Church was photographed by Jack E. Boucher, July 1987. *Library of Congress.*

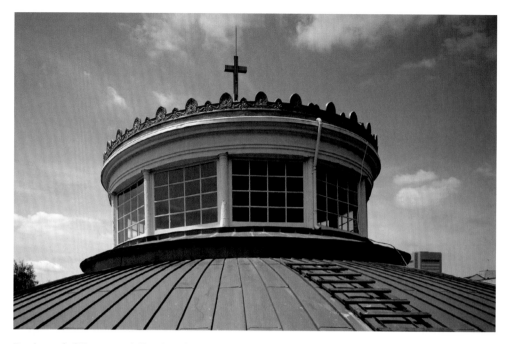

For the roof of Monumental Church, Robert Mills employed the French seventeenth-century architect Philibert de l'Orme's ingenious construction (derived from a system of small wood sections joined by pegs, and similar to that used by Thomas Jefferson at Monticello), which successfully covered an octagonal rotunda with a shallow circular dome and fenestrated cupola. Jack E. Boucher took this photograph, a detailed view of Monumental Church's dome clerestory, in July 1987. *Library of Congress.*

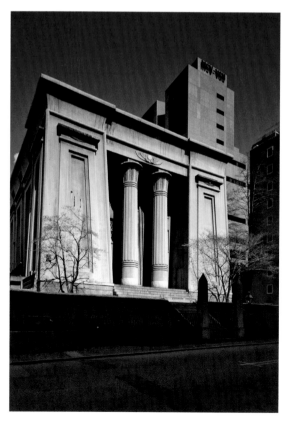

In 1838 Hampden-Sydney College established a medical department in Richmond that occupied the old Union Hotel at Nineteenth and Main Streets, but it was realized that the budding medical school required a building dedicated to the study of medicine. The Egyptian Building, designed by the noted Greek Revival architect Thomas Stewart, was the first building put up for the purpose of this new medical college. The Egyptian Building, located at 1200 East Marshall Street, was completed in 1845 as the first permanent home of the Medical Department of Hampden-Sydney College (later renamed the Medical College of Virginia) and now part of Virginia Commonwealth University. This important structure is considered by architectural scholars to be one of the finest surviving Egyptian Revival style buildings in the United States; it was added to the Virginia Landmarks Register on November 5, 1968, the National Register of Historic Places on April 16, 1969, and finally designated as a National Historic Landmark on November 11, 1971. *Contines on page 127.*

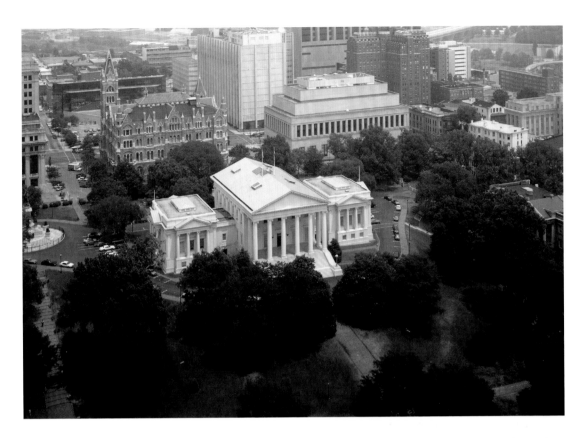

Above: This aerial view looking northeast to the Virginia State Capitol and Capitol Square, taken in June 1988 by Jack Boucher, provides an updated view of the same taken in the first decade of the twentieth century. As an expression of Thomas Jefferson's classically inspired architectural vision, the Capitol, the first temple-form public building in the United States, became the prototype for American civic architecture of the nineteenth and twentieth centuries. Serving as the home of Virginia's legislature for more than 200 years, the Capitol is the symbolic and functional center of representative government in the Commonwealth. *Library of Congress.*

Right: Located at Bank and Tenth Streets, this is the southwest façade of the Virginia State Capitol main block, photographed in June 1988 by Jack Boucher. *Library of Congress.*

Continued from page 126:
The Egyptian Building was originally called College Building and later the Old College Building. The National Register of Historic Places considers it to be the oldest medical college building in the South. The battered corners of the walls of the structure recall the ancient temples of Egypt. The building, in continuous use since construction, was photographed (shown here) by Jack E. Boucher, July 1987. *Library of Congress.*

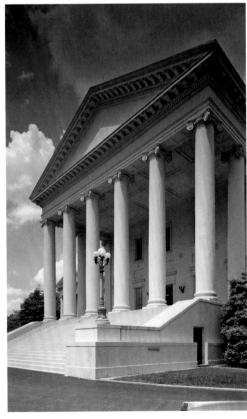

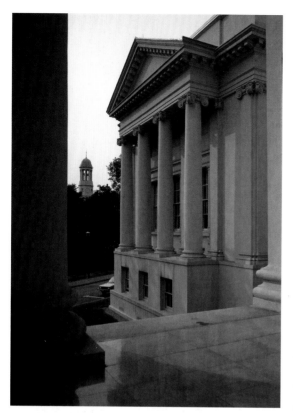

The West Wing of the Capitol is occupied by the Senate. Jack Boucher took this picture of the building's southwest façade showing the Senate section in June 1988. This chamber of the Capitol was first occupied by the upper house of the Virginia General Assembly in 1906 following the completion of the Capitol wings designed by John Kevan Peebles. The Senate is comprised of forty members, who are elected every four years. The lieutenant governor, the president of the Senate, is elected to a four-year term in a statewide election, and presides over the Senate from the upper dais at the front of the chamber. The clerk of the Senate and the clerk's staff work at the podium and lower desk. The clerk is elected by the Senate members for a four-year term. *Library of Congress.*

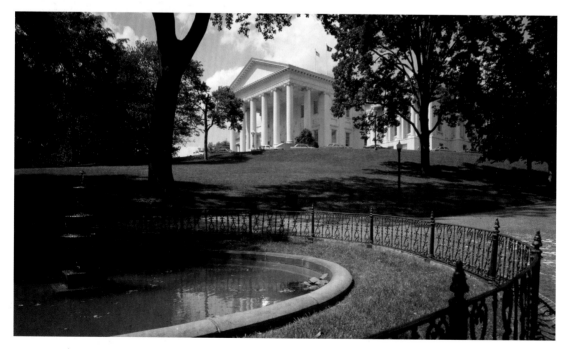

In 1850, John Notman, a native of Edinburgh, Scotland, who practiced architecture and landscape gardening in Philadelphia, developed a plan of meandering walkways and native trees and shrubs that gave Capitol Square much of the appeal it retains today. Notman channeled the springs in the Square to two fountains he placed near its southeast and southwest corners. The fountains still exist, but are now fed by the municipal water supply. Jack Boucher took this picture in June 1988 of the Capitol grounds looking west (fountain the foreground). *Library of Congress.*

In the southwest corner of Capitol Square near the Bell Tower is a five-foot high bronze statue of a seated Edgar Allan Poe, who grew up in Richmond and returned years later to edit *The Southern Literary Messenger.* The statue, wrought by sculptor George Ruby, was a gift to the state by Dr. George E. Barksdale in October 1959. Jack Boucher took this picture of the statue in June 1988. *Library of Congress.*

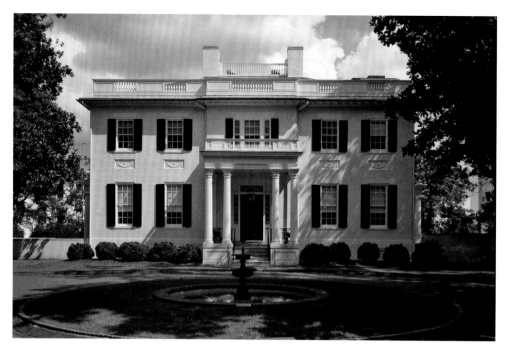

Designed by architect Alexander Parris specifically as a residence for governors, the Virginia Governor's Mansion is the oldest continually occupied executive mansion in the United States. This Federal-style structure has been the home of Virginia governors and their families since 1813 (shown here, June 1988 Boucher photograph). A Virginia and National Historic Landmark, the mansion has had a number of successive renovations and expansions in the twentieth century. *Library of Congress.*

Adjacent to the Washington monument in Capitol Square (shown here, June 1988, Boucher) is a statue (left) of Harry Flood Byrd, governor 1926-1930, and United States senator, 1933-1965, that was dedicated on June 10, 1976, in the north section of Capitol Square. The Byrd statue by sculptor William M. McVey stands ten feet high on a two-foot high dark marble platform and depicts the senator carrying the federal budget in his left hand, as he was known for his "pay as you go" policies. *Library of Congress.*

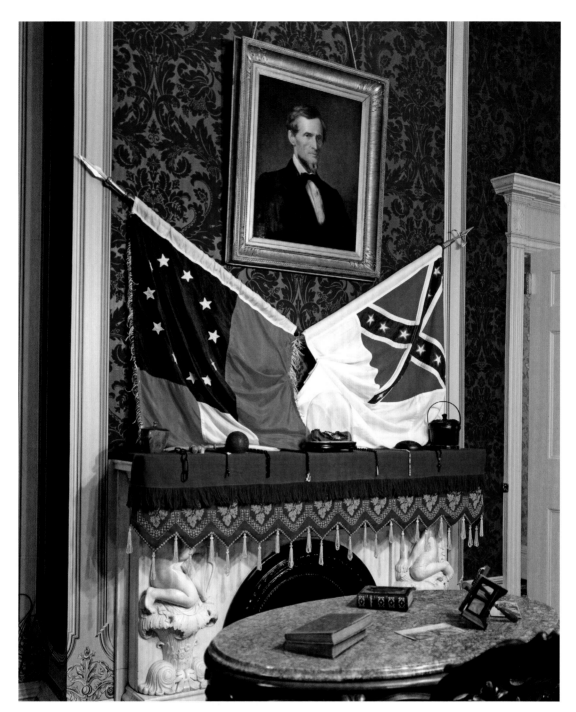

Carol Highsmith took this contemporary interior photograph of the White House of the Confederacy, a historic house located in Richmond's Court End neighborhood that, along with the adjacent Museum of the Confederacy and nearby American Civil War Center at Historic Tredegar, is part of the American Civil War Museum. The White House, first opened as a Confederate museum on February 22, 1896, just two blocks from the Virginia State Capitol, was closed in 1976 to be fully restored to its wartime appearance. The restoration project was completed in 1988, gaining high marks from the preservation community for its accuracy and richness of detail. Since it reopened for public tours in June of that year, the White House featured extensive reproduction wall coverings and draperies, as well as the majority of original White House furnishings used by the Davis family from the Civil War period. *Carol M. Highsmith Archive, Library of Congress.*

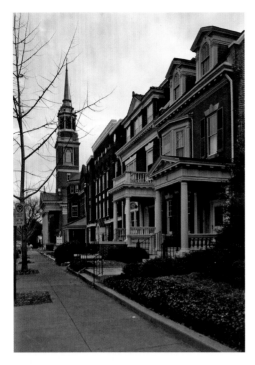

Jack E. Boucher took this picture of the 1200-block of West Franklin Street looking southeast toward Saint James Episcopal Church in 1991. This block is exceptional for the mix of building types it presents in a small area. Although the concentration of residences is high (three apartment buildings and seven houses), the addition of two churches, a parish house, and hospital within the block reflect the multiple activities that take place in this neighborhood. The fact that all but one of these buildings was constructed after most of the houses on the avenue's first three blocks were completed suggests that the 1200-block might best be understood as a response to that development. Certainly the stylistic character of this mostly Colonial Revival block has more in common with the avenue than with the concentration of Queen Anne, Italianate, Romanesque, French Renaissance and Georgian Revival town houses in the four blocks of West Franklin to the east, between Birch Street and Monroe Park. *Library of Congress.*

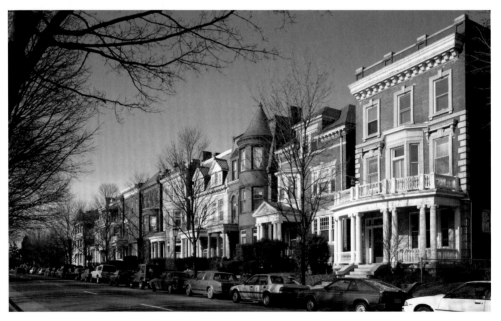

This view looking northwest at the north side of the 1600-block of Monument Avenue was taken by Jack E. Boucher in 1991. This block of Monument, between Stuart Circle at Lombardy Street and Lee Circle at Allen Avenue, is anchored on the east by the equestrian statue of J.E.B. Stuart and on the west by the Lee Monument. Designed by French sculptor Jean Antoine Mercie, the statue of Robert E. Lee mounted on his horse, Traveler, sits on an elaborate Beaux-Arts pedestal. Commissioned in 1887, the statue was unveiled in May 1890. As platted on Burgwyn's layout accompanying the 1887 deed to the Lee Monument Association, Monument Avenue's 140-foot width on this block, contrasting with narrower West Franklin Street, forms a ceremonial approach to the monument. Quadrant lots mark all four corners of the 1600-block, and what was built on each quadrant demonstrates a unique attitude towards its monumental circle. *Library of Congress.*

This is a close view looking northeast at the north side of the 1800-block of Monument Avenue taken in 1991 by Jack E. Boucher. The 1800-block is architecturally rich and dense, including among its dwellings several variations of the Queen Anne, Neoclassical, and Colonial Revival styles, and one especially fine Georgian Revival example. One-story Colonial Revival front porches, most with white classical columns but some with brick or stone pillars, are a significant unifying compositional element down the block, as they are throughout the length of the avenue, along with a generous distribution of balustrades and limestone or brownstone accents on brick façades. These are the primary threads out of which the avenue's signature fabric is knit. *Library of Congress.*

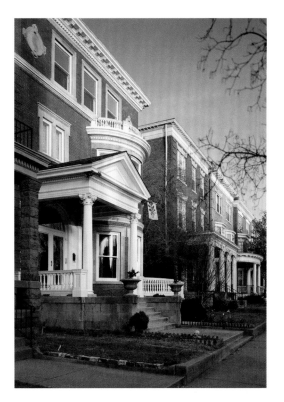

In the 1920s, long after the city straightened Monument Avenue and extended it to Roseneath Road, the first houses were built on the 3100 block between Belmont and Cleveland Streets. The statue of Matthew Fontaine Maury was unveiled after the blocks were nearly complete, in 1929. The Matthew Fontaine Maury Association, backed by the United Daughters of the Confederacy, laid the cornerstone for a memorial to the commodore on June 22, 1922, at the intersection of Belmont and Monument Avenues; the monument, sculpted by Richmonder F. William Sievers, was unveiled on Armistice Day, November 11, 1929. Jack E. Boucher took this picture of the Matthew Fontaine Maury statue in 1991. *Library of Congress.*

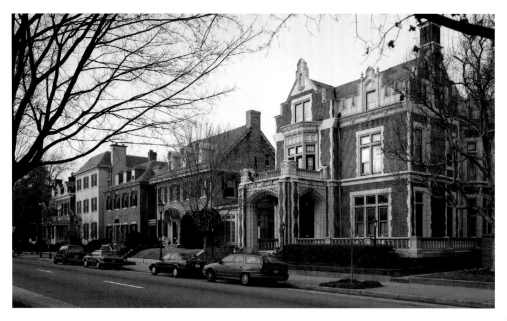

Above: The 2300-block of Monument Avenue, shown here looking northwest, is bounded by Strawberry Street (formerly Addison) on the east and Davis Avenue (formerly Cedar) on the west. This block has fewer buildings and wider lots than most other blocks on the avenue, giving it a greater sense of space, especially on the south side, where lots are typically twice and sometimes as much as three times the width of lots on the north side of the block. All nineteen of the buildings on this block are single-family houses. At the intersection of Monument and Davis Avenues is the monument to Jefferson Davis. A giant column surmounted by the allegorical figure Vindicatrix is framed by a Doric colonnade; the statue of Davis is overwhelmed. Richmond sculptor Edward V. Valentine designed the two figures, while local architect W. C. Noland was responsible for the elaborate setting. The site was chosen nearly a year after the design was accepted in November 1903. The statue was unveiled in June 1907. *Library of Congress.*

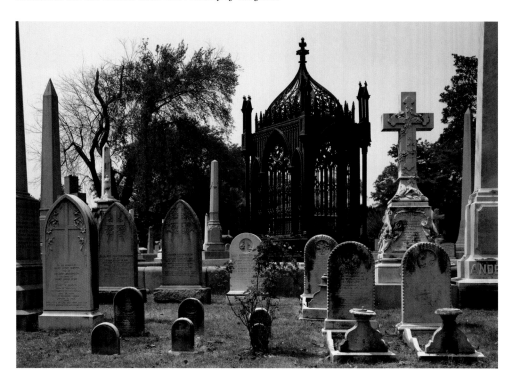

Above: This contemporary photograph of the ninety-foot stone pyramid honoring 18,000 Confederate enlisted men buried at Hollywood Cemetery was taken by Carol M. Highsmith. *Carol M. Highsmith Archive, Library of Congress.*

Opposite below: James Monroe, fifth President of the United States, died in New York City on July 4, 1831, and was buried in the New York City Marble Cemetery. In 1856 plans were proposed to erect a monument in memory of the late President in New York. At this time, Governor Henry A. Wise received a letter from the governor of New York inquiring if Virginia, birthplace of Monroe, wished to have the body reinterred in the state. Two thousand dollars was voted by the Virginia State Legislature, and the body of Monroe was returned on the steamship *Jamestown*, on loan from the Virginia Steamship Company, accompanied by the Seventh Regiment from New York. Impressive ceremonies were held in Richmond, highlighted by speeches from the governors of New York and Virginia calling for national unity. The records of Hollywood Cemetery were burned in 1865, and as a result there are no specific records of Monroe's burial from that time. The granite sarcophagus surrounded by a cast iron cage set, designed by architect Albert Lybrock, an Alsatian who had lived in Richmond since 1852, was installed in 1859 on a bluff overlooking the James River. Jack E. Boucher took this photograph in 1991. *Library of Congress.*

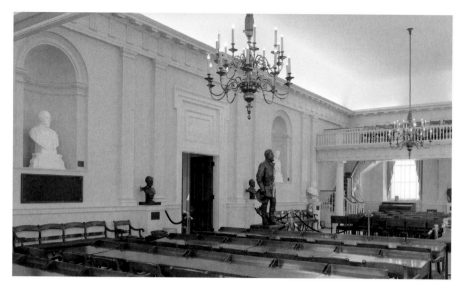

The Old Hall of the House of Delegates, also called the Old House Chamber, is located off the north end of the Rotunda. It is the largest room in Thomas Jefferson's original Capitol building, measuring 76 feet long. A dramatic coved ceiling, projecting cornices, and carved interior woodwork reflect the building's Roman Classicism. From 1788 to 1904, the Old Hall was the meeting place of the Virginia House of Delegates. Delegates assembled here in rows of seats arranged around the Speaker's chair. As there was no other large meeting hall in the area, the room was also used for community events and church services in its early years, with Episcopal and Presbyterian congregations meeting on alternate Sundays. The old chamber showing detail of the southeast balcony stair was photographed by Jack E. Boucher in 2005. *Library of Congress.*

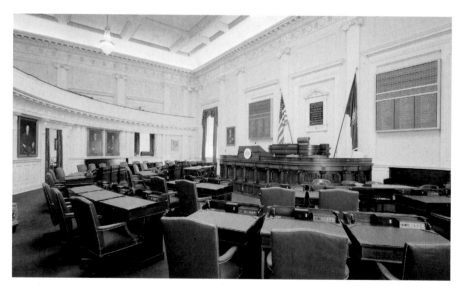

The Virginia Senate Chamber (also called the West Wing) was photographed in 2005 by Jack E. Boucher. Two significant surprises came to light during the Capitol's 2004 to 2007 restoration. Decorative wall and ceiling paintings done in 1908 by Richmond commercial painter R. L. Peters were discovered under twenty-four layers of paint. Some of this work was still intact in the Capitol's Rotunda, but most of the paintings in the House of Delegates and Senate Chambers had been covered over by the 1930s. Restoring the Rotunda's decorative panels without damaging the early twentieth-century fabric proved impossible. Instead, the decorative details were encapsulated in place, and reproductions were superimposed over them. *Library of Congress*

During the most recent Capitol restoration, Jack Boucher took this picture from the window of room 322 of the Capitol building in 2005; the Governor's Mansion is in the distance. *Library of Congress.*

The bronze Virginia State Seal set into the floor of the lobby inside the Bank Street entrance to the Capitol Extension was relocated to this location at the beginning of the $104.5 million Capitol Restoration and Expansion Project in 2004; the Capitol was rededicated and reopened to the public on May 1, 2007. The seal is 53 inches in diameter, 3 inches thick, and weighs roughly 300 pounds. Made of bronze and marble, it was cast in one piece and originally placed in the first floor of the Capitol in 1936. This contemporary photograph of the state seal is by Jack E. Boucher. *Library of Congress.*

Originally opened in 1901, Main Street Station (shown here, rooftop detail) has always been one of Downtown Richmond's most visible landmarks. Once a bustling transportation hub, the station was closed in 1975 due to a decline in passenger rail service. The historic reopening of Main Street Station in 2003 marked the culmination of years of renovation to this landmark building, and the return of passenger train service to downtown Richmond. *Carol M. Highsmith Archive, Library of Congress.*

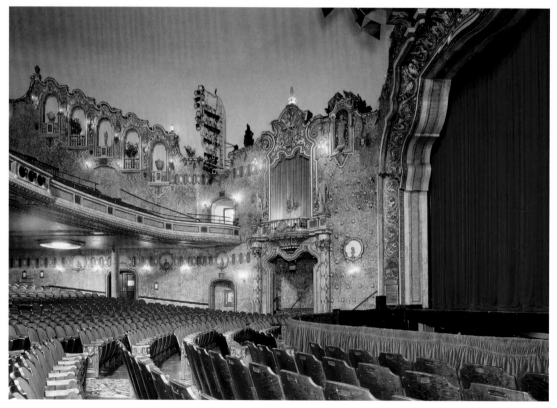

Designed by New York architect John Eberson as a Loew's Movie Theatre, the Carpenter Theatre first opened its doors in 1928 at 600 East Grace Street; it showed films until 1979, when it was closed due to suburban multiplexes. The theatre remained vacant until 1983 when it was restored and reopened as the Carpenter Center for the Performing Arts; however, this restoration did not sufficiently address the theatre's aesthetic and mechanical issues, including a stage that was too small for major touring shows to stop at the Carpenter. In December 2004, the Carpenter closed while the CenterStage Foundation began a twenty-five million dollar renovation and restoration of the theatre (interior, shown here). *Carol M. Highsmith Archive, Library of Congress.*

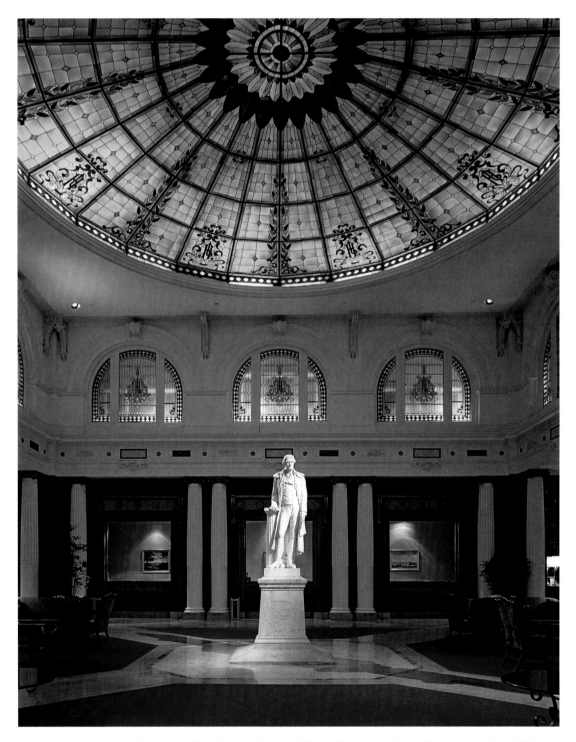

As a centerpiece for the upper lobby – The Palm Court – Jefferson Hotel owner Lewis Ginter commissioned Richmond sculptor Edward V. Valentine to create a life-size image of Jefferson from Carrara marble. The statue (shown in this contemporary photograph) cost $12,000 and took two years to complete. Valentine was able to borrow clothing actually worn by Jefferson, which he copied for the statue. *Carol M. Highsmith Archive, Library of Congress*

SELECT BIBLIOGRAPHY

Primary Sources

Government Documents

City of Richmond Planning Commission. "A preliminary report on the background and character of the city," Part 2 in a series. July 1941.

City of Richmond Planning Commission. "A master plan for the physical development of the city," 1946. Commonly called the "Bartholomew Plan."

Commonwealth of Virginia, Department of General Services, Division of Engineering and Buildings. "Virginia State Capitol Master Plan," March 2005.

Gibson, Campbell, "Population of the 100 largest cities and other urban places in the United States: 1790 to 1990. United States Census Bureau, June 1998. https://www.census.gov/population/www/documentation/twps0027/twps0027.html

National Park Service, Department of the Interior. "James River and Kanawha Canal Locks 1-5, between 10th and 13th streets, north of Byrd Street, Richmond, Virginia," Historic American Engineering Report, May 9, 1969.

National Park Service, Department of the Interior, Office of Archaeology and Historic Preservation. "Jefferson Hotel, northeast corner of West Main and North Jefferson streets, Richmond, Virginia," Historic American Building Survey, May 12, 1969.

National Park Service, National Register of Historic Places (registration form). "City Hall," June 2, 1969. National Register of Historic Places, October 1, 1969.

— "Grace Street Commercial Historic District," October 1, 1997. National Register of Historic Places, July 13, 1998.

— "John Marshall House." National Register of Historic Places, October 15, 1966.

— "Monroe Park Historic District," November 15, 1983. National Register of Historic Places, July 5, 1984.

— "National Theater," February 12, 2003. National Register of Historic Places, November 2, 2003.

— "Shockoe Valley and Tobacco Row Historic District," May 10, 1982. National Register of Historic Places, February 24, 1983.

— "Stewart-Lee House," October 1971. National Register of Historic Places, May 5, 1972.

— "The history and architecture of the University of Richmond, 1834-1977. National Register of Historic Places, May 7, 2013.

— "The Masonic Temple," December 14, 1982. National Register of Historic Places, February 10, 1983.

— "Virginia House," June 1, 1989. National Register of Historic Places, June 13, 1990.

— "West Broad Street Commercial Historic District," December 7, 2000. National Register of Historic Places, January 16, 2001.

— "West Franklin Street Historic District," March 21, 1972. National Register of Historic Places, September 14, 1972.

State Highway Commission of Virginia. Minutes of Meeting, August 28, 1958. www.ctb.virginia.gov/meetings/minutes_pdf/CTB-08-1958-01.pdf

United States Census Bureau. Richmond, Virginia QuickFacts 2013 population data. quickfacts.census.gov/qfd/states/51/51760.html

Virginia Department of Historic Resources/Virginia Department of General Services. "Real estate assessment and general plan for the property bounded by 8th, 9th, Grace and Broad streets in the city of Richmond," appendices, July 12, 2005.

Secondary Sources

Books

Brownell, Charles E. et al. *The Making of Virginia Architecture.* Charlottesville: Virginia Museum of Fine Arts/University Press of Virginia, 1992.

Dabney, Virginius. *Richmond: The Story of a City.* New York: Doubleday, 1976.

Dementi, Elisabeth, Wayne Dementi, and Corrine Hudgins. *Celebrate Richmond.* Richmond: Dietz Press, 2000.

Dulaney, Paul S. *The Architecture of Historic Richmond.* Charlottesville, Virginia: University Press of Virginia, 1968.

Flannagan, Roy C. *The Story of Lucky Strike.* New York World's Fair Edition. Richmond: Richmond News Leader, 1938.

Kibler, J. Luther. *Historic Virginia Landmarks.* Richmond: Garrett and Massie, 1929.

Klein, Maury. *The Great Richmond Terminal: A Study of Businessmen and Business Strategy.* Charlottesville, Virginia: University Press of Virginia, 1970.

Perdue, Nancy J. and Charles L. Perdue Jr. *Talk About Trouble: A New Deal Portrait of Virginians in the Great Depression.* Chapel Hill: University of North Carolina Press, 1996.

Robert Sacré. "The Harmonizing Four," in *Encyclopedia of American Gospel Music* (edited by W. K. McNeil). London: Routledge Press, 2005.

Scott, Mary Wingfield. *Old Richmond Neighborhoods.* Richmond: Whittet and Shepperson, 1941.

Silver, Christopher. *Twentieth Century Richmond: Planning, Politics, and Race.* Knoxville: University of Tennessee Press, 1984.

Smil, Vaclav. *Creating the Twentieth Century: Technical Innovations of 1867-1914 and Their Lasting Impact.* New York and London: Oxford, 2005.

Tyler-McGraw, Marie. *At the Falls: Richmond, Virginia, and Its People.* Chapel Hill: University of North Carolina Press, 1994.

Waterman, Thomas Tileston. *The Mansions of Virginia 1706-1776.* New York: Bonanza, 1945.

Wilson, Richard Guy. *Buildings of Virginia: Tidewater and Piedmont.* Oxford: Oxford University Press, 2002.

Winthrop, Robert P. *Architecture in Downtown Richmond*. Richmond: Historic Richmond Foundation, 1982.

Journals, Magazines, Newspapers and Pamphlets

Associated Press. "Flooding devastates historic Richmond, Virginia," September 1, 2004. www.nbcnews.com/id/5851220/#.VN5yDy6Jdv8

Blackwell, John Reid, "Cigarette making still going strong in South Richmond," *Richmond Times-Dispatch*, August 30, 2013. www.timesdispatch.com/business/manufacturing/cigarette-making-still-going-strong-in-south-richmond/article_27bad786-788e-570a-b837-b008519c1c39.html

- "Six local companies make the Fortune 500 list," *Richmond Times-Dispatch*, May 13, 2013. www.richmond.com/business/local/companies/altria-group/article_3c00985a-a080-5885-bd24-5b862b704cd1.html

Broadcasting. "WRVA's new wood antenna using single-wire radiator, greater efficiency in transmission is said to be achieved," June 15, 1935. www.americanradiohistory.com/Archive-BC/BC-1935/1935-06-15-BC.pdf

- "Stronger WRVA signal credited to wood tower," October 15, 1935. www.americanradiohistory.com/Archive-BC/BC-1935/1935-10-15-BC.pdf

Business Facilities. "Honeywell expands advanced fiber production in Virginia," February 9, 1012. businessfacilities.com/2012/02/honeywell-expands-advanced-fiber-production-in-virginia/

Clark, Steve, "Murphy's law crafted at hotel," *Richmond Times-Dispatch*, January 30, 2001.

Harness, Volume XXIV, March 1910.

Mahoney, Ryan, "City's bid for corporate HQ lost in traffic," *Atlanta Business Chronicle*, March 19, 2007. www.bizjournals.com/atlanta/stories/2007/03/19/story2.html?page=all

Retailing Today. "Amazon to open two fulfillment centers in Virginia," December 22, 2011. www.retailingtoday.com/article/amazoncom-open-two-fulfillment-centers-va

Rice, Bradley R., "Twentieth-Century Richmond: Planning, Politics, and Race by Christopher Silver," *Georgia Historical Quarterly*, Volume 68, Number 4, Winter 1984.

Richmond-Jamestown Festival Committee, "Richmond: city of churches," June 1957.

Richmond News Leader. "More automobiles for Richmond," December 5, 1922.

Richmond Times-Dispatch. "Murphy's grew out of oyster shop in 1872," October 9, 1932.

- "60th anniversary of Murphy's new improvements," March 10, 1926.

Slipek Jr., Edwin, "Open indulgence," *Style Weekly*, March 31, 2010. www.styleweekly.com/richmond/open-indulgence/Content?oid=1382068

The Commonwealth. "Murphy's Hotel in Richmond," Volume IV, Number 11, November 1937.

Trader, Carly, "A grand old house," *Inside Richmond*, September 15, 1992. members.tripod.com/~g_cowardin/byrd/grand.htm

Ward, Mike, "6th Street to be torn down?" *Richmond.com*, September 26, 2001. www.richmond.com/city-life/article_db63cf07-05df-5b29-95db-671ec7883628.html

Yahoo! Finance. "Minacs to hire 250+ in Richmond, VA: Invites applications," March 20, 2013.

Yolen-Cohen, Malerie, "Richmond, Virginia: A city of historical significance, emerging artists and great food," *Huffington Post*, December 9, 2013. www.huffingtonpost.com/malerie-yolencohen/richmond-va-a-city-of-sin_b_4399655.html

Papers and Reports

Accordino, John, Ph. D., AICP, *et al.* "Richmond, Virginia: a downtown profile 2013," Virginia Commonwealth University, L. Douglas Wilder School of Government and Public Affairs.

Brown, Jeffrey, "A tale of two visions: Harland Bartholomew, Robert Moses, and the development of the American freeway," Institute of Transportation Studies, School of Public Policy and Social Research, University of California, Los Angeles, July 24, 2002.

Web Sites

"About the Robert E. Lee Camp Confederate Soldiers' Home," Library of Virginia www.lva.virginia.gov/public/guides/opac/campabout.htm

Agecroft Hall www.agecrofthall.com/View.aspx?page=home

Capitol Visitor Guide hodcap.state.va.us/publications/Capitol_Visitor_Guide.pdf

City of Richmond, master plan and other documents www.richmondgov.com/planninganddevelopmentreview/PlansAndDocuments.aspx

–Richmond riverfront plan dated November 26, 2012 www.richmondgov.com/PlanningAndDevelopmentReview/documents/2_Belle_Isle.pdf

Fan of the Fan fanofthefan.com/2012/01/the-fan-area-historic-district/

Historic Richmond Foundation historicrichmond.com/

Radio in Virginia www.lva.virginia.gov/exhibits/radio/voice.htm

Reveille United Methodist Church reveilleumc.org/reveille-history

Richmond Federal Reserve Bank www.richmondfed.org/about_us/history/

Saint John's Church historicstjohnschurch.org/

The Carillon Civic Association www.carilloncivic.org/

The Fan Area Historic District fanofthefan.com/2012/01/the-fan-area-historic-district/

The Jefferson Hotel www.jeffersonhotel.com/

"Virginia House," Virginia Historical Society www.vahistorical.org/your-visit/virginia-house

ABOUT THE AUTHOR

AMY WATERS YARSINSKE is the author of several best-selling, award-winning nonfiction books, most recently *An American in the Basement: the Betrayal of Captain Scott Speicher and the Cover-up of His Death*, and while it has led to major media interviews and speaking engagements across the country, it importantly continues the national conversation of POW/MIA accountability. The book won the Next Generation Indie Book Award for General Non-fiction in 2014.To those who know this prolific author, it's no surprise that this Renaissance woman became a writer. She learned at an early age that self-expression had to be forceful, accurate and relevant. This drive to document and investigate history-shaping stories and people has already led to over 60 nonfiction books, most of them spotlighting current affairs, the military, history and the environment.Amy graduated from Randolph-Macon Woman's College in Lynchburg, Virginia, where she earned her Bachelor of Arts in English and Economics. She earned her Master of Planning from the University of Virginia School of Architecture, where she was a DuPont Fellow and Lawn/Range resident. She also holds numerous graduate certificates, including from the CIVIC Leadership Institute and the Joint Forces Staff College, both headquartered in Norfolk, Virginia, and from the Massachusetts Institute of Technology for a military course completed at Suffolk, Virginia. She is a member of the American Society of Journalists and Authors (ASJA), Investigative Reporters and Editors (IRE), Authors Guild and the North Carolina Literary and Historical Association (NCLHA), among her many professional and civic memberships and activities.

If you want to know more about Amy and her books, go to
www.amywatersyarsinske.com